WATERCOLOR BY DESIGN

WATERCOLOR BY DESIGN

MARIO COOPER

N. A. A. W. S.

WATSON-GUPTILL/NEW YORK
PITMAN HOUSE/LONDON

First published 1980 in the United States and Canada by Watson-Guptill Publications,
a division of Billboard Publications, Inc.,
1515 Broadway, New York, N.Y. 10036

Library of Congress Cataloging in Publication Data
Cooper, Mario.
 Watercolor by design.
 Bibliography: p.
 Includes index.
 1. Cooper, Mario. 2. Water-colorists—United
States—Bibliography. 3. Water-color painting—Technique.
I. Title.
ND1839.C67A2 1980 759.13 80-16495
ISBN 0-8230-5655-4

Published in Great Britain by Pitman House,
39 Parker Street, London WC2B 5PB
ISBN 0-273-01625-3

Manufactured in Japan

First Printing, 1980

Edited by Bonnie Silverstein
Designed by Jay Anning
Graphic production by Anne Musso
Set in 11-point Palatino

One more time to Dale

Many thanks to the staff of Watson-Guptill:
especially to Marsha Melnick, Dan Kagan, and Bonnie Silverstein;
to Jay Anning, who designed this book;
and to my wife Dale for her many suggestions.

CONTENTS

FOREWORD

If Mario Cooper hadn't become an artist, he might conceivably be singing *Pagliacci* with brilliance and pathos instead.

But he did become an artist, a teacher, and a longtime president of the American Watercolor Society (AWS), known for his able leadership. In all his roles, Cooper is on stage with an enthralling wit and a Renaissance man's broad range of interests.

Cooper's background encompasses a mixture of people and places. He has lived in Mexico and in California. He studied at Chouinard Art Institute in Los Angeles and the Grand Central School of Art in New York. For many years he has been a New Yorker. Cooper is an urbanite, a lover of good restaurants, theater, and stimulating conversation.

He is also an experienced author, and his books reflect his teaching techniques. Cooper began his career in illustration and became a top-ranking illustrator before turning to the fine-arts field. Illustration is demanding work, and Cooper developed the knack of keeping his skillful technical ability always available to carry out a wide variety of assignments on tight deadlines. Even today Cooper uses streamlined techniques that are neat and save time. He teaches them to his students at the Art Students League and at the National Academy, as well as to readers of his books.

Many of Cooper's paintings have been widely reproduced. Their subject matter ranges from houseboats in Tokyo to Venetian bridges. Travel is a way of life to Cooper. For more than 20 years he has been an official artist with the Air Force and has been accorded the courtesy rank of brigadier general on trips to far-flung air bases or NASA launchings. On assignment he wears what appears to be a uniform shirt with a shoulder patch that reads "Official Artist, U.S. Air Force." Yet, he's just as apt to wear it with his gray jeep hat decorated with a droopy red sable tail while teaching a workshop somewhere in the United States.

It was on such a trip in 1961, after teaching a three-week summer course, that Cooper helped a local group of painters form a watercolor society in Springfield, Missouri. This group was offered a show by Kenneth Shuck, at the time the director of the Springfield Art Museum. Cooper asked, "Why don't you make it a national show?" This was the impulse that led to "Watercolor USA," now a major, career-making event held each year in Springfield. When the first show was held in 1962, Cooper and Rex Brandt were the judges.

Talent in organizing has much to do with his willing expenditure of energy. Cooper has such talent in abundance and he gives of it freely. He has helped in the founding of the Aquarelle Club of Port Washington, New York, and for four years was president of the Audubon Artists. But it is the American Watercolor Society that has been the main forum for his efforts, and for which he has performed the greatest service. His term as president of the AWS began in 1959. At that time the group had numerous outstanding bills, and Cooper took out a loan to pay them. He also instituted what the late Ralph Fabri described as an "austerity program" in the book *The History of the American Watercolor Society*, published in 1969 on the occasion of the group's 100th anniversary.

Cooper's program is probably the reason the AWS survived to celebrate its centennial and is flourishing today. He eliminated the paid secretary, increased the dues, and cut the grand prize in half, to $500. The austerity paid off—now, the society's annual awards are up to $15,000, and they increase every year.

Cooper designed a series of handsome bronze medals to be used for the society's awards (all of which, incidentally, he has won himself).

Among the changes he instituted was an increased reliance on women. In 1960 two women were elected to the board: one as assistant treasurer and one as assistant corresponding secretary. Later, another woman became assistant to the president. When Cooper began a newsletter, Dale Meyers became its first editor. She did so well on the job that Cooper began courting her, and that, too, turned out happily. They were married in 1964.

Dale Meyers and Mario Cooper are both academicians of the National Academy in Aquarelle, whose membership is limited to 25 seats. She continues to be active on the board of the AWS and with other groups as well. She also served as the first woman president of the Allied Artists of America.

The AWS has done away with the idea of purchase awards. Cooper explains the reason behind this alteration in a time-honored custom: "Artists," he says, "will often accept the offer of a purchase prize even when it is less than their asking price for the work." He feels cash prizes given to the artist serve a better purpose. The artist gets to keep his painting and its value increases because it has won a prize. When the artist finally sells it, it is for the full price. Today, cash awards and bronze medals are the rule at the society's annual exhibitions.

It has been an ongoing desire of Cooper and the AWS board to expand the representation of society shows. Since 1964 jurors have been invited from around the country, and their expenses have been paid by the society. Money for this purpose is now ample as a result of well-invested inheritances and gifts.

Through his willingness to teach workshops, Cooper has carried the idea of the "professional artist" to all parts of the country. One result of his trips is that the number of entrants in AWS shows has increased. By widely sharing his knowledge he is partly responsible for the exciting rise in the quality of work—particularly in watercolor—shown by artists across the United States. Watercolor is Cooper's preferred medium, although he paints in other media and sculpts as well.

Former students of Cooper's remember for years some of the practical tips that he lavishes on his classes. For example, there is the clean water trick, using two pots of water with a sponge in between. Wash out the brush in one pot; wipe it across the sponge; and scoop up clean water out of the jar that is *always* immaculate.

Speaking of sponges brings to mind another anecdote: Cooper gives little demonstrations of foliage-making with daubs of paint on a natural sponge. Most of us used that idea in first grade, but somehow it seems more serious when Cooper does it. He tells his class, "Dale doesn't like me to do this. I have to do it when she's not looking."

Such asides impart humor to his serious, demanding teaching. At a workshop, he moves through a vigorous series of exercises in only a few days while giving many demonstrations. He paints subjects that are familiar to him, stressing methods and procedures for students as a basis for freedom to create. It is clear that he favors acquiring dependable

knowledge and control before becoming "expressive," and he can quickly let you know if a painting, however creative, is wanting in some fundamental of design.

Throughout his lessons, Cooper talks. One moment he is reciting Shakespeare, Dante, or Lorca—or a Japanese haiku—Dante in Italian, Lorca in Spanish, the haiku in Japanese. The next he is referring to art history—della Francesca, Corot, Turner, Breughel, Rembrandt, Poussin—the names fly by. Color theory is displayed with diagrams, slides, and demonstrations. Aphorisms abound.

He expounds dramatically: "When you want more power, don't change value; change color." And again, "Think first. It's hard, but ten minutes won't ruin the brain cage."

"Beware the formula!," he tells us. "Don't make dingbats! Forget it!" And what is a dingbat? "Dingbats are frilly brushstrokes. Overuse of them is a crutch."

So plan, then paint. Cooper instills a high regard for thinking. In fact, Mario Cooper's most impressive trait is his intellectuality. He is a thinker's painter, blessed with a powerful and delightful personality.

Some of us have the good fortune to know him.

Mary Carroll Nelson

MARIO COOPER: THE ARTIST AND HIS WORK

MY LIFE
AS AN ARTIST

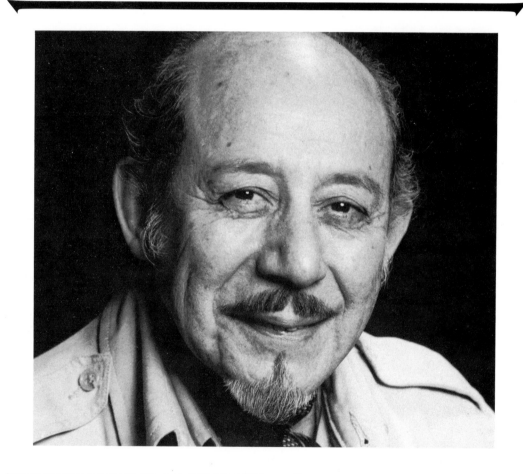

My father was born in 1884 in Anaheim, California, about 25 miles southeast of Los Angeles, and he was very proud of being an American. He was a great believer in reincarnation and told me that in my former life I had been the artist in Puccini's opera *Tosca*, which made quite an impression on me. My mother's maiden name was Maria Garfias de Hidalgo y Costilla.

I was born on November 26, 1905, in Mexico City. The oldest of four children, I had two brothers (Henry and Horacio), and a sister (Laura Dolores). Thanks to my father, I got very early schooling in opera, Spanish proverbs, and American folklore, all laced with George Washington and the cherry tree, the Alamo, and American manners.

It seems that I was always interested in art. I remember as a child—I guess I was about five—looking at the Sears, Roebuck catalog and, fascinated by all the pictures, copying the horses with their harnesses. My father used to take me with him when he browsed through bookstores, and on one of our book escapades he bought me a book on Greek mythology. It contained numerous engravings of sculpture, mostly of gods and heroes, of which I made many pencil drawings. I still have the book.

One day my father decided I was ready for art lessons. His sister, a maiden aunt, was a painter mostly of still-life and popular subjects. Her specialty was decorating folding screens, usually with a branch of flowers, oranges, apples, or flowers in each panel, invariably painted on a black background. She was also handy at arts and crafts and decorated boxes, panels, and other objects with flowers and landscapes by burning them into the wood with a hot needle. She also gave lessons in painting. In 1913—I was in the second grade at the time—my father decided that I should take lessons from her. But I did not enjoy her classes because she slapped me when I got paint on my hands. I told my father about it and the classes were stopped.

I was about seven when some friends of the family invited my younger brother Henry and me to spend two months in their hacienda in Telles, near Pachuca, which is about 40 miles north-northeast of Mexico City. I learned a lot about life in those two months.

On April 21, 1914, the U.S. Marines had landed in Veracruz and, of course, the Mexicans were up in arms about it. It was then that I realized that I was an American—a gringo! When my second-grade teacher asked me if my father was an American, I said he was. The rest of the class, upon hearing this, wanted to hang me.

By 1915 the revolution in Mexico had worsened. The United States government asked all its citizens to leave and made arrangements for them to do so. My father and one of his sisters, my two younger brothers, my sister, and I joined the group that left Mexico City on a train bound for Veracruz. We narrowly escaped being blown up by bandits—they had blown up the train ahead of us the night before. We were to see the wreckage and the burned bodies the next morning.

My parents had been separated shortly before we left, and my mother remained in Mexico City, moving in with a wealthy widowed aunt. She enrolled in a medical college, was graduated at the top of her class magna cum laude, and became physician to Mrs. Alvaro Obregon, wife of the President of Mexico. My mother died in 1923 at the age of 38.

Childhood in Mexico

At age four.

Los Angeles: Early Education

We went to Los Angeles, where we had relatives. There my sister, my brother Henry, and I were enrolled in the Utah Street School. But since we did not speak English, we all were put in the first grade. When the teacher saw my drawings (I had started a sketchbook), I was advanced to the second grade. And when my second-grade teacher looked at my sketchbook, she put me in the third grade.

Although my fourth-grade teacher, Miss Clark, was very interested in my drawings (my sketchbook consisted mostly of cartoons, caricatures of Charlie Chaplin, and portraits of my fellow students), not all teachers are turned on by art. My fifth-grade teacher couldn't have cared less for my drawings. But Miss Clark got her to ask my father to let me go to a special drawing class in downtown Los Angeles once a week, and I enjoyed it. Yet, as a youngster, I took my ability to draw for granted; I really wanted to be an automobile mechanic someday.

I was about ten when my father told me about the Russo-Japanese War (1904–1905) and how, when it came to hand-to-hand combat, the diminutive Japanese easily disposed of the mountain-like Russians. Since I was not very tall, this impressed me a great deal. I quickly went to the library and took out all their books on jujitsu, which literally means "soft art." (It's now called judo, which means "soft instrument.") I studied and practiced it with my brother Henry. It was very useful in school.

Mushy Callahan, later world junior welterweight champion from 1926 to 1930, was in my sixth-grade class. In 1918 we both must have been about 12 years old. He was larger than I was, but because of my knowledge of judo, I was able to pin him down.

During my junior high school years (1919–1922), my father fell on hard times. He was a teller in a bank, and bricklayers were making in two days what he made in a week. It was during this time that I sold papers for the *Los Angeles Times* from 9 P.M. to midnight. I used to ride five miles home to get what sleep I could, then try to get up and make the early classes at school.

One evening during this time, someone saw me shadowbox and asked if I would box with the Pacific Newsboy champion, Fidel La Barba (nicknamed "Fiddles"). At the time he was boxing for the Los Angeles Athletic Club. This used to be the main event of an all-newsboy card. It sounded great! (Most artists are hams at heart and I am right in the middle of them!) The great Jack Dempsey refereed the fight and called it a draw. While I went on to become an artist, La Barba went on to win the Olympic flyweight championship. He later turned professional and became flyweight champion of the world!

Los Angeles: Beginning a Career

In 1922, when I was graduated from junior high, I had to go to work full time, though I continued to attend high school once a week. It was then that, by chance, I got a job as an errand boy for Bryan & Brandenburg, the largest engraving house in Southern California. They made electrotypes, halftones, line engravings, and three-color plates. Little did I know then just how important the opportunity to learn about these things was to be in the rest of my life.

In Bryan & Brandenburg's offices, examples of printed advertising art hung on the walls. I remember asking Mr. Brandenburg when I got the job if there might be an opportunity for someone who could draw. He said there was and he liked me right away. Until then I hadn't thought much

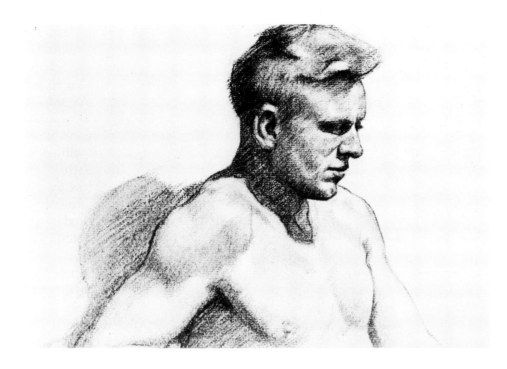

about my drawing or doing anything with it. I had a sketchbook, but to me drawing was one of those odd abilities a person was born with, like being double-jointed. This was truly a turning point in my life. For the first time I saw a future in something I could do.

The delivery department was made up of two dispatchers and four delivery boys, three of us with our own bicycles and one with a small company truck for the delivery of heavy forms of type. One day the bicycle boys quit over some dispute. Mr. Brandenburg, who was not one to be pushed around, asked me if I could handle the job for the day; he also said he had been thinking about a job for me in the art department. He then gave me a raise of $2 a week, bringing my weekly earnings to $17—this was in 1922. I handled the deliveries that day with no difficulty, but I also had slid my drawings into my delivery bag. Whenever I made a delivery to a sympathetic artist, I'd take them out and show them to him. One artist—I was to meet him again in Laguna Beach half a century later—was Walter T. Foster, who published large paperbound books on different artists that were sold around the world.

Mr. Brandenburg kept his word and I did get a job in the art department as an apprentice. I kept the department in apple-pie condition, earning the pleasure of my elders, and in my spare time I copied advertising illustrations by J. C. Leyendecker and other prominent artists in black-and-white gouache (poster colors). I also learned by watching the others. One of the artists in the department was a wood engraver from Boston. He made boxwood engravings to be used as illustrations for surgical instruments, which was a lesson in itself.

In that year, 1922, archeological history was made. The tomb of the boy-king Tutankhamen was discovered in Egypt in the Valley of the Kings. It was opened on November 26 (my birthday)! After that, the whole world "went Egypt," and Egyptian fashions, toys, candy, and the like were the rage. At Bryan & Brandenburg I was given the job of designing the cover of a box of chocolates in the shape of a sarcophagus. I did some "homework" on the glyphs—my first research venture—and made a line drawing of a

Design for the Otis Art Institute catalog, 1924.

mummy surrounded by heiroglyphs to be printed on a wooden box shaped like a sarcophagus.

One of the people to whom I used to make deliveries was A. A. Vaillancourt, a very successful advertising artist. I had shown him my drawings in the past, and from time to time when we met in an elevator, he would say, "One of these days we are going to talk turkey." One day, in the spring of 1923, he finally gave me a job. He was the top moneymaker in Los Angeles in those days and I did a lot of work for him: drawings, some house-organ covers for his leading accounts, lettering, and so forth—all for $15 a week!

It was about this time that I made a cover for the catalog of the Otis Art Institute. The director wanted to pay me for it, but I wouldn't accept the payment; I wanted it to be a gesture. He accepted it, but "got back at me" by giving me a $25 award.

Finally, in late 1924, I got a job with William C. McKee, Jr. Bill had been a "boy wonder," having won a national competition for a war poster when he was only 17. Like the other artists, I had met Bill while making deliveries for Bryan & Brandenburg. Bill could have been a great teacher, for he was a great help to me in my studies. He also used to help me with my composition and lettering. (His wife was a concert violinist and I took violin lessons from her.)

Just before I left Vaillancourt I turned 18, so I no longer had to attend high school part time. But I had made friends with a number of teachers and students, and had contributed drawings and cartoons for their paper, so I kept up my contacts with them. Meanwhile, I continued to attend classes at the Chouinard and Otis Art Institutes at night.

Bill McKee and I worked well together. Most of our work was for newspaper advertising, but quite a lot of it was for real estate and involved drawings of maps, bird's-eye views of terrains, sketches of homes, and a lot of lettering. I kept making black-and-white brush drawings for my portfolio every time I had a chance, though I didn't give much thought to a career in fine arts. Dreaming of someday being an illustrator was awesome enough.

The following May Bill McKee was offered a position as head of the art department of the Southwestern Advertising Agency in Dallas. When he asked me if I wanted to go with him, and offered me $25 a week, I said yes. In June 1925, Bill, his family, and I left for Dallas.

The previous year, in 1924, my father had received an offer of the position of executive vice-president from the Southwestern Pacific Railroad in Enpalme, Mexico. He had worked for them in Mexico City years before. The offer had the stature he needed at that time, so he took it. Since I had little to hold me in Los Angeles in regard to my future in art, I borrowed $25 from Bill and gave him my Graflex camera for security. Looking forward with enthusiasm to what looked like a great future, I went to Dallas.

Dallas: Advertising Illustrator

I didn't know what to expect from Dallas as a city, but when I got there, I was very impressed. Dallas looked like a small New York. I reported to work one Monday in the middle of June 1925. The people at the agency were grand and did all they could to make us feel at home. They kept saying, "Oh, you'll like Dallas"—and we did. The agency's primary work was black-and-white drybrush illustration and lettering. The subjects of

the drawings ranged from locomotives to Mount Rushmore to grapefruit to single figures.

Byron Bruce was the third artist in the art department. He was a good artist, and though he was ten years my senior, we became very good friends. Actually, he was more like an older brother. Since we lived in the same boarding house, we hired an empty garage from our landlady and turned it into a studio. After work, we would come back to the garage and work on our drybrush drawings to add to our portfolios. In 1925 drybrush drawings were in great demand.

The drybrush technique was really quite simple. First, I would dip a no. 5 pointed sable brush into a jar of black poster paint, then add enough water with the point of the brush to make the paint flow (though just barely). Then I would mix a portion of it on a small porcelain dish or palette and draw the brush along on the paper with a sweeping motion, giving some of the brushstrokes a grainy effect. The result was a soft edge that would be reproduced by a line engraving. The texture of the paper, which ranged from hot press (smooth) to rough, controlled the texture of the drybrush.

In September 1925 Bill McKee left for New York, I got a raise, and Byron got married. I was restless in Dallas, and at the end of the year I returned to Los Angeles. There, I tried to get freelance work or a job in a studio, but it was very discouraging. One day I met a sympathetic artist who was a friend of Louis Treviso, art director for the Honig-Cooper Advertising Agency. He advised me to go to San Francisco and see Treviso.

The San Francisco Days

With a railroad pass from my father and $8 in my pocket, I found myself in San Francisco on the morning of January 24, 1926. It was foggy and raining slightly. I have always found rain to be lucky for me.

Louis Treviso was a bit of a genius. He liked my portfolio and suggested a number of places where I might find work. When I soon discovered that no jobs were available, he gave me a job in the agency bullpen for $35 a week. Eventually, Louis and I found two rooms over a diner on the corner of Sacramento and Montgomery streets that we turned into studios. This was fine, except for a problem that developed: I needed my afterhours and weekends to work on my portfolio and study, while Louis wanted to play and drink with his pals. It wasn't easy.

I still remember my San Francisco days and the artists I met. I love to narrate their adventures and escapades, their practical jokes and the frequent insanity of their doings. Since I myself didn't drink or smoke, I was in a great position to just watch. Once, during a drinking bout, I rescued artist Bill DeLappe (an intellectual when sober and a monster when drunk) from sailing out of a fifth-floor window by grabbing his feet with a flying tackle. (I used to be halfback on my junior high school football team.) Maurice Logan was another artist I met in San Francisco. At 40, he was easily the number-one artist in the West, and his brilliant advertisements for Canadian Pacific had given him a national reputation. Then there was Fred Ludekens, at 26 the star of the Honig-Cooper bullpen, full of ability. He later went to New York and specialized in advertising illustrations for magazines; with Albert Dorne he formed the Famous Artists Correspondence School in Westport, Connecticut.

By the summer of 1926 I had a stronger portfolio, with more important-looking subjects. One of my drybrush drawings had even been used as the

Illustration for cover of Western Advertising, *San Francisco, 1926.*

cover of the June 1926 issue of *Western Advertising*. I felt I was ready to freelance in Los Angeles. I had managed to save $200, so I could quit Honig-Cooper. On July 24, 1926, I left San Francisco for Los Angeles.

Return to Los Angeles and Marriage

I had made some contacts in Los Angeles on previous trips, and the R. C. Buffum Advertising Agency had offered me free space and the possibility of freelance work. I also took my portfolio to different advertising agencies and managed to get some work. By the spring of 1927, the year that Lindbergh flew across the Atlantic to Paris, I was making from $400 to $700 a month. I did all kinds of drawings: automobiles, furniture, layouts, lettering, and figures.

On February 25, 1927, I married Aileen Whetstine of Pasadena. I had met her at the Chouinard Art Institute, and over the years we had kept up our correspondence. I continued to work in Los Angeles until the end of that summer, when I decided to move to New York. In Los Angeles, through a friend, I had met the parents of Pruett Carter, one of America's leading illustrators. They had offered to introduce me to Pruett if I ever went to New York. It was this that made up my mind to study illustration in New York.

The International Studio

In those days I always looked forward to reading *The International Studio*, an important art magazine of the twenties that contained articles on painters, sculptors, illustrators, and mural painters. Reading about these famous people added fuel to my dream of joining the New York City art world, though I never thought that someday I would actually meet the artists whose names I read on those printed pages.

One of those articles was on Eugene Savage, F.A.A.R. (Fellow, American Academy in Rome), and his murals, whose controlled design I greatly admired. (I was to meet him 30 years later as a fellow academician of the National Academy.) Another was on Paul Manship, F.A.A.R., an outstanding sculptor. I once cut out and framed a reproduction of his *Dancer and Gazelles*, but I never dreamed that someday I was to be his friend. I also read about muralist Frank Brangwyn, R.A. (member of the Royal Academy), with his dramatic point of view and fantastic versatility, and the Russian artist Nicolai Fechin, who had moved to the United States in 1925 and had all the painters talking about his brilliant colors and brushwork. His lithographs of Balinese natives and Taos and other American Indians were magnificent. I also read about the Spaniard Ignazio Zuloaga, another artist who took the country by storm. But of all the articles in the magazine, I especially looked forward to the ones on the illustrators, especially Henry Raleigh, with his Irish imagination and dramatic witchery; and Dean Cornwell, with his dramatic and romantic interpretations of *The Desert Healer* and *Never the Twain Shall Meet*. The article on Cornwell mentioned how he had studied with Harvey Dunn; I thought how great it would be to study with Dunn. Yes, the art world of New York was very alluring!

New York: The Dreams Materialize

That September Aileen and I boarded the S.S. *Manchuria*, bound for New York with stops in Panama and Havana. We arrived early in the morning. Manhattan was enshrouded in a mist that made a silhouette of the towers that were breathing steam.

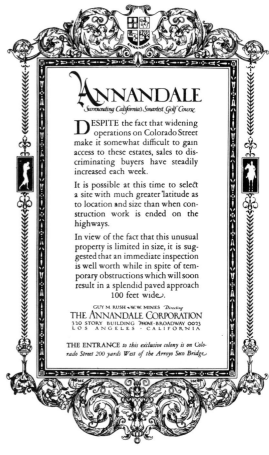

ANNANDALE
Surrounding California's Smartest Golf Course

DESPITE the fact that widening operations on Colorado Street make it somewhat difficult to gain access to these estates, sales to discriminating buyers have steadily increased each week.

It is possible at this time to select a site with much greater latitude as to location and size than when construction work is ended on the highways.

In view of the fact that this unusual property is limited in size, it is suggested that an immediate inspection is well worth while in spite of temporary obstructions which will soon result in a splendid paved approach 100 feet wide.

GUY M. RUSH · W.W. MINES *Directing*
THE ANNANDALE CORPORATION
320 STORY BUILDING *PHONE·*BROADWAY 0023
LOS ANGELES · CALIFORNIA

THE ENTRANCE *to this exclusive colony is on Colorado Street 200 yards West of the Arroyo Seco Bridge*

(Above left) Illustration for The Thumb Tack *magazine, 1926. (Above) Design for The Annandale Corporation, Los Angeles. (Left) Work for the Charles Stuart Agency, Los Angeles, 1926.*

LOYALTY

Sample advertising layouts, 1929.

We found a studio with a skylight in Greenwich Village, a fourth-floor walkup that had just been decorated. I went shopping: an easel, two chairs, a double sofa-bed, a few groceries, and the studio was ready. The next day I went out with my portfolio. The Art Service of W. O. Floing held the portfolio overnight and the next day I had a job: $75 a week, sharing a studio with another artist.

W. O. Floing did most of its business with the advertisers of Detroit motorcar companies. Most of my work consisted of making comprehensives, which are finished sketches of what an advertisement will look like. There was also a lot of drybrush drawing and lettering to be done, but mostly I did comprehensives. When there was an illustration of any consequence, an illustrator with an established name was called in to do the finish.

You can't study to be a genius, and I had known for a long time that I wasn't one. That meant that as much as I liked to work, I had to work harder than those who were geniuses in order to achieve my goals. So I enrolled in Pruett Carter's night class at the Grand Central School of Art, located above Grand Central Station. There the class painted in oils from a model. Carter, who had the image and manner of Ronald Colman, would give everyone a personal criticism, but would never touch anyone's canvas. When class ended, we would sit in a semicircle around the dais on which our homework was placed and, one at a time, he would criticize the work.

Meanwhile, at work, one of the comprehensive layouts had a Western illustration and Floing commissioned Harold Von Schmidt, an up-and-coming illustrator from San Francisco who specialized in Westerns to do the finish. Von Schmidt had been considered a legend in San Francisco, so now that I was in the East, I made a point of meeting him. With great enthusiasm, he offered to help me with my painting. I took advantage of this offer and made a number of trips to his studio in Connecticut, which looked like an MGM warehouse for Western movies.

It was early in those visits that Von told me I needed more preparation in my work, and he didn't have to say it again. This advice was to be a tremendous help in my art career. Little did we know that 27 years later we would find ourselves each with the courtesy rank of a brigadier general in

the United States Air Force in the Far East for the Air Force Art Program.

Early in 1928, W. P. Floing moved to Detroit. I decided to stay in New York and continue my studies there. New York was where the great illustrators lived, many in the famed Hotel des Artistes. I had saved some money, so I didn't worry about getting a job right away; besides, I was working on some illustrations for use as samples. In those days they were all done in oils. Two or three weeks.later I got a job with the then-fabulous advertising agency Barton, Durstine, and Osborne. I was to be in the bullpen, doing about the same kind of work that I did at Floing. Meanwhile, I continued to go to night school.

New York in 1928 was the New York of Jimmy Walker, the Casino in the Park, Harlem and the Cotton Club, the speakeasies, elevated and ground-level streetcars, the Pirate's Den in the Village, and the organ grinder and his monkey.

Working at Barton, Durstine, and Osborne was an education. Everyone there was busy; they all ran around in their shirtsleeves. It wasn't until the agency merged with George Batten that they all began to put on their coats. Many well-known illustrators also did commercial advertising illustration then, and I would get to see the original paintings of such famous artists as Pruett Carter, Walter Biggs, and J. C. Leyendecker. There at the Barton, Durstine, and Osborn bullpen I also met Barney Tobey, who was later to become one of America's top cartoonists. While he was still working in the bullpen, he started to make covers and cartoons for a new magazine, *The New Yorker*. That was in 1928; he is still doing them now, more than half a century later. (We are good friends and still play chess.) At Barton, Durstine, and Osborn we made a lot of comprehensive layouts on tracing paper with indelible colored ink. The paper wrinkled a bit, but not enough to take away the ink's brilliance. Later, I was to use colored ink for my illustrations. It was during my years at that office, in 1929, that my ink poster for Sir Walter Raleigh Tobacco was reproduced in the *Eighth Annual of Advertising Art*.

<div style="float:right">Professional Illustrator:
A Style Develops</div>

In 1930 I accepted a job as art director for Lord, Thomas and Logan. Again, it was an opportunity. I developed a style of layout: I would come to work about 10 A.M., which—though he never told me—used to drive the office manager up the wall, and I would spend most of the day doing very little. Then, at about four in the afternoon, I would lay out a whole campaign. The president of the company was much impressed and showed it with a handsome raise. This was shortly after the Wall Street crash!

I had been working on what I believed was a new style of illustration (it was). Many years before, when I was very young, I had gone with my father on one of his book hunts. We stopped to look at a painting in an art gallery window and he remarked that it was a watercolor, "which was very difficult to do." I guess my father's remark scared me, for I chose to use colored inks instead of watercolor for my illustrations.

My illustrations were small—the average head was about the size of one in a miniature painting—and I worked on mounted hot-press Whatman paper. And because the inks were indelible I could paint a wash of one color over another a number of times without disturbing the initial wash.

Whatever the reason, I was developing a style, but the pressure of working five days a week in addition to attending night school was beginning to get to me. (In those days we lived in Woodlawn, on the Bronx River

Illustration for Collier's, *1934.*

Parkway, and the train ride to Manhattan took 30 to 40 minutes.) Lord, Thomas and Logan had offered me a salary of $14,000 a year and I was only 24—in 1930 that was very good money. But had I taken it, I might never have become an illustrator. So, after much consideration, I quit to devote full time to illustration. A career in fine arts still seemed far away and unobtainable. I thought about it, but it was always a vagrant thought, with a question mark at the end. Illustration seemed glamorous and something I could sink my teeth into.

New York is really a very small town, and the story got around that I had given up a great future in advertising to be an illustrator. I spent the following year developing my painting style and reading stories, poems, and histories—anything that would inspire me to make an exciting illustration. To put bread on the table, I filled in as a layout man for some agencies. I had a reputation for that. I also made some full-color ads for RCA—and that bought cake.

In 1930 Pruett Carter moved to Los Angeles. Just before he left for California, he told Henry Quinan, the brilliant art director of *The Woman's Home Companion*, about me. In the early spring of 1931 I met with him. By now I had made a series of illustrations in colored inks. Quinan liked my work and a week later he gave me a manuscript, *Last Adventure*, to be done in two colors: black and orange. Since the story had to do with a Maine lobster boat, I went to the New York Public Library and researched lobstermen and their boats. The result was an illustration that delighted Quinan. However, one assignment doesn't keep you alive very long, and I got more commissions from other magazines. When Quinan saw my work elsewhere, he was very annoyed. It took a new set of pictures and many months to get back into his good graces. But then he gave me a serial to do in full color, and this did establish me as someone new in illustration.

I wasn't fully aware of my growing reputation until other illustrators began to imitate me. I also discovered quite by chance that other successful illustrators admired my work. I was using the same model who posed for James Montgomery Flagg and one day she reported to me that Monti had said of me, "I like his work, and it's his own." I was to hear almost the same words said by Henry Raleigh, again repeated to me by a model whom we shared. (One model who posed for my illustration was Cornell Wilde, who later became a movie star. He used to give me fencing lessons, too.)

Another event that made me aware of my rising position in illustration occurred when Dean Cornwell, the dean of illustrators, came to my studio and asked me what kind of pen or brush I used to outline my illustrations. Until that time I thought that the question of what kind of pens or brushes one used was a joke! But Dean, a superb technician himself, was always interested in technique. No, the question was no joke.

Harvey Dunn: Teacher and Friend

At about this time, Harvey Dunn decided to teach at the Grand Central School of Art, where I had studied earlier with Pruett Carter. I had heard a lot about him from Harold Von Schmidt, and had liked what I heard. He had also been Dean Cornwell's teacher. Dunn, as it turned out, had also heard of me and my work. I joined his class and offered to be his monitor, and we soon became good friends.

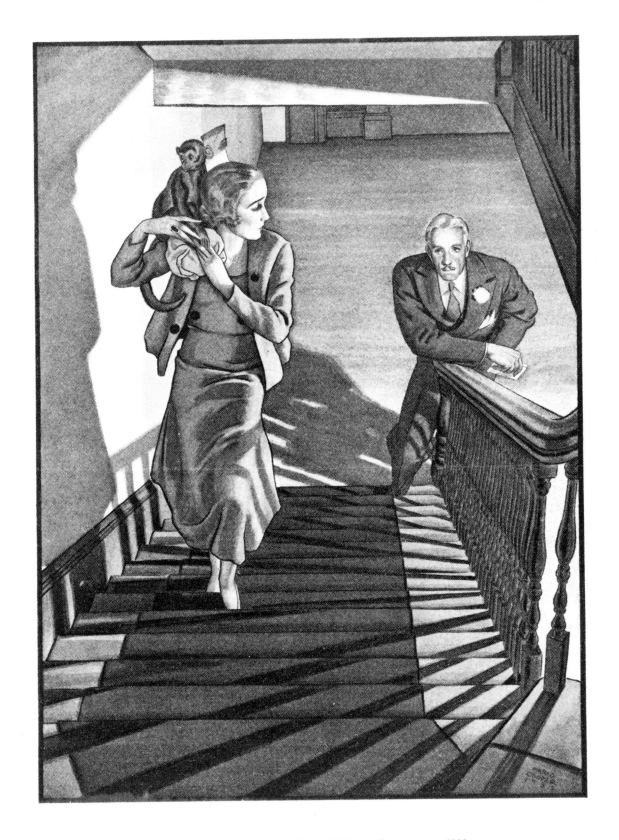

Illustration for "The Rake," Woman's Home Companion, 1932.

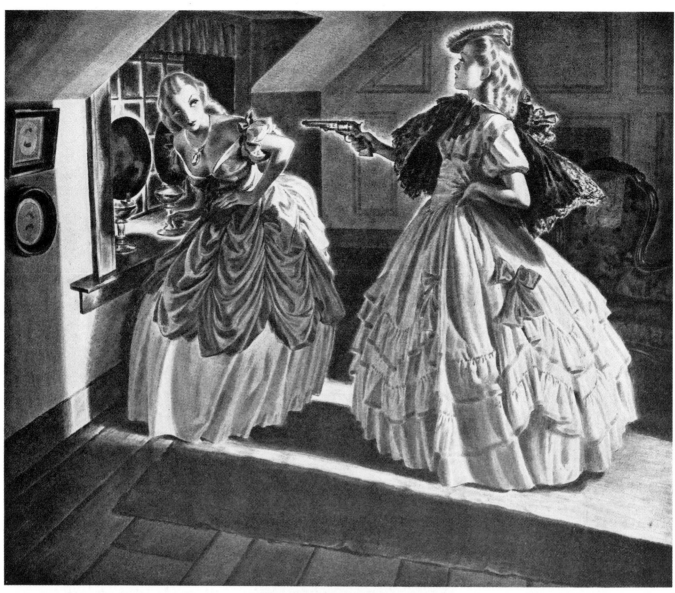

Illustration for "Distances of the World,"
Collier's, *1942. The four preliminary studies shown here explore (1) the rhythms in the composition, (2) the angles in the design, (3) the placement of objects, through a careful pencil drawing, and (4) patterns and values, through a wash drawing on tracing paper.*

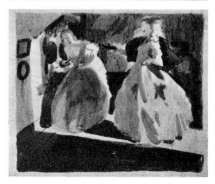

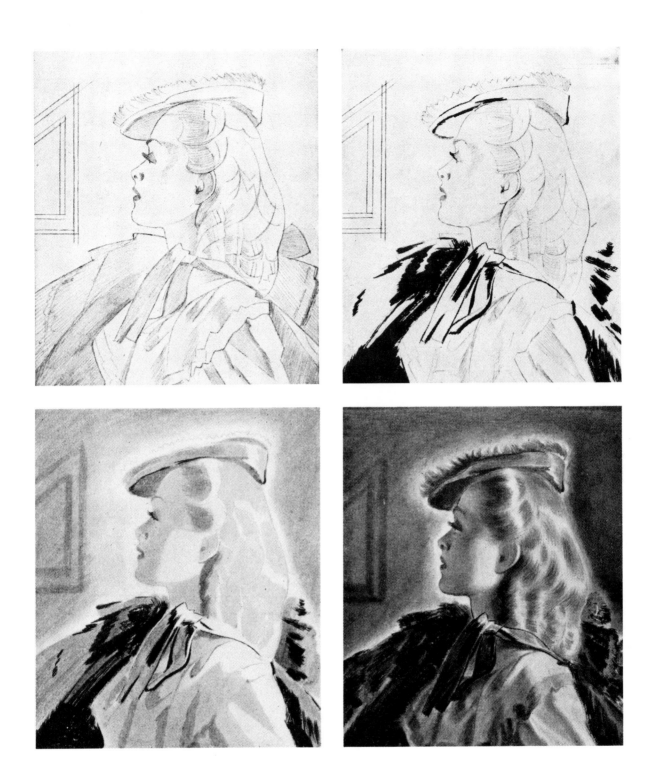

Illustration technique: (1) The outlines of the composition are transferred to the illustration board, noting with pencil shading where the heavy and light tones should go and checking to see that the design is balanced. (2) Surplus pencil lines are removed with a kneaded eraser and heavy black lines are painted in India ink, leaving fine lines for last. (3) Colored ink glazes, the lightest tones first, are then applied, to "feel" the texture of the paper. Final tones are gradually built up through a series of glazes. (4) When all tones are in, the final black lines, used mostly as accents, are added. A line is added only where a tone will not suffice.

One day I talked him into putting out a book of his lectures. Its production was not easy. I not only had to make layouts and get Dunn to make linoleum cuts for the book, but I had to get the printer, who was accustomed to turning out house organs, to understand why I wanted wide margins on the pages. The book was called *An Evening in the Classroom: Being Notes Taken by Miss Taylor in One of the Classes of Painting Conducted by Harvey Dunn and Printed at the Instigation of Mario Cooper*. In the book, Dunn praised one of my illustrations. I later gave it to him and he hung it in his studio.

Over 20 years our friendship grew into a father-and-son relationship—he was born the same year as my father, 1884. As a pair we made a rather interesting sight: he was 6'2", broad, and powerful, and I am 5'3". He died of cancer in 1952, but to me he is still very much alive. From him I learned simplicity.

In 1950, after looking at some of my watercolors, Dunn put me up for associate membership in the National Academy. I got my diploma that year and my full academicianship in 1952.

Branching out: Professional Society Activities

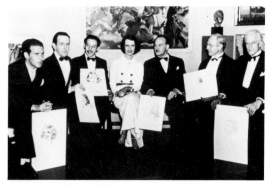

Lily Pons surrounded by the artists and their sketches of her at the 1937 annual exhibition of the Society of Illustrators at Radio City Music Hall.

I was made a member of the Society of Illustrators in 1932, and I became very active in it. From time to time I gave lectures in the society's house, and even had a one-man show of my illustrations, which covered both sides of the gallery. I was also corresponding secretary at one time. In 1932 I was made a member of the Artists Guild of New York. I became very active in that too and, in 1934, was made vice-president.

During these years I met a number of artists who became lifelong friends. One of them was George deZayas. George was a fine caricaturist. He looked like a French diplomat and in fact, had lived and studied in Paris as a member of the same group as Picasso, Braque, Modigliani, and Marcel Duchamp. We both love chess, and George was a close friend of Capablanca, the world chess champion. (I once had a chance to play chess with the great Capablanca as he was playing a group at the Society of Illustrators, but because of the meeting of the Artists Guild, I was only able to get there after the master had gone.) My friendship with Abner Dean also goes back many years. Abner is an extremely talented illustrator, author, inventor, and sculptor. In 1936, when I was Chairman of the Exhibition Committee of the Society of Illustrators, we invited Lily Pons, the great coloratura soprano, to our membership opening and six of us sketched her (see photo, left to right): Abner Dean, William Meade Prince, me, Lily Pons, McClelland Barclay, Norman Price, and Lynn Bogue Hunt. Today, only Abner and I are left. He is also a chess player and we still see each other for a game when time allows.

Introduction to Teaching

In 1937 I got a call from Professor C. C. Briggs, chairman of the art department of Columbia University. I had been recommended by Dean Cornwell to teach a night class in advertising art and illustration. Naturally, I was greatly flattered. I little suspected then how that class would change my art career. I had always been bothered by not having finished high school and, suddenly, there I was teaching, in a university, no less. By then my work was appearing in national magazines like *Cosmopolitan*, *Woman's Home Companion*, *American Magazine*, and *Collier's Weekly*. Somehow that hadn't impressed me, but it evidently had pleased Professor Briggs.

On New Year's Day, 1939, I was a passenger in a car involved in a head-on collision on Long Island's Grand Central Parkway. I was so busy with commitments and deadlines at the time that the five weeks in the hospital came as a welcome relief. It gave me time to think, and I enjoyed it. As a welcoming home from the hospital, Al Lefcourte, art director of *American Magazine*, threw a small dinner party for me. Among the guests were the famous illustrators Norman Rockwell, Peter Helck, and Mead Schaefer. While we were having dinner, Rockwell turned to me and said, "Mario, you scared us. We need you."

In the fall of 1939 Professor Briggs resigned his chair at Columbia and went west to practice architecture. Frank Mechau was asked to take the chair. Frank had a long list of credits: painter of murals for the WPA, Guggenheim Fellow, associate of the National Academy—he was a legend in Colorado. I liked Frank and we became friends. It was a delight to talk to someone who was so interested in art and was so lucid in expressing it. It was Frank who introduced me to the work of Piero della Francesca, the 16th-century Italian artist.

My fine-arts career began with sculpture. I grew fascinated with it while teaching at Columbia, and began carving in wood, marble, limestone, and ivory. My efforts were encouraged by another new friend, a professor of sculpture, Oronzio Maldarelli, whose studio and classes at Columbia were in the same building as mine. I remember one day when I had started to carve marble, and somehow the marble wasn't coming off as fast as I would have liked. So I bought a 2-lb hammer (instead of the usual 1-lb one), and when Oronzio came in and saw me, he smiled and said that it didn't matter how much marble came off, but how much *had* to.

Sculpting: Beginning a Fine-Art Career

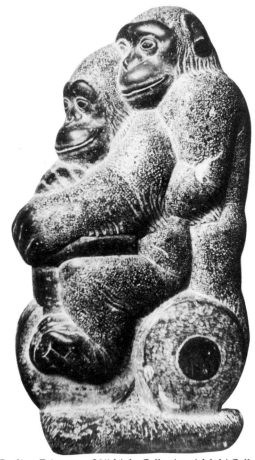

Cycling Primates, 21" high. Collection Adelphi College.

Koala Bears, 21" high. Collection Dale Meyers.

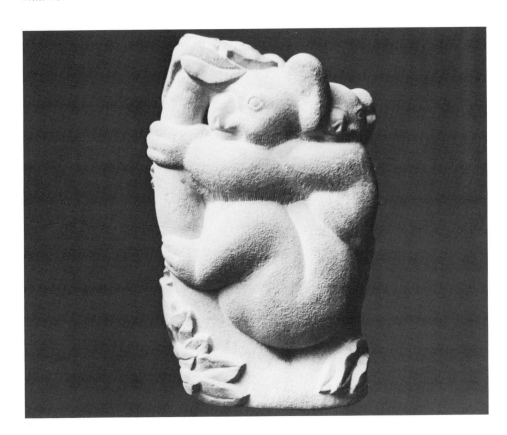

The day came when I couldn't keep up my classes at Columbia and do my illustrations as well. The university tried to help me, by providing an assistant, but it just didn't work. The pressure of meeting illustrating deadlines was too much. In the spring of 1941 I resigned.

Although I was no longer teaching at Columbia, I still continued to see some of my students and criticize their work. It was then that I realized what teaching meant to me; it was in my blood.

It was the forties and magazines were not doing too well; television was breathing down their backs. When I had first started illustrating, the illustrator's byline was almost as large as the author's. But gradually that byline became almost nonexistent. So in the fall of 1941, when Renee Faure, director of the Grand Central School of Art, asked me to take a class temporarily, I did—and fell in love with the class.

The War Years: USO Artist

Drawings of the wounded, 1944–1945.

The Japanese bombing of Pearl Harbor on December 7, 1941, changed many things for me. I had loved the Japanese since I was a child in Mexico. In Los Angeles I had worked with them as a clerk and errand boy and I had been buying and enjoying an annual Japanese magazine put out by one of the big newspapers in Japan as far back as 1937. I knew haiku and Zen long before they become fads. I even had a studio built in Port Washington, Long Island (it really was a studio with a house attached to it), with a Japanese garden on one side. I had studied the art of Japanese gardens and had one built accordingly. In the garden I had made a Japanese stone lantern out of concrete poured into molds. The day after the bombing, on December 8, I was busy with a sledgehammer breaking them into bits. I also took down every Japanese print I had on the walls.

The draft board classified me as 4-H, a hardship case. I was 36 and had a wife and a son Vincent and a daughter Patricia; I was their only means of support. Though I wasn't drafted, I made numerous paintings and posters for the war effort.

In the meantime, I kept up my sculpture in Port Washington, making trips sometimes to see Oronzio at Columbia. Oronzio used to love to tell how he ruined me as an illustrator—meaning, of course, that I fell for sculpture and neglected my illustration. There was a lot of truth to that. But the die had been cast; Mechau and Maldarelli had opened a door. I knew that eventually I had to pursue a career in fine arts.

The year 1944 was approaching. The war was still on, but the news was better. The USO Camp Shows and the Society of Illustrators had a program that gave some of the artists who stayed at home an opportunity to contribute. I joined it. It was to be a two-week trip: one week each in an army and a navy hospital sketching the wounded soldiers as a morale-builder. In 1944 I was assigned to the Moore General Hospital in Swannanoa, North Carolina. There I worked with the Red Cross drawing approximately five portraits a day. I was given officer's rank. Being able to draw a pretty girl, I once offered to sketch the Red Cross nurses after hours. They were very appreciative and once *ten* of them took me to dinner!

Black Mountain College was about five miles from Swannanoa. I had heard that there was a very distinguished professor from Germany there, Josef Albers, and I arranged to meet him. I was to meet him again at the White House during the Festival of the Arts in 1965.

During the USO assignment I also met an artist, Carolyn Edmundson, who had a studio in one of the apartment houses owned by Paul Man-

28

ship, America's foremost sculptor and the one I'd read about in *International Studio*, years before. Through her I was introduced to Isabel, Paul Manship's wife. I had made a number of small carvings out of apple wood and Isabel was delighted with them, but she couldn't get Paul to look at them. One day Paul saw one of my marble carvings in the National Academy and asked Isabel if that was the same Mario Cooper she had been talking about. From then on, Paul Manship and I became close friends. He was always full of life. He died in 1966 at the age of 80. From him I learned to be elegant and generous when paying a compliment.

In 1945 *Collier's* gave me a serial to illustrate by Erich Maria Remarque, best known for his book *All Quiet on the Western Front*. We managed to meet and I found him to be a person of tremendous charm. Like me, he loved chess and we played a game—it was a draw.

The Juggling Act: Balancing Four Careers

After the war, from 1945 to 1950, I taught a veterans' class at the Society of Illustrators. The classes were held in a studio on the fourth floor, and the windows faced an apartment building across the street. One evening a lovely blonde was posing nude for us. I was a few minutes late in getting to class and arrived to discover the entire class, including the model, at the windows, looking into an apartment across the street where a young woman was getting undressed.

In 1947 I exhibited one of my marble carvings at the Pennsylvania Academy in Philadelphia. I also submitted two watercolors to the American Watercolor Society; both were accepted. Two years later I entered the Philadelphia Museum's Third International Exhibition of Sculpture with a black marble carving entitled *Cycling Primates* (page 27), now in the collection of Adelphi College on Long Island. A career in fine arts no longer seemed impossible.

In 1950 Khosrov Ajootian, chairman of the department of illustration at Pratt Art Institute, invited me to teach a class in illustration. I ended up teaching at Pratt for five years and made many friends among the faculty and students there.

In January 1954 I was elected president of Audubon Artists, a 13-year-old society of painters, sculptors, watercolorists, and graphic artists. I felt highly honored by this and gave it my best, but the position consumed a great deal of my time. Between this and my teaching assignments, my illustration commissions declined, and I turned to less glamorous work— book jackets and illustrated books. There is always some work to do if you're willing to do it.

But my art life was changing. I was part teacher, part illustrator, part sculptor, and part administrator. At best, it was a juggling act. You cannot serve two masters; I had four. My illustration work suffered, and I along with it. Had I had a sponsor or mentor I might have gone into the fine arts from the start, but then I would have missed my illustrator's life, which was rich in experience.

Illustrator for the Air Force

When the Air Force became a separate branch of the armed forces, they found that they needed art. Any art that involved planes belonged to either the Army or the Navy, who were not about to give it up. Air Force Major Robert Bales, in addition to being an ace fighter pilot, was also an artist who knew of the Society of Illustrators. So the Air Force and the Society of

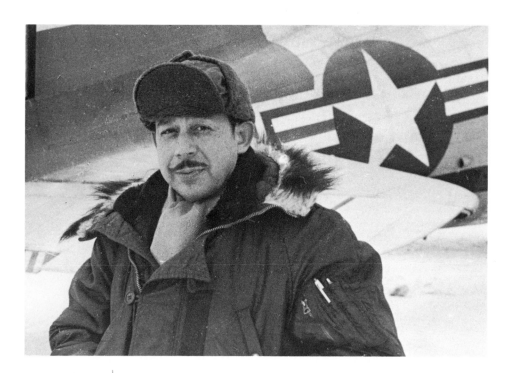

In Alaska, 1956, courtesy rank of brigadier general with the U.S. Air Force art program.

Illustrators made a pact. They would give us transportation and a per diem salary if we would give them paintings of the Air Force. In September 1954 Robert Geissman, president of the Society of Illustrators, asked me to be one of four artists to go to the Far East for a month. (The others were Harold Von Schmidt, Tran Mawicke, and Louis Glanzman.) Our orders came from the secretary of the Air Force. We were given the courtesy rank of brigadier general and were assigned a plane with a crew of seven. We visited Okinawa and Taipei, and went through a typhoon on the way to the Philippines. In all, I made about ten trips for the Air Force, including three to the Far East, one to Alaska, and one to Europe, and eventually I contributed 15 paintings in oil, casein, and watercolor.

My last Air Force trip was in the summer of 1960, when I was sent to Europe to visit places where it was active and gather material for paintings. I landed in Frankfurt, and a staff car took me to USAF headquarters at Wiesbaden. There was trouble in the Congo that year and the USAF was participating in an airlift. At first I tried to go there, but I later decided to remain in Europe. This being my first trip to Europe, I made the most of it. The Air Force had sent me to Paris and told me to play it by ear! So I went to Rome, Venice, Madrid, Berlin, Chateauroux, Casablanca, Segovia, London, and back to Wiesbaden. There I met my friend John Groth on his way to the Congo. Since the Air Force was having trouble getting the proper orders for him, they gave him the orders originally intended for me. I still have the journal I kept on my European trip. (I always keep journals of important trips; they contain names that are sometimes hard to remember. In my recent journals, I have added postcards and clippings of places printed in the travel folders, which makes the journals more interesting.)

More Commissions

In 1954 the vicar of the Chapel of the Intercession, the Reverend Dr. Joseph S. Minnis, came to me for private watercolor lessons. In 1958, after he was made bishop of Colorado, the St. Luke's Hospital in Denver commissioned me to make two five-foot carvings for the travertine columns at the en-

trance of the new wing. I showed the models I made to Paul Manship and he highly approved.

John Groth, fellow artist and teacher at the Art Students League, had become a good friend in 1956, during my second trip to the Far East for the USAF. In 1959 he recommended me to the art director of the Hudson Bay Company of Canada, who was looking for an artist to depict the official ceremony of the payment of the rent to Queen Elizabeth. So, in the summer of 1959, I was invited to attend the ceremony in Winnipeg, Canada. There I made sketches and took a lot of 35mm slides. I presented the finished watercolor to the Canadian government officially on July 24, 1959.

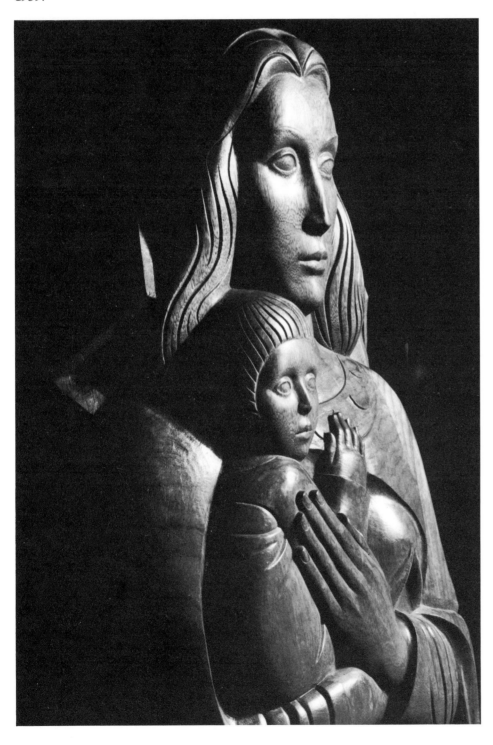

Detail of the Madonna, a 5' (152-cm)-high carving in korina wood. One of two figures at the entrance of St. Luke's Hospital, Denver.

Teaching: A Career in
Fine Arts Takes Root

In the summer of 1957 I had just returned from an assignment in the Far East for the Air Force and was having a drink at the Society of Illustrators when I got a phone call from Stewart Klonis, the director of the Art Students League. (I will never know how he knew I was there. Actually, I really do know—ESP. It has happened before.) He asked to see me right away. It seemed that his brother, Bernard Klonis, who taught still-life, flower, and figure painting at the League, had recently died and they needed a watercolor teacher to take over his class. I agreed.

In the fall of 1959, Vernon Porter, director of the National Academy, asked me to teach an afternoon class there—watercolor, of course. Again I accepted.

At the time of this writing, I have been teaching at the Art Students League for 23 years and at the National Academy for 21. I love teaching. There is a line in Rupert Brooke's poem "The Soldier" where he speaks of ". . . dust whom England bore, shaped, made aware . . ." Ah! That word _aware_. I am always finding new things as I work and study. I like to share them, and teaching allows me to do that. I can quote many passages and soliloquies from Shakespeare, from Dante in Italian, and some haiku in Japanese. My second language is Spanish, so I do better in that, and I am one of the millions who adore Federico Garcia Lorca. I use all these in the classroom to illustrate points. Teaching is a part of me; it's an extension of my studies.

Enter Mrs. Dale Meyers

From 1957 to 1960 I taught adult classes in watercolor and sculpture at Port Washington High School on Long Island.

In 1961 one of my students, Yuri Yagima, and her friend Sue Fuller, brought in a flyer from the Springfield Museum in Springfield, Missouri. The museum needed a teacher who could teach a three-week course in realistic watercolor and the ladies thought it should be me. I agreed. So I grabbed a copy of the Art Students League catalog, tore out the page that had my credits on it, and wrote across it, "I think I am your man," and mailed it. I got the job. The three weeks of teaching the course passed quickly, and when it was over the students all wanted more. So I suggested that they form a watercolor club and the director of the Springfield Museum, Kenneth Shuck, offered to give them a show. "Why not make it a national show?" I said to Shuck. He answered, "Yes; if you will judge it." I agreed and "Watercolor USA" was born.

In 1960 in Manhasset, Long Island, an art gallery had been recently started by three women: Florence Wilmer, Jean Conner, and Dale Meyers. It was called The Little Gallery, and the women were trying to serve the artists of the community and stir up interest in art by holding exhibitions. I received a call from them. They wanted to represent me and I agreed. One of them, Dale Meyers, eventually joined my adult class at Port Washington High School. She was an unusual person—the kind of person who, if criticized, accepts the criticism, makes corrections, and improves. This was only the tip of the iceberg; there would be more to come from Ms. Dale Meyers.

In 1961, Professor A. P. d'Andrea, chairman of the art department at City College, asked me to conduct a class in watercolor there. I did. That one class grew into additional ones. At one time I was teaching 18 hours a week at City College alone. So I decided to give up my adult education class at Port Washington High School.

But I did not completely sever my connections with my students. In 1958 I suggested that they form a watercolor club, which they did: the Aquarelle Club of Port Washington. They are still active (I hear from them all the time) and they list me as their founder. In fact, their leader, Yuri Yajima, organized a class which was conducted in my studio.

It turned out to be one of those classes one dreams about. We all worked very hard. During the coffee break (somebody would always bring some delicious home-baked cookies), we would talk about art, music, life, and any other subject that came up. Yuri always had some humorous story to tell and Dale would bring something unusual to read—and she read well. We all loved the class, but some of the students eventually had to leave, including Dale, when her husband was transferred to Washington, D.C. The class was like a very good painting; it was exciting to work on, but now it was finished.

Dale Meyers and I each had had problems in our marriages, which were resolved when, on October 11, 1964, we were married by the Honorable Supreme Court Justice Abraham Gellinoff, a former student of mine. Our very close friends were our guests: Barney and Bea Tobey (both *New Yorker* artists); Sol Litt (a financier) and Mary Litt (an artist); Mrs. Jean Gellinoff; and Dale's lovely daughter, Dale, Jr. Our wedding dinner was at Luchow's, the famous German-American restaurant.

Professional Leadership: The Circle Widens

In 1959 Chen-Chi, chairman of the nominating committee of the American Watercolor Society, phoned and asked if I would take on the presidency of the Society. He had been on the board of the Audubon Artists when I was president and knew of my administrative ability. I had also been secretary of the AWS for three years and vice-president for two. I took the position, but was immediately confronted with a society that was operating deeply in the red. Also, it was not tax-exempt. As president of the Audubon Artists, I had called on A. Lincoln Lavine, a distinguished lawyer and author of parliamentary law books, and asked his advice about running a society. He said to use common sense. I did, and it worked! That was in 1954, and here I was again asking my good friend for help. Tax exemptions are not easy to get but he said with the "Cooper luck" we would probably get it, and we did, a year later. We also borrowed $2,000 to pay then-current bills; the loan was paid off three years later. Also, against some opposition, I introduced women officers.

In 1964 one of my colleagues at the Art Students League and a master of anatomy, Robert Beverly Hale, was also curator of American paintings and sculpture at the Metropolitan Museum of Art. The idea of holding the centennial celebration for the American Watercolor Society in the Metropolitan Museum seemed like a good one, so I approached Bob Hale with the suggestion and he agreed. Two years later, on December 6, 1966, the exhibition finally took place. The crowd of some 350 invited guests included then-Mayor John V. Lindsay, Thomas P. F. Hoving, New York's celebrated parks commissioner and later director of the museum; Arthur A. Houghton, president of the museum; T. S. Buechner, director of the Brooklyn Museum; several curators of the Metropolitan, including Bob Hale; many collectors; and, naturally, many artists. It was a turning point in the future of the AWS; it gave us stature. Donations poured in for our different projects.

The following year, the 100th Annual Exhibition was held at the National

1966 AWS Centennial Exhibition at the Metropolitan Museum of Art. Photo Dale Meyers.

Academy. It was a fitting place to house it because our very first exhibition, in the winter of 1867–68, had been held in the National Academy gallery. This and the subsequent history is described in a book entitled *History of the American Watercolor Society, The First Hundred Years*, written by Ralph Fabri and published in 1969.

I probably hold the record for being president of a major art society for the longest continuous term. At the time of this writing, I am well into my 21st year! Needless to say, I am deeply devoted to the AWS. I have seen exchange exhibitions from Canada (1972), Great Britain (1962), Mexico (1970), and Australia (1975), and have judged paintings both by myself and with other jurors from all over the country; I have seen thousands of watercolors. In all my 31 (at the time of this writing) years of exhibiting, I have watched the importance of watercolors grow. They are more impressive, and much, much more serious. Watercolor societies, too, have sprung up all over the country.

National Recognition and The Space Program

On June 11, 1965, I received a telegram from President and Mrs. Johnson inviting me to a buffet supper at the White House Festival of the Arts. Of course, I accepted. In all there were 400 guests: musicians, poets, authors, and patrons of the arts. For the first 15 minutes I didn't see anyone I knew. Then Mrs. Johnson came over to greet me, but I quickly lost her to Edward

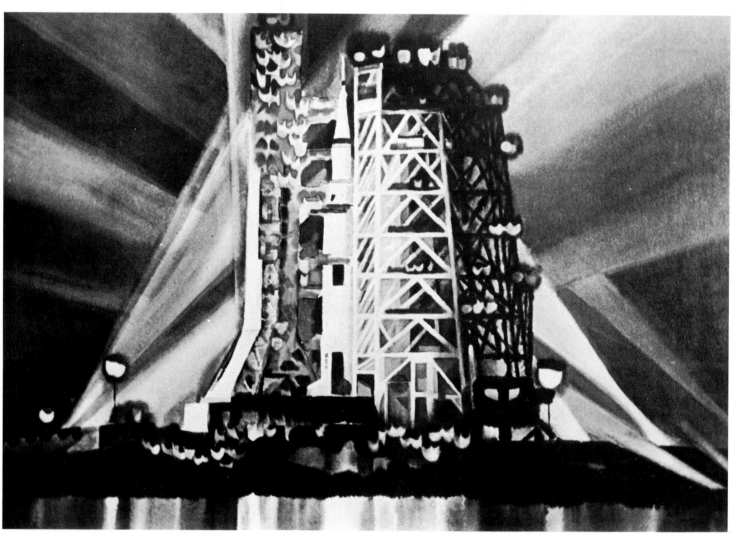

Apollo 11 on the Pad, *Cape Canaveral, 1969, watercolor.*

Steichen. I also saw Jose de Creeft and his wife, who introduced me to Josef Albers—I had met him many years before at Black Mountain College. Then my friend Paul Manship came over, and I was at home!

In 1969 Dr. H. Lester Cooke, curator of art at the National Gallery, asked me if I wanted to cover the Apollo 10 launching that had been scheduled for May 18. I felt highly honored and agreed. The Apollo project had been photographed thousands of times, and Dr. Cooke believed that the views of artists would be an important addition to the record. A number of artists we knew were also asked to cover the event: Paul Calle, Henry Pitz, John Pike, and Nicholas Solovioff. Dale was not yet cleared for restricted areas, but she joined a tour that would see the launching from a position seven miles away. By the time Dale finished the tour, she could lecture on the project.

The next launching, of Apollo 11, was to occur on July 16, 1969. By this time Dr. Cooke knew Dale's work, and so we were both invited. This was the one that was going to land on the moon! The only question was how soon could Dale be cleared with the FBI. When the FBI finally gave her clearance, it was under her maiden name of Wetterer: so she wore one badge that read Wetterer—NASA Artist; and another that said Meyers—NASA Artist. To make the matter even more confusing, everyone was addressing her as Mrs. Cooper! Among other artists invited for the Apollo 11 mission were Robert Rauschenberg, James Wyeth, William Thon, Norman Rockwell, Paul Calle, Nicholas Solovioff, and Robert McCall. The art inspired by these launchings was gathered in a book entitled *Eyewitness to Space*, which was published in 1971 and featured 258 paintings and drawings by 47 of America's great artists.

The liftoff was scheduled for 9 in the morning but at 2 A.M. Lester Cooke phoned and advised us to get to the site right away, since a traffic jam was anticipated. When we arrived—even at 3 A.M.—the press site was packed. Apollo 11 blasted off on schedule six hours later. The odd thing was that when the rocket took off there was silence. Somehow we had forgotten about the speed of sound. The sound took about 18 seconds to reach us, and then sounded like a bunch of Chinese firecrackers. The rest is history.

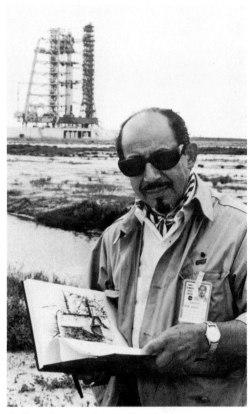

At Cape Canaveral, July 16, 1969.

Dale and I: Professional Teamwork

After this invitation, Dale and I received a number of other invitations as a team. We were invited to do paintings for the Viking 1 project, its destination, Mars. The Environmental Protection Agency also invited us to do a similar project. They paid our expenses, and we donated the paintings for all of these projects. We have since taught several workshops together, including my watercolor class at the League, and have participated on many juries as co-jurors.

Dale came into her own when she became president of the Allied Artists of America. She was the first woman president in that over-50-year-old society and served three-and-one-half years with distinction. Since 1961 she has also been active in the American Watercolor Society and has held many important chairs there. Her paintings have won many awards and medals of honor. She was made an associate of the National Academy in 1971, and a full academician in 1979. (There are only 25 seats in the aquarelle section of the academy. The associates are not limited in their number, and they don't vote in the academy.)

Dale and I love to travel. Besides Venice, it would be rather hard to say which other place we love best. Bangkok? Athens? The Taj Mahal? We never know where we will travel next.

IN THE STUDIO

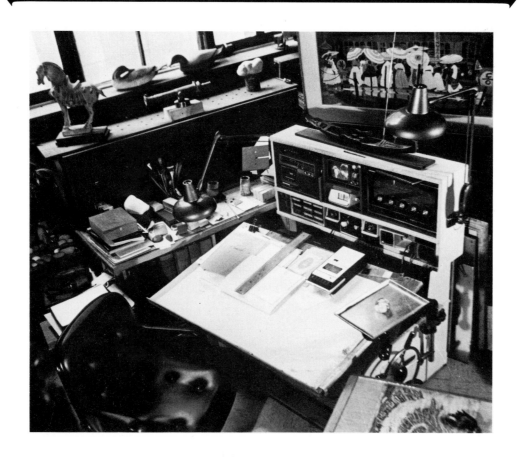

D
ale and I share a studio apartment in a building called the Hotel des Artistes. Built in 1915, its much-coveted apartments have housed many celebrities in the past, including Howard Chandler Christie, James Montgomery Flagg, Wallace Morgan, New York State Governor Hugh Carey, former New York City Mayor John V. Lindsay, and many famous dancers and playwrights. Our studio was once occupied by Rudolph Valentino. It's a corner apartment on the third floor, with windows on three sides, with a ceiling 20 feet high. A second floor extends partially across the lower studio. This is Dale's studio; we call it "The Eagle's Nest." The foyer entrance is filled with Japanese *no* masks, machetes, keys, daggers, and a clotheshorse I made, and there's a small window recess with a small Tuckahoe marble sculpture I made of a woman.

The studio part is 15' x 40' and is paneled in oak. An *L*-shaped cushioned seating arrangement in the corner surrounds a table with a lamp made from a huge bronze bowl that came from Kyoto, Japan; the finial above the shade is a Mandarin sitting on a horse. Sculpture and large books lie everywhere. There is a Chinese chest with two locks, one a bronze and stainless steel yin and yang, the other a large Chinese lock. On top of the chest is a Chinese head, probably dating from the Tang Dynasty, given to me by my friend the late Joseph Dunninger, a great mentalist who was once the confidant of the great Houdini. Beyond a limestone sculpture, by two ionic columns, is our "cocktail lounge." There, a large mask from the Baga tribe hangs on a wall of chocolate and light-brown squares. On one side of the couch there's a bookshelf that houses part of our poetry collection, while other glass shelves in the studio are filled with art objects of personal value.

In the main part of the studio, a giant easel with spars rising to 15 feet is silhouetted against the north-light window that goes clear to the 20-foot ceiling. The easel was made to my design from Philippine mahogany. There are two large bookshelves on either side of the easel facing each other. On top of them are 75 legal-size filing boxes. Award certificates plus more "African" masks that I made are everywhere. My working desk looks like the cockpit of a 747 jetliner! (See photograph.)

Work Area
I do my watercolors on a drawing table that I designed myself. It's quite large with compartments for a radio, television, slide viewer, and books. The angle can be changed easily when desired. Nearby are two easels, used mostly for viewing, displaying, and studying my paintings. There's a side table on casters to my right that I have also designed and made. Under its glass top is a 16th-century map of Venice; my paperweights rest on top. The upper drawer contains my most frequently used materials: pencils, pens, erasers, knives, reading glasses, dividers, compasses, and ruling pens. The lower drawer contains my sliding palette (a description of my palette follows) with six or seven brushes beside it. At the side of the palette is a drawer with two water containers: one to rinse the brushes, and the other with fresh water to paint with.

Lighting
I have found that an artist's working light, be it natural or artificial, is a personal choice. We must adjust to whatever satisfies our own needs. North light is usually preferred because it is constant. But all this talk about

(*Opposite page*)
Working area, seen from The Eagle's Nest. Photo M. Stephen Doherty.

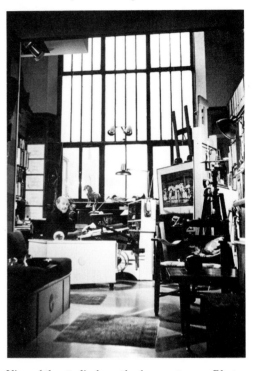

View of the studio from the foyer entrance. Photo Dale Meyers.

Work Area

north light doesn't make much sense to me because paintings done under it are seen under artificial light.

Being a night person, I once went through an extensive search for the true artificial light years ago. It was quite an experience—and I didn't find anything suitable. Today, even though I have north light, the lighting for my working table consists of two 150-watt spotlights placed side by side about eight feet from my drawing board. I also have two smaller ones, 100 watts each, attached to the console in front of my drawing desk.

Palette Years ago I used a butcher tray, but today the palette in my studio is one made especially for me. It is white enamel on a 14″ x 17″ (38 x 42 cm) metal tray. On one side is a cut-down row of a plastic ice-cube tray where I keep washes I have premixed in quantity that I can reach quickly to paint, for example, a sky. But as a rule, I squeeze out fresh tubed paint every day in the amount required for that session.

Colors

Though my paintings are mostly done in grayed, muted tones, the colors in my palette are strong and transparent. I avoid using certain colors, such as yellow ochre and Naples yellow, because they are too opaque and thick and tend to make a gray that looks more like mud—the wrong kind of mud. Siennas and umbers *are* mud (they're made from earth), but mud of the right kind—they're more transparent.

My palette consists of the following colors: Indian yellow, cadmium red deep, Winsor red (an arylamide color—you can substitute phthalo or quinacridone reds), alizarin crimson, Winsor violet (a blend of napthol and azo lakes—you can use phthalo purple), French ultramarine blue, Winsor blue (phthalo blue), Winsor green (phthalo green), and Payne's gray. I don't use black from a tube but instead make mine from combinations of red, blue, green, and yellow as follows:

> Red black: alizarin crimson with a touch of burnt sienna, added to Payne's gray
> Blue black: Winsor (phthalo) blue or French ultramarine added to Payne's gray
> Green black: Winsor (phthalo) green added to Payne's gray
> Yellow black: Indian yellow added to lamp black. (Here I *do* use a tubed black in the mixture.)

Demonstration Palette

When I demonstrate outdoors, I use a folding palette and lay out my colors (the same ones my students use) in a row in the following order: Winsor yellow (lemon yellow), Indian yellow, cadmium orange, Winsor red (phthalo red), cadmium red deep, alizarin crimson, Winsor green (phthalo green), Winsor violet (phthalo purple), French ultramarine blue, Winsor blue (phthalo blue), Payne's gray, and lamp black.

Lamp black must be used with care because if you have ever cleaned a chimney, what you got on your hands is lamp black—soot. And unless you know how to use it, it will dirty your colors. On the other hand, Payne's gray is a mixture of colors—you can make it yourself by mixing lamp black, alizarin crimson, Winsor (phthalo) blue, and French ultramarine. Because the three colors added to the lamp black are very transparent, the resulting

mixed black is less likely to muddy your other colors. If your tubed Payne's gray is too blue, you can add a little alizarin crimson and burnt umber to it.

When I demonstrate in the classroom, I use a white enamel or plastic tray, about 15″ x 20″ (38 x 50 cm), and squeeze out only the colors I plan to use in the demonstration, usually only five or six. For example, if a demonstration calls for sky, rocks, and trees, I squeeze out Winsor blue for the sky, raw sienna and burnt umber for the rocks and trees, alizarin crimson for part of the sky, and Payne's gray for making darks with the alizarin.

The variety of colors I can get by mixing these five colors is extensive. Try creating your own mixtures and record your results. Here are some of my favorites:

alizarin crimson + Winsor green: a kind of black, one that makes a silver gray;
lamp black + Indian yellow: a grayed old gold color;
Payne's gray and Indian yellow: a gray green (because of the blues in Payne's gray).

Brushes

I recently counted my brushes, got as far as 200—and stopped. In the classroom and for demonstrations I use square brights, sometimes called aquarelles. They are short-haired brushes and are made in white sable, a synthetic substitute for red sable, which is now quite costly. (I use red sable brushes for my studio paintings, of course.) I mainly use three sizes: nos. 20, 18, and 16 brights. I also use a nylon 1½″ (4 cm) housepainter's brush for wetting the paper, though I sometimes paint with it too. Square (bright) brushes tend to keep your work simpler than pointed rounds and are delightful to use once you learn how to manipulate them.

For my exhibition paintings, which are quite large, I use mostly round brushes: nos. 10, 11 (in some brands, a no. 10 is larger than a no. 11), 6, 4, and even 2. This is because most of the areas in my paintings are rendered rather than painted. The difference between painting and rendering is that in painting the brushstrokes are more important and the technique is looser and more flamboyant; in rendering, the control of the total value of the area (getting a flat color, that is) is all-important, and you may not be able to see a single brushstroke. It is the skill or technique of control that is essential here.

Another brush I use a lot is a scrub brush, usually a no. 3 bristle brush that has had its bristles cut down to a stub. I use it to soften edges.

Paper

I use 200-lb Arches or Whatman paper when I can get it—the paper is no longer being manufactured—for my exhibition paintings. (Whatman paper is so good that I have even used the backs of some of my discards.) Because I like semi-fine detail, a semi-smooth, cold-press surface is best suited to my paintings. For the same reason, I seldom use rough paper, and I use hot-press (smooth) paper only for carbon (pencil) drawings.

I generally use 22″ x 30″ (56 x 76 cm) imperial-sized paper or 26″ x 40″ (66 x 102 cm) paper, which is a double-elephant size. I also use an even larger size paper, 30″ x 40″ (76 x 102 cm), which I cut to 28″ x 39″ (71 x 99 cm). In the classroom, my students work on 140-lb paper, that is usually half a sheet of imperial-sized paper.

Miscellaneous Items

I use the following from time to time in making a painting:

Facial tissue is very handy when laying a wash that looks as if it's going to be too dark. I use the tissue flat, as if it were ironed, and press it into the wet wash to remove the color. (Don't wrinkle it. If you wrinkle it you will get a different effect, though it could be one that you might like.)

Another useful item is a piece of scrap paper to put under your hand as you're working. Don't let it rest on the watercolor paper or the oils from your skin will repel or bead your washes.

To correct my work or lighten certain areas, I use a kneaded eraser. It looks and acts like chewing gum and when I roll it over a dry area that contains a pencil mark that is disturbing, it will pick it up. I also use other types of erasers to lighten certain areas, including ink erasers to remove the more recalcitrant colors. Razor blades are also useful for scratching an occasional highlight in an eye or on a piece of jewelry.

I use a flat, ordinary sponge, the type you can buy in grocery stores, to wipe excess water from the brush before painting with it, or to remove paint from an area on the paper I'm correcting. Once in a while I use the sponge to suggest foliage by picking up paint from the palette with it, then pressing it lightly against the paper. I then add branches with a round brush. I never use the sponge for wetting the paper, however. I do that with the large housepainter's brush I described earlier. I also use a 4" (10 cm) housepainter's brush to dust specks of paint or dirt off the paper.

From Idea to Painting

My paintings are carefully planned and my ideas go through a rather lengthy evaluation process before I consider them worthy of becoming a painting.

Sketches

I usually begin a painting by making a number of small studies in watercolor about 4" x 6" (10 x 15 cm) on a piece of ordinary white writing paper. They almost look like photographs because of their precision, but they're actually made up of very carefully considered and organized dynamic abstract shapes.

 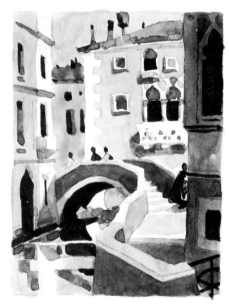

Early stages in developing an idea into a painting.

Evaluation

I pin these sketches onto the bulletin board and there they remain, going through changes every now and then, for as long as two or three years, until they are discarded or end up as paintings (or sculpture). During this period of assessment, I must also decide if the idea will work better as a painting, in a flat dimension, or as a sculpture in a three-dimensional form. An inspiration can call for many different kinds of expression. For instance, the monumental vision of Dante's *Divine Comedy* could only be told in poetry, and Beethoven's ideas are best expressed in musical form. Many ideas and inspirations are not meant for visual expression—but enough of that.

During this evaluation stage, I may refer to a number of my own slides or look at books on the subject, if they exist. I use every piece of information available to become thoroughly immersed in my subject. A good example of how this process works can be seen in the second demonstration, *A Tribute to Kukulkan*. The idea of the lost civilization of the Mayans had intrigued me since 1929. I referred to books, magazines, and anything else I could get my hands on for information on the Mayans, to read all I could on the subject. For many years, nothing came of my research. Then, in the fall of 1978, I started making visuals that looked more like scribbles than comprehensive sketches in color. So the following year, 50 years after I first became interested in the subject, Dale and I finally decided to visit Chichén Itzá in Mexico. Upon my return I made more sketches and finally the finished painting, which didn't resemble any of the hundreds of slides I took.

Chichen Itza

Handling a Large Painting

I approach a large painting pretty much as I would a mural; I work on one part of the painting at a time. The problem is to make it look like it was done all at once. There are times when something that looks good in a small sketch won't look good when enlarged. For example, in my painting *A Marble Song to Mumtaz* (page 128), the Taj Mahal and the sky with the calligraphy looked great, but the figures in the foreground did not. So I had to go through the painful process of sponging out and erasing the whole section containing the figures until the paper was white and I could start all over.

Composition and Abstract Shapes

All the while I'm developing a sketch, I'm striving for several things I believe to be important. One of them is good composition. I like simple compositions. Simplicity calls for greater selectivity and more economy of pattern, line, and value—the "less is more" of Mies van der Rohe. It's like saying something very important in a few words, like the Japanese haiku, "The summer grass, all that is left of a warrior's dream," or one of Whistler's nocturnes, or a portrait by Rembrandt, or one of Josef Alber's homages to the square. They all have that simplicity.

An abstract can create a response by its design and color alone. In my painting *Peace Memorial, Hiroshima* (page 138), the original sketch was an abstraction of a white and a black shape on a red background. I could have left it that way, but, because I like to build a representational work on an abstract base, I made the shapes into objects.

As a further aid to abstract thinking, I collect solid and patterned patches of color from magazine advertisements and now I have quite a collection of

Typical abstract paper collage.

them in all colors. Many times when a painting is in the small-study stage, I will use the cutouts as abstractions and make a number of collages, moving them about until I get a pleasing pattern of colors and design. In addition to being helpful in planning a painting, just making arrangements out of these patches is an excellent exercise in developing your color taste.

Selecting a Subject

A number of subjects appeal to me as a basis for my paintings. I am intrigued with history, especially the Italian Renaissance, and with mythology and Greek plays because they mirror the psychological frustrations of today. Also, the romantic and dramatic have always intrigued me—especially the drama of the city, with its buildings, palaces, and castles. In my paintings *Moscow of Yesteryear* (page 130) and *Pageant of Jerusalem* (page 126), I was fascinated by the thought that we are all basically alike; that only our dress, homes, and foods are different. Our tragedies are the same; so are our happinesses. Even so, the homes and dress interest me because they provide drama and color.

Historical buildings also intrigue me, and I believe that their tragedy or glory can be imparted through design and color. For example, I have already made three paintings of the Castel Sant' Angelo in Rome, all award winners (page 110). Yet the subject still intrigues and challenges me. I am still trying to paint one that will capture the drama and intellectual excitement that I actually feel for that structure. Its history is fascinating: Benvenuto Cellini, the famous goldsmith and artist, was imprisoned there more than once, and many important nobles died of starvation or torture in the dungeons within its circular walls. There Catherine Sforza was reduced to a scullion in the space of one year, a far cry from the beautiful, ruthless, brilliant princess and commander of troops she once was. When freed she said, "If I were to tell you what I suffered, you would turn to stone."

I also love calligraphy and regard letters and their structure, especially Arabic letters, as a design form. I always wanted to see the Taj Mahal, and when I finally did, I wanted to paint it. The exquisite beauty of that structure is unbelievable. Its romantic history is well known (a king's memorial to his beloved queen), but painting the subject was a problem because so many photographs have been taken of this gem that it was hard to avoid a clichéd treatment. I finally got the idea of using the calligraphic quotation from the Koran on the sarcophagus of Mumtaz Mahal, and I used it as a veil across the entire painting (page 128).

I also love the sea and hope to do more paintings with ocean themes. I especially like to paint fishing boats because they are working boats. But because they're too picturesque when painted "as is," I will have to aim for something more subtle and artistic. I have my work cut out for me.

I am also fascinated by light and the shadows it creates. Shadows and their shapes have fascinated artists for centuries. In the designs of my best illustrations, shadows have played an important part. Long shadows cast by shutters, balconies, poles, and the like can all contribute to an imaginative composition. At sunset and sunrise in particular, some of the best shadows are cast. Long shadows cast on soil or snow can define the form of the terrain. And just think what a lantern shining at night can do to an old city street—casting shadows on the cobblestones, doorways, and balconies.

The sketch must now undergo a series of stages before it is transformed into a finished painting.

Making a Grille

Once I approve one of my small sketches (which itself usually looks like a finished painting) and decide to make it into a watercolor painting, I prepare it for enlargement. I place a piece of tracing paper over it and trace the border. Then I draw diagonal lines from corner to corner on the tracing paper so that it looks like a flattened letter *X*. The lines intersect at the center of the picture. Then I draw a horizontal and vertical line through the center, making a cross that divides the whole idea into four sections. Then I draw an additional diagonal to each section so I have an *X* in each of the four squares. (Don't forget, this is all done on the tracing paper, not the sketch.) If I require more divisions I can break it down further. The four diagrams on the right illustrate these steps.

Enlarging the Sketch

To enlarge the sketch onto tracing paper, I make a grille the size I want the new sketch to be, keeping the same angle as the first diagonal, which in this case is 35 degrees. Then I place my sketch-size grille over my sketch (I am using a black flower for simplicity), and, noting how the lines intersect the drawing, I reproduce or copy the patterns intersected by the little grilles onto the larger ones. (See the final step below.)

When I am satisfied with the enlarged sketch (this may take time, since my additions and changes may sometimes take days; this is a work of art, not a race!) I turn the tracing over. My drawing table has a white covering so I can easily follow the lines on the other side of the tracing paper. Now, working on the *reverse* side of the large tracing-paper drawing, I outline the lines I want to trace with a dull-pointed pencil.

Steps in making a grille, the first stage in enlarging (or simply transferring) a sketch from one paper to another.

Enlarging a sketch.

Transferring the Drawing to the Watercolor Paper
When this is finished, I lay the tracing right side up on top of the watercolor paper, which should be stretched and dry by this time, and pin it in position with a couple of staples near the edge. Then, with a ballpoint pen (preferably a red one so I can easily see what lines I've traced and what remains to be done), and with a little pressure, I trace over the lines I want. Because I work the drawing out on tracing paper first, I save the watercolor paper needless wear.

Stretching the Paper
First I put on white gloves, which I always wear when handling the watercolor paper. Then I place it on a ¼" (6 mm)-thick piece of plyboard that is ½" larger all around than the paper itself. I insert one staple in the middle of each of the four edges. Then, with a 1½" (4 cm) nylon house-painter's brush, I wet the dry side of the paper, which is facing up, and brush the puddles of excess water away. As soon as the shine disappears from the paper, which by this time is buckled in a convex condition, I remove the four staples. The paper has now stretched so that it is about the same size as the plyboard. Now, still wearing the white gloves, I place another four staples in the same places, making sure the paper lies flat. On each side, halfway between the middle and the corner of the paper, I add another staple all around, continuing until they are about 1½" (4 cm) apart. Then I put the paper and board aside to dry.

General Painting Procedures

I usually start with the largest areas in the painting first and aim for a flat, unvarying wash of color. (I can always adjust it later by overpainting it when it is dry.) Since the sky is usually the largest area in the painting, I paint it first. I mix a color for it on my palette and test it on a scrap of watercolor paper to see how it looks. Mixing colors directly on the paper is gambling or working for effects or "accidents" as far as I'm concerned, and I am strictly a "straighten-out-and-fly-right" man. (But by all means try mixing your colors on the paper if you want. Try everything—and keep a record of the results.) When I get the right color, I mix a quantity of it in the ice-cube receptacles on my palette—which may take three or four cubes because I usually vary the colors in the sky. Also, I always mix more paint than I think I'll need so I don't run out as I'm working. Then I'm ready to proceed.

Holding the paper flat, I first dampen the sky area with a 1" (2.5 cm) aquarelle brush, making sure there are no puddles. Then, raising the paper to a 30- or 45-degree angle, I apply the washes with a no. 20 bright brush. (Sometimes I find it easier to turn the paper upside down to paint the sky.) When I'm not laying in large washes, I usually work with my drawing board tilted at an angle of about ten degrees.

I generally start with the biggest brushes and work down to smaller ones by the time I am ready to sign my name. But there are times when the edge of a large, say 1" (2.5 cm), brush can furnish all the details I need, like the small branches of trees or bushes.

The same procedure holds true for color. I always try to work as long as I can without using my deepest darks. So the larger areas, which are painted first, are rarely in their final color or value. I also try to make them light

enough so that the painted area can be left in its first state without having to be further lightened.) When the main areas are established, I begin to play with color and value, working one area against the other, joining some, contrasting others, all the time trying to get a maximum richness of color without the aid of the darks. When I'm satisfied that I have reached the limit in working with middle values and the painting is crying for darks, I add them—and they perform like the clash of cymbals in a symphony.

Wet-in-Wet Technique

Wet-in-wet painting begins with a thoroughly moistened paper. At first the washes are loose and broad and the brushstrokes blurred and soft, but gradually, as the paper dries, the brushstrokes become crisper and more defined. It is a technique that requires careful planning, and the greatest thrill of a wet-in-wet painting is to finish it when it has dried enough to sign it without your name spreading. I use the technique a lot in lecture-demonstrations because of the speed involved—it's an instantaneous illustration. But many areas in larger paintings also call for a wet-in-wet technique.

I look upon a wet-in-wet demonstration as a fencing match. Once I've started, there's no time to vacillate. So I prepare to work nonstop like Cyrano De Bergerac in his duel with Le Vicomte. Before the duel, he stopped only long enough to select his duelling verse and refrain. So first I prepare for my duel. I make a small sketch, more like a diagram, just to show the main colors in the different areas. Then I remove a sheet from a 15″ x 20″ (32 x 50 cm) 140-lb block of cold-pressed watercolor paper and, with an ordinary no. 2 pencil, quickly place the orientation points of the drawing dark enough so that when I wet the paper they won't come off. Then, with a 1½″ (3 cm) housepainter's brush, I "paint" both the front and back of the paper with water, working it well into the paper. I work on a water-repellent board or table top (a piece of Plexiglas is excellent), pressing out the air and removing excess puddles of water when they form. The wetting process takes about six minutes and, when done properly, gives the water on the paper a surface tension. Surface tension is what keeps the water in an overflowing glass from spilling. This same quality keeps the water like a film, which keeps the paint from spreading wildly. Puddles will destroy the tension, which is why the paper is brushed carefully on both sides. If done right, the paper will stay flat, with no buckling. But you should be prepared to paint instantly.

I have on hand two containers of water, one to rinse my brushes in and the other to add to the paint, and two square brushes, nos. 18 and 20. My palette contains the colors, squeezed freshly from tubes, I will be using in the painting. Always conscious that colors lighten as they dry, I use thick color wherever I can. As I work, and the paper dries, the edges get sharper. I try to determine ahead of time where the hard and soft edges will be needed. When the paper is dry to the touch, the duel is over.

Working wet-in-wet, the order of procedure is usually dictated by the problem at hand. For example, the sky in most cases calls for a flowing effect, so I prepare my colors for immediate application, and wet the area with a 1″ (2.5 cm) brush—it can be a white sable or any other kind of a square bright or short-haired aquarelle brush. Since the brights don't hold as much water as the round brushes, and since my colors are ready to be used, the paper doesn't have to remain wet too long.

Speeding Up the Drying Process
While one area of the painting is drying, I usually work on some other part. In a large picture, there's always some area that needs attention. In the classroom, some of my students use hair dryers to speed the process. To dry a small area, I often place a lighted match near the back of an area, rotating it to keep the paper from burning. But in general you must get used to waiting without letting it bother you.

Drybrush Technique

Drybrush means nothing more than mixing very little water with your pigments. The best brushes for drybrush are the pointed round ones. The technique allows total control and is therefore excellent for finishing details like eyes or fingers in portraits. I also use a drybrush technique when I'm consolidating the value of a pattern. That is, sometimes through no fault of technique, a wash may leave some blemishes that must be corrected. It takes patience and skill to lighten or darken these areas so they match the value of the rest of the wash. The most essential step in drybrush is to first test the color on a piece of paper so you can regulate the degree of dryness and intensity of the paint.

Making Corrections

As the painting progresses, I check it for errors by placing it under glass in a mat and frame and studying it. I have frames and mats for all the sizes of paper I use, set up to hold the unfinished painting while it is still stapled to the board.) I then try to work out solutions for the problems I observe on bond paper—I use a 36″ (14 cm)-wide roll. When I find a potential solution, I tape it onto the glass over the area where the problem exists to see how it works with the painting as a whole. If a painting is in a lot of trouble though, it is best to do it again. After all, what do you do when you burn the biscuits? In some cases you can save the painting by wetting the area and lifting out the undesired paint with a flat piece of facial tissue or facial sponge. If the composition and idea are strong enough, the blemish might even be a blessing in disguise.

For example, in *A Marble Song to Mumtaz*, the sky with the calligraphy on it looked great, but the figures in the foreground did not. So I left the painting on the easel until I made a whole new painting in a different color scheme, with the problem solved. Then all I had to do was to copy the figures and just change their colors to fit the first painting. (Of course, I had to go through the painful process of sponging out the old color first until the paper was white again and I could start all over.)

Finishing a Painting

I have a saying: When you don't know what to do, don't do it—because it will just look that way. A painting is finished when you realize that you have nothing further to do on it.

Framing and Matting
Preferences in framing and matting are rather personal and involve interior decoration. Since I paint with exhibitions in mind, I keep my mats neutral, a sort of warm off-white gray. Colored mats may interfere and compete with the painting. The mats are usually about 4″ (10 cm) wide. The frames

are simple and not heavy or ornate, and are about 2″ (5 cm) wide. I use Plexiglas instead of glass over watercolors. Plexiglas is safer—broken glass can seriously damage a painting.

A Successful Painting
A successful painting is one that captures the imagination. Andrew Wyeth's *Christina's World* and Pablo Picasso's *Guernica* appeal to different audiences, but they are both successful. One expresses a powerful heart throb, the other cruelty and barbarism. Personally, I consider one of my own paintings a success when I begin to enjoy it. But this rarely happens right away.

On-Location Sketches and Studies

The only time I paint on location is when I am demonstrating for a class. On my travels, I draw with a ballpoint pen and make many small sketches on location. The ballpoint sketch acts like tying a string around my finger to help me recall an impression or idea that was important enough to put down. I also take many color slides. On a month's trip I might end up with 40 rolls of 36-exposure 35mm film—that's about 1,400 slides! Although it may be interesting to view 1,400 slides when I get home, they don't necessarily suggest an idea for a painting. On many occasions I have shot roll after roll of film in an attempt to capture a certain impression and feeling a place had for me, only to come home and look at a lot of pretty slides and find nothing—the inspiration was within me!

I also make little studies that look like finished miniature paintings. I make several versions of the same subject using different color schemes, trying in an abstract way to interpret my feeling and response. Certainly *that* is not in the slides. Even though I only have these little studies to go by, if the original idea is strong enough, it will remain, like the eternal nonscratchable itch.

What is Art?

As I see it, there are three kinds of artists: the reporter, the commentator, and the author. All three can produce forms of art. The reporter tells or paints a scene as he sees it. The commentator tells or paints it, expressing his own opinions. And the author just imagines the whole thing and contributes his philosophy, color, and point of view; he is the creator. This last is my approach.

I believe that you can't think up ideas—they must come to you. Ideas are a form of inspiration. As Harvey Dunn once said, you might grow corn on the moon someday, but you can never think up an idea. There are ways of making yourself an instrument receptive to ideas, however. Constantin Stanislavsky, the great actor, teacher, and originator of the "method" school of acting, found a way; it has to come from within.

Design is composition—a living, visual organism. Generally speaking, photographs may be your raw material—but they are only this. I have a tremendous collection of postcards, picture books, and other sources of information for my paintings. It's all grist for the mills of imagination. But imagination is the key. When you work from a photograph alone, you eliminate imagination. And the success of a painting all comes down to how much *you* have to contribute.

On Technique: The Glorified Postcard

If you are a good technician, you can more or less follow a photograph and come up with a glorified postcard—and believe me there are plenty of these around. Now, I don't want to knock the glorified postcard. A lot of people would give anything to be able to paint one, and there are many master technicians who can do it well. (A master technician is one who, by the manipulation of brushstrokes, can create an effect that is very pleasing to the eye.) But technique, plus a picturesque subject, gives you only a postcard—no message, no suffering, no problems. So what is the difference between the artistic and the merely picturesque?

A pirate sitting on the stern of a galleon with all the accessories—cutlass, tricornered hat, patch over eye, and so forth—that's picturesque, and not bad as illustration. But a simple still-life painting of a book on a table, with only the composition and color scheme to make it a work of art, like the squares of Josef Albers, is something else. Exciting? Well, not to everyone, but the artistic potential is there.

A good-looking technique is like good-tasting jam. You can put it on a slice of bread and make the bread taste good. But I want to make my own bread—and one that doesn't need jam to make it taste good! A virtuoso violinist can play music by any composer and win applause. But he relies on the creation of the composer, someone else. *I* want to be the composer. So my goal when I'm on location is to collect sketches and photographs as inspirations to spark my imagination when I finally begin painting back in the studio. These things help me to create *my* kind of painting—not a painting that looks like the original subject, but one that reflects what *I* see in the subject.

A Word of Advice

If I were to describe the difference between a professional and an amateur, I would say that the professional is good all over or bad all over, while the amateur is both good and bad at different times. The amateur's work is uneven; the professional is consistent in the work he or she produces.

The advice I would give to a beginning professional is to be honest with yourself and try to distinguish between your ego and the real you. Above all, learn to work, and work hard. Also, when you feel you're ready, start to exhibit your work. Many regional watercolor societies afford the beginning professional this opportunity. Try to get the opinion of an artist you respect as to your exhibition potential.

Why Watercolor

Watercolor has had an interesting history. Not many people, not even professional artists, know that the walls and ceilings of the Sistine Chapel were painted in watercolor. (It was selected because the transparency of the medium allowed the architectural structure and design of the building to show through.) The best miniatures have also been painted in watercolor on ivory panels.

Watercolor was a challenge for me, and I am self-taught in that medium. There are many reasons why I find it special. For one thing, watercolor is always exciting. The values change as the paint dries and you must always estimate the density of paint needed to get the result desired. Then it dries quickly, so you can work over an area or finish an entire painting in little time compared to other media. It's transparent; no matter how darkly you apply the pigment, the paper shines through. And it's versatile: You can get thick, broad, soft lines or fine, sharp ones. It's also a clean medium—cleaner than, say, oil or pastel.

DEMONSTRATIONS

DUSK IN CENTRAL PARK

The most difficult and important problem that confronts me in art is to put into graphic form the inspiration, feelings, responses, and enthusiasms that run through my mind and make my nerves vibrate—my wanting to express something that I feel must be expressed. I always ask myself the big question: Is painting the way to do it? In music, you can build up to a great emotion, as Richard Wagner did in the love music of *Tristan and Isolde*. And, working with words, the poet has a chance to stimulate the imagination and stir up endless feelings before the end of the poem is reached. What I am trying to say is that literature and music unfold their full potential slowly. It takes more than one sentence to read Dante's *Divine Comedy*, more than one chord to hear a prelude by Rachmaninoff, and more than one step to see Rudolph Nureyev dance. But in art, where the idea has to be said graphically, it must be said *instantly*. You can't build up to it; it's got to be all there at once.

So my problem lies in dealing with vision. Once I have decided on the subject of a painting, I put aside all emotion and proceed with the painting as a problem in arithmetic. The problem lies in the division of space; I must decide how much black, white, gray (and color) there will be, and what shapes to make these areas.

Crossing Central Park in New York City about five in the afternoon one winter, a feeling I have had a number of times recurred. Seeing the tall skyscrapers silhouetted against the sky and the still darker trees and bushes in turn silhouetted against the buildings, and seeing the snow-covered grass and terrain making a stark white pattern with it all, an overwhelming feeling of romance and expectation took possession of me. The problem was: How could I show this graphically?

I decided to treat the problem abstractly, through values. A picture can be reduced to three main values: light (white), gray, and dark.

If I had to reduce this particular scene to an extreme abstraction, I would select three horizontal bands of values: a gray band for the buildings and the sky, a dark band for the trees and the bushes, and a white band for the snow-covered terrain. But this is too abstract for the way I paint. So . . .

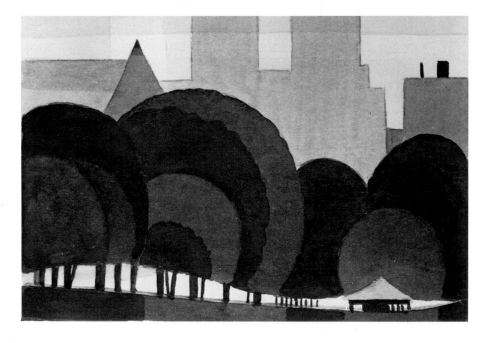

I go a step further and make three variations of each of these values. I now have a total of nine values: three lights, three grays, and three darks.

51

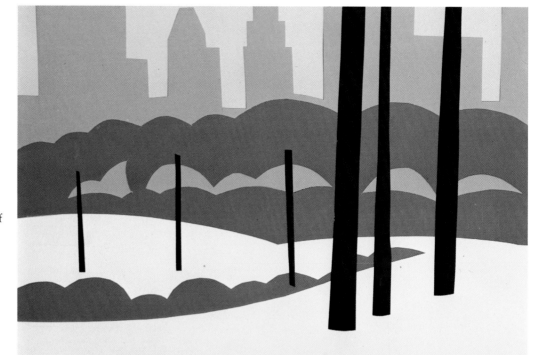

To keep the problem very simple, I usually first make a paper collage. I take two pieces of gray paper and make the lighter one the sky. Then I cut the darker paper into shapes of buildings and glue them into place with Elmer's or any white glue. Then I take the lighter of the two darks and cut it into shapes of trees and bushes and distant branch patterns. The darker of the darks I cut into trunk patterns. At this point, it is pretty simple—I don't try to get fancy. The white paper, of course, becomes the snow.

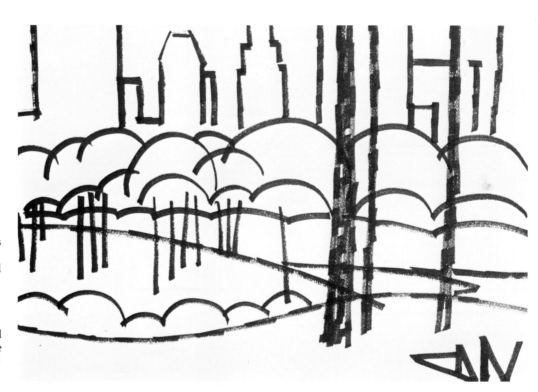

Once I establish my values, I work on the lines and rhythms of the composition, using the parts and combinations of a circle, square, and triangle, as shown here. I also decide what colors I'll be using and test them out by redoing this value sketch in full color. Then I lay out the entire picture on a piece of tracing paper the same size as the watercolor sheet I'll be using. On this tracing paper, I work out the drawing, composition, and volumes (masses) until I'm satisfied.

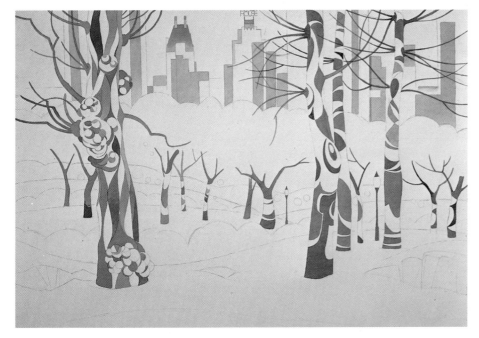

I now stretch a 300-lb sheet of watercolor paper, 22″ × 30″ (56 × 76 cm)—imperial size, staple it to the plywood board, and let it dry taut. (See page 44 for details.) When it is dry, I transfer the tracing paper drawing onto it. Because the pencil lines are not strong enough to survive a series of washes, I strengthen some of the patterns and key points with initial washes of the colors, using a no. 5 pointed sable brush. The reds are alizarin crimson with a little Payne's gray to neutralize it. The yellow is raw sienna diluted with water. The gray purples are Payne's gray and alizarin crimson with a little Winsor blue added. Payne's gray and water make a good gray blue. The lines from the tracing still can be seen, though with repeated washes they will disappear.

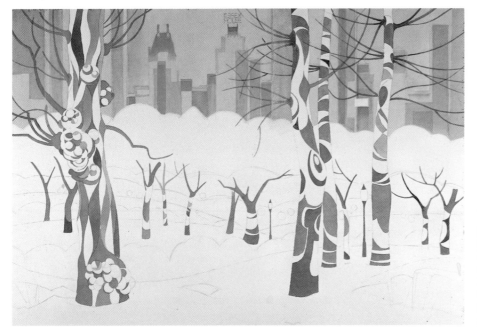

With a no. 20 bright, I wash a light mixture of alizarin crimson over the left third of the sky and a light mixture of raw sienna over the right third, leaving the center white. Then I combine the raw sienna and alizarin crimson in a plastic ice-cube receptacle (see the description of my studio palette of colors on page 38), being careful not to make the mixture too dark. Now I paint all three areas of the sky with the mixture. This gives the sky variety.

Ever since I first saw this tree years ago at the entrance to Central Park on Columbus Circle, I have always wanted to be able to use it in a painting, and I finally have found a spot for it. I reduced its burls to circles for the sake of design. In this close-up you can clearly see the various colors I used. The gray-green circle in the center is a mixture of raw sienna and Payne's gray. The other mixtures are combinations of alizarin crimson, Payne's gray, and Winsor blue for purples, Payne's gray and water for gray blues, Payne's gray and alizarin crimson for a soft purple, and raw sienna with a little water for the yellow.

With a no. 18 square sable brush, I apply a mixture of Payne's gray and a little Winsor blue to the buildings on the upper left side of the picture, to the left of the big tree. I do the same on the right-hand side of the painting, except the mixture there is alizarin crimson and Payne's gray. Then I combine the two mixtures for the center portion. For the present, I left white the tops of the bushes running across the picture in horizontal bands, but painted the color under the bushes Payne's gray and alizarin crimson. Since I plan to use a sponge for the texture of the background trees, I will have to block out the trees with masking tape.

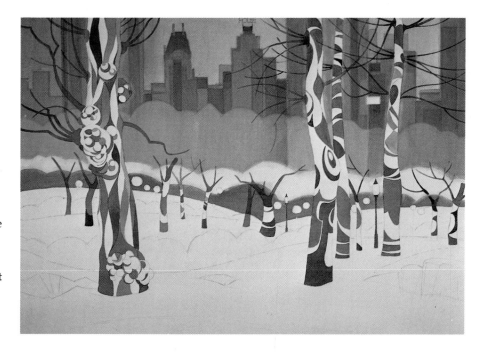

Here I have started to mask some of the trees. The best way to do this is to place a piece of tracing paper over the area, trace the outline of the trees with pencil, then place masking tape over the tracing and just lift off the pencil marks. Just enough of the pencil will come off on the tape to guide you in cutting out the tape to the exact shape of the area on the watercolor paper that you want to mask. The street lamps will have to be blocked out too, the same way as the trees. I paint a wash of Payne's gray and raw umber over the white area of the bushes.

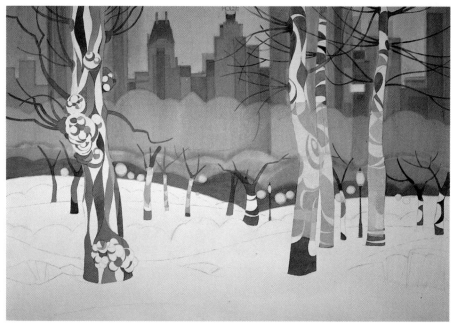

There is little foliage in winter, but the minute branches at a distance form a lacework that looks a lot like foliage. That and the motion of the branches in the wind make a textural pattern I find easier to express with a sponge. To control the sponge pattern, I cut some lunettes or fan-shaped windows out of bond paper. Then, with a bit of water, I place some areas of Payne's gray, Winsor blue, alizarin crimson, raw umber, and burnt umber on my palette and, with patting motions of the sponge, I mix the colors—though not too thoroughly. Using the mask I had cut out, I test the colors on a piece of scrap watercolor paper first. When I am satisfied with the mixture, I apply it to the painting using the same technique.

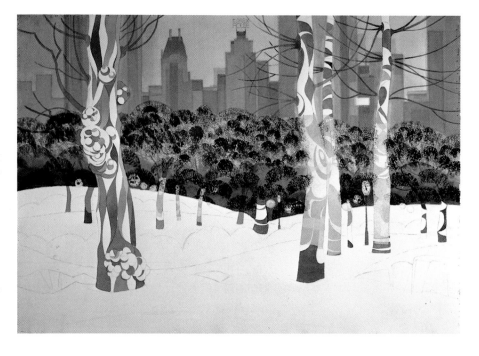

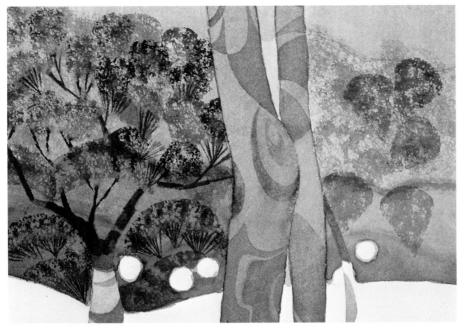

This is a scrap of paper on which I tested my sponge. On the right you can see the fan shapes the sponge made beyond the window of the mask. At the left there are areas with darker color and additional radiating strokes I made with the edge of the no. 20 square brush, using the edge like a chisel.

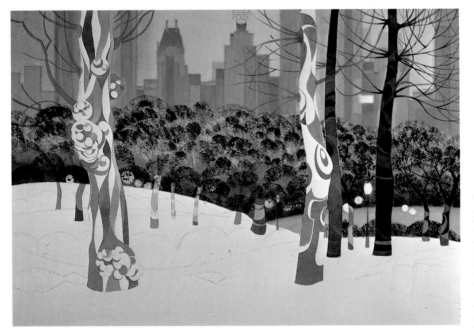

The tape has been removed from the trees on the right and the two trees to the right of the big tree have had their final color added. I have also added a light gray color (Payne's gray and water) to the snow below the middle right. Covering the snow part with a mask, I now add the bushes on the lower middle right. I paint the branches against the sky with a no. 5 red sable. Ordinarily I would use the edge of a 1″ (2.5 cm) aquarelle brush, but this picture calls for more lyrical calligraphy.

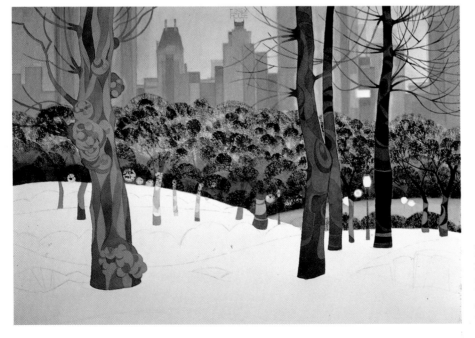

I continue to develop the big trees. The color I use for the overwash is a combination of cadmium orange, Winsor violet, and Payne's gray. To vary the color of each tree, I juggle the amount of one color or the other. The small trunks on the middle trees are still covered with masking tape.

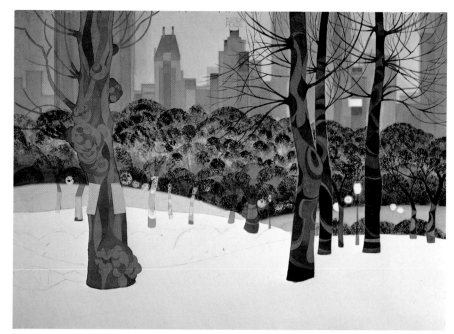

I paint the snow mound on top of the lower left half with a light mixture of gray violet (Winsor violet and cadmium orange). I leave the masking tape on the trees because I must still add some bushes beyond the mound behind them.

Many times a painting gets to a stage of completion when I feel it needs additions that can only be tried out on the painting itself. At such times, I resolve the problem by painting the proposed addition onto a piece of thin acetate and placing it over the painting. Here I wanted to add extra branches to the tree at the left. When I held the painted acetate in position there, it looked fine, so I drew it in, and painted it. The tree also has to be darkened.

When the wash of the buildings is applied, it leaves a little dark edge against the sky. In some paintings I might leave this line, but here, because I want the buildings to recede, I soften these edges. In this detail, I have already removed the lines on the green-roofed building and I will remove those on the Essex House. The method I use is first to wet the lines with a no. 5 pointed brush, count to ten to allow the glue in the paint to soften, then blot off the lines with facial tissue. The paint usually comes off on the tissue.

PAPER MASK

A paper mask is a useful item for blocking out areas. Here the mask, cut in the shape of mounds of snow, has been placed at the base of the bushes, and I have painted the trunks and branches into and above the bushes. I have masked out the foreground tree too, and you can see my radiating brushstrokes crossing into the masked areas. I used the edge of a no. 20 square sable (the edge of the brush, of course) for these radiating strokes. For darks, such as the branches, a mixture of Payne's gray, alizarin crimson, and a touch of burnt umber and Winsor blue makes a very rich "black."

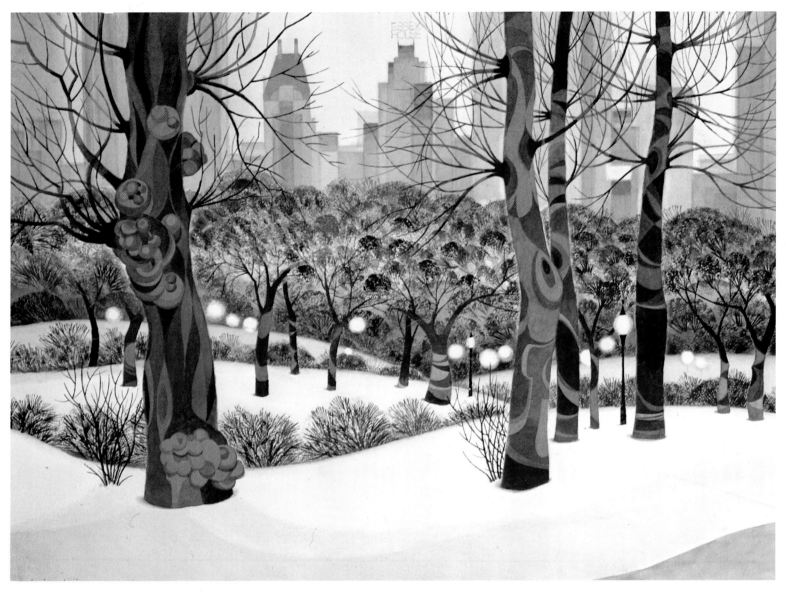

When I remove the masking tape from the street lamps, I have to soften the hard edges they left. Instead of wetting and blotting it, as I did in the detail on page 56, I use another method because I want the lamps to have a soft, glowing effect. I use my cut-down no. 3 brush (see page 39) to scrub it out and give it a halated effect. I also add more briars to the painting. I first try them out on acetate and check their positions until I am satisfied, then paint them in with a no. 5 pointed sable brush.

TRIBUTE TO KUKULCAN

For many years I tried various approaches to making a painting of the Castle of the Warriors in Chichén Itzá, Mexico. I had first seen the castle years ago in an article on the Mayas that ended: "What happened to the Mayas?" The civilization intrigued me, but after many abortive attempts at depicting the Castle of the Warriors, the idea, like the Mayas, abruptly vanished.

Many years later, like a recurring dream, the idea of a Mayan painting once again occupied my thoughts. By then I had developed a new style and I felt I could now put the castle down on paper. So, after gathering all the pictorial information I could, I made a number of preliminary sketches, more like scribbles. I got so involved that Dale and I decided to go to Yucatán and see Chichén Itzá for ourselves.

The visit didn't add much to the information I already had, but we enjoyed it. I had expected the stairs to the top of the castle to be narrower and taller. Actually they were very comfortable to climb, even without the use of the guide cable.

Tribute to Kukulcan is pure imagination, and the sacrifice of the virgins by throwing them down a sacred well is pure conjecture on my part. But there is no doubt of the authenticity of the ceremonies to Kukulcan, the feathered serpent.

HIGH WINDS MEDAL, AWS, 1979

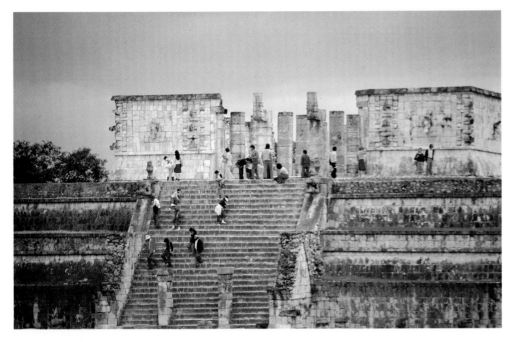

This is one of many photographs I took of the Castle of the Warriors in Chichén Itzá. If you compare it to the finished painting, you can see just how much of it I use for reference—and how much I owe to imagination:

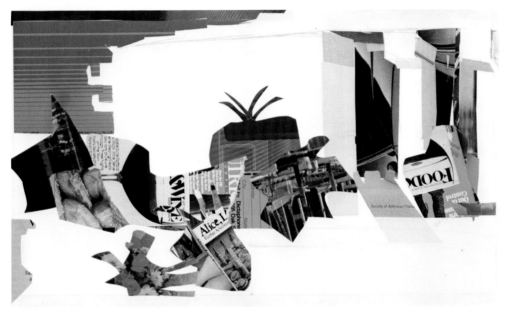

As I've explained before, I find paper collages extremely useful in deciding the colors and placement of my composition. You'll notice that I decided to flop the building and sky in the final sketch below.

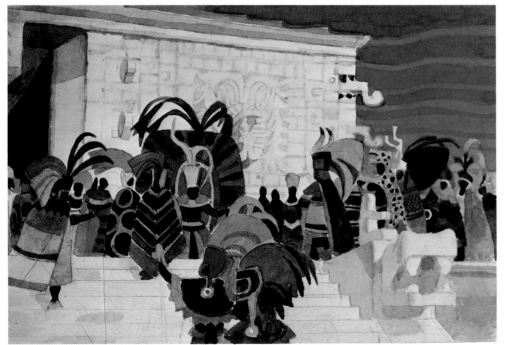

I work out several ideas in a number of sketches like this one. I also place many corrective tracings over specific areas in these sketches to decide if potential revisions are of value. After a great deal of thought, I finally arrived at this sketch. As you will see, I follow it quite closely.

First I enlarge it on a large piece of tracing paper, which I buy in 36″ (14 cm)-wide rolls that are a few yards in length. I scale it to the final size of the drawing, which is 27½″ × 39½″ (58 × 77 cm). After working out all the elements on the tracing paper, drawing and redrawing parts until I am satisfied they will work, I trace the drawing onto a large piece of cold-pressed Arches watercolor paper, the same size as the tracing paper, that has been stretched on a piece of plywood ½″ (13 cm) larger all around.

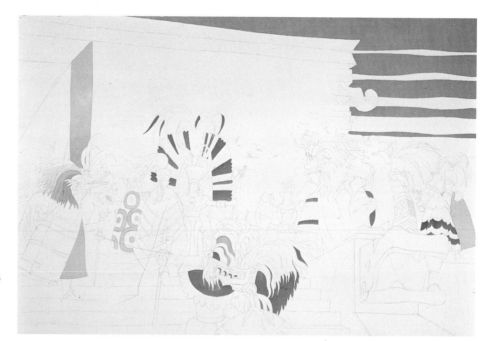

I paint the sky first with a mixture of Winsor blue, Payne's gray, and alizarin crimson, using a no. 16 square sable brush. Then I add a little more Payne's gray to the mixture and paint the darks of the costumes with a no. 5 round sable brush. The warm color in the architecture and the circular decorations on one of the costumes is raw sienna.

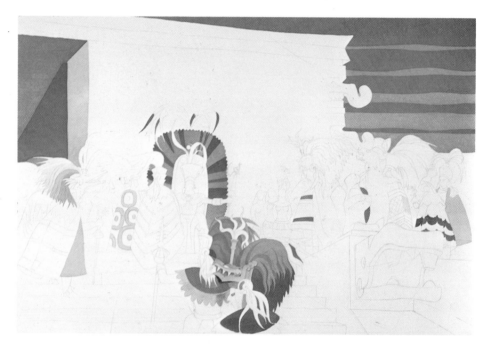

The color I use on the upper left triangular areas is a mixture of Winsor violet, Payne's gray, and raw sienna. I add more water to the lighter triangle. I paint the horseshoe feather headdress with the same combination of colors, adding more Payne's gray for the darker passages, and adding Winsor green for the headdress just below it. For the one below that, I repeat the original mixture. The light values are raw sienna with a touch of Winsor violet. The gold color is raw sienna used full strength for the dark areas and diluted for the lighter ones.

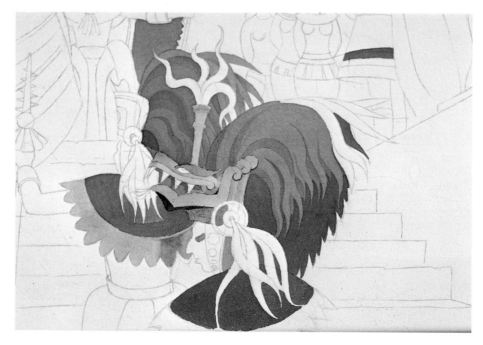

Here you can see the edge definition within the main colors. This is also an excellent example of the amount of drawing I do for a major painting. I usually keep the shadow areas pretty simple, as I have here, since there is practically no definition in shadow. I add a little alizarin crimson to the prevailing color mixture to define the feathers on the lighter side of both headdresses. I use a no. 4 and no. 5 round sable for these passages.

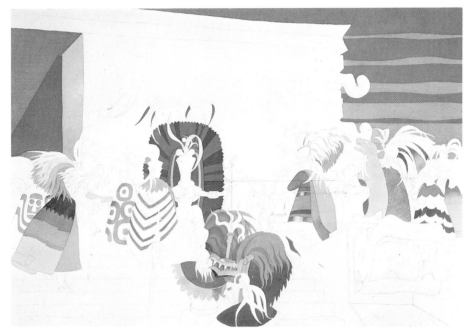

The figure on the far left is painted with varying intensities of raw umber. The patterns on the figure next to the high priest are mixtures of raw sienna and raw umber. I use Winsor violet and cadmium orange for the suit on the figure just to the right of center, and then dilute the color and add alizarin crimson for the tunic on his back. With a stronger mixture (that is, with less water), I paint the shadow of the feathers. The leopard is painted a greatly diluted raw sienna, and the figure to the right of it is burnt umber. On the next two figures to the right, I use Payne's gray for the dark blue and add burnt umber for the collar.

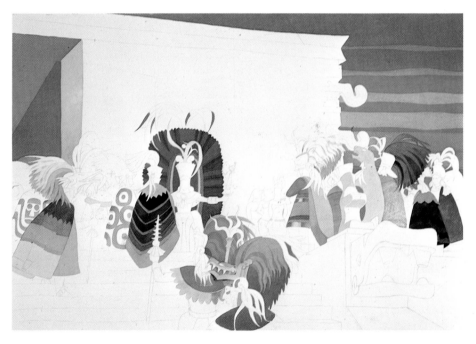

The main thing I do here is add alizarin crimson to the sky with a no. 18 bright sable brush. The darks of the figure to the left of the high priest are burnt umber with Payne's gray. I use raw sienna for the golds, and raw umber when necessary to darken them. The dark figure on the extreme right is a mixture of burnt umber and Payne's gray. The feathers on the headdress just to the left of that are a middle value of Winsor violet and cadmium orange, with Payne's gray added to darken it. Again I worked with nos. 4 and 5 round sable brushes.

From here on, it's going to get a little complicated, so I will give names to some of the important color mixtures. The flesh mixture is generally made up of Winsor violet and cadmium orange. It's a very strong color that can be used light or dark. You can also glaze another color over it and change the color considerably, as I did the flesh of the virgins to the right of the high priest. You can see the high priest clearly here. I lay a wash of Winsor blue and alizarin crimson over his feathers. His flesh is the full-strength flesh mixture. His shoulder collar is Winsor blue and raw sienna greatly diluted, and the serrated collar of the figure to the left is raw sienna and cadmium orange. I gray many colors by adding their complement. For example, to gray something red I add green or vice versa; to gray violet I add orange. An even combination of alizarin crimson and Winsor green makes a terrific black, and when diluted, a rich, silvery gray.

I put a light bluish-gray wash of Payne's gray and Winsor blue over the sky. In painting the building and stairs, the most important thing to keep in mind is that they are to be a symphony in white. So any colors I use must be extremely light. The inside of the giant serpent's mouth is a pale blue (Payne's gray), and the side of its head is Payne's gray even more diluted. The side of the structure that goes into the stairs is also a very light value of Payne's gray with a touch of raw sienna. I rely on darkening the values quickly, just before they hit the light, to give the effect of form moving into the shadows.

The painting of the virgins is almost finished here. I leave a few areas in their ornaments white. Because I'm not sure what color to make the plumage of the figure to the right of the virgins, I build it up very slowly. The upper left part of the entrance to the main hall looks too heavy, so I introduce the serpent's tail that forms the capital of one of the two serpent columns that are part of the entrance.

The headdress of the figure with the concentric circles is being advanced. His golden headgear is light and dark raw sienna. I add alizarin crimson to the stripes of the figure on the right. The tan figure on the far left will have to have some accents, perhaps some darker stripes. His face contains the flesh mixture used full strength.

I do quite a bit of work on the left entrance. Note that I make both narrow vertical sides of the entrance different values. I add the leopard's spots and paint the deep-colored headdress on the figure to the right of the leopard a mixture of Payne's gray, alizarin crimson, and Winsor blue. The figure on the left with the tan headdress holds his staff at the same angle as the central figure—I will have to correct that. I draw several alternative positions for the staffs on tracing paper and place them over the area when dry, then select the best solution.

I remove the dark staff on the right by using my "scrub brush." I wet the length of the staff, scrub lightly, count to ten, then blot up the paint. If more must still be removed, I will use an ink eraser when it's dry—and that will definitely remove it.

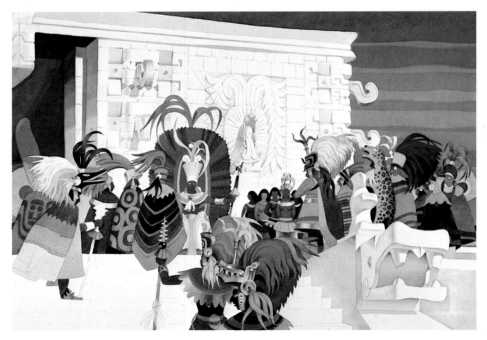

Changing the angle of the staff was no problem, and the new angle is much better. The decorations on the front of the building are well advanced. Since the building is to be a symphony in white, I must see how light I can keep the values and still get a three-dimensional effect. The solution is to get form through color. For example, say I want to paint a white cube. The cube can cast a shadow on a horizontal plane, and the shadow can be blue. The vertical left side of the cube can get an orange-yellow reflected light, and the vertical front of the cube can be violet, and its right side green. The top plane of the cube (which has no shadow and gets lit from above) can be the white of the paper. This may sound complicated, but if you study this step, you'll see that it works. Remember—the colors must be a white that looks like a light color.

Here you can see the variety of color in the flesh of the sacrificial virgins. The flesh mixture (Winsor violet and cadmium orange) is slightly diluted on the figure on the left. The next virgin has the same mixture with a little more water and a touch of Winsor blue, and the next has the flesh mixture with less water and Payne's gray added. The princess (with the crown and feathers) has orange added to the flesh mixture, while the young girl to her right has the mixture full strength. The strong value and intensity contrasts here make her collar gleam like gold.

This mask is giving me a hard time. I've already changed it several times on the tracing. The face of the warrior is the flesh mixture full strength. His plumage is a combination of Winsor blue and raw umber.

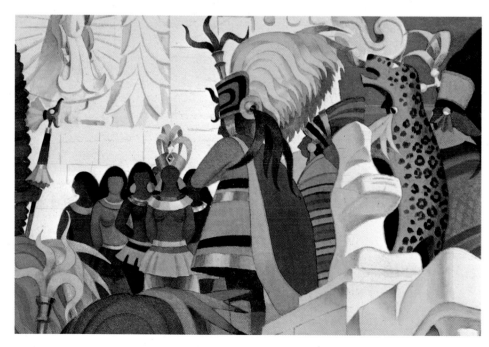

As you can see, I succeed in creating a symphony in white. The castle in the background stays far back and suggests a three-dimensional quality. If you examine the white sculpture, part of the serpent's head, and the stairwell, you will see the different colors of white I used. The yellowish look is raw sienna, greatly diluted. Virtually all the detail has been done with small round-pointed sables, nos. 2, 4, 5 and 6.

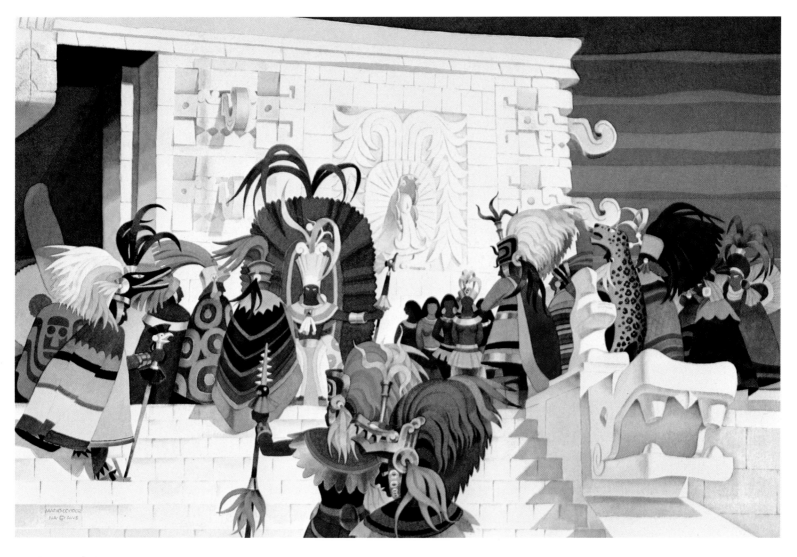

I work on the entrance to the main hall of the castle on the left and darken the inside of the castle. I add more stripes to the tan figure on the left and make the shadows on the steps a light mixture of Payne's gray and burnt umber. I do my usual "policing": darkening areas, adding color to others, other times lightening areas where they appeared too dark by erasing or wetting and blotting, trying for a finer polish without "picking" at the work.

KIYOMIZU TEMPLE

Kyoto, the ancient capital of Japan, is rich in history and legends. It is also famous for its shrines and gardens of unsurpassed beauty. The Kyoto of today is a bustling, noisy city. Southeast of the city, in the foothills of the Higashiyama Mountains, is the Kiyomizu Temple. Two streets lead up to the crest of the hill and there, away from the city noise, you can relax and think and hear your heart beat.

I want to get this serenity in my painting, so I use the stairs as simple horizontal bands, like counterpoint, in contrast to the vertical figures and the ovals of the parasols. I also keep the foliage shapes simple, decorative, and geometrical.

The sky is the "Sargasso Sea" of landscapes and seascapes. Just as the masses of floating plants in the Sargasso Sea often get caught in the motors of ships, so an amazing number of paintings have foundered on the rendering of the sky, with its clouds and delicate nuances of color. Since the sky is often the major part of a painting, it must therefore make an important contribution. There's nothing worse than a bleached-out sky that looks as if it died of malnutrition.

I make my skies interesting through their colors and by introducing abstract patterns. Here I dramatize the sky by turning it into a geometric shape that resembles the letter *W*.

This is one of the photographs I took of the Kiyomizu Temple. Again, the difference between a photograph and the painting speaks for itself.

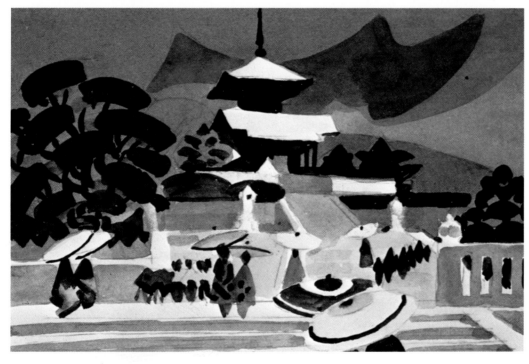

I worked from this 4″ × 5½″ (10 × 14 cm) sketch. As you can see, the most important decisions—the values, shapes, and basic composition—have already been worked out. Only the details remain.

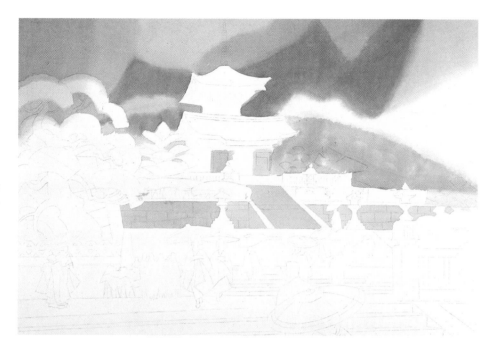

I work on a 21½″ × 29″ (55 × 74 cm) sheet of stretched, cold-pressed, watercolor paper. I work on the sky first, masking out the roof of the temple and the parts of the tree that cross into the sky first. Then I mix the sky color—Payne's gray, Winsor blue, raw umber, and a dash of alizarin crimson—in my plastic ice-cube container and test it on a scrap piece of watercolor paper until I'm satisfied with the color. Then in two other ice-cube containers, I mix a darker version for the letter W and the distant hill. With a no. 20 bright brush, I wet the sky just enough so the paint doesn't leave hard edges when I apply it. Then I remove the masking tape.

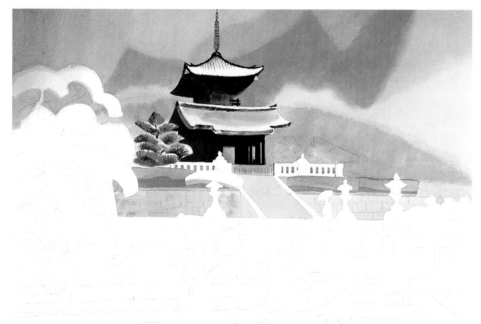

I add the darks under the roof—a mixture of Payne's gray, alizarin crimson, and Winsor blue—with a no. 5 round sable brush. The lanterns aren't masked because I can paint the surrounding areas one section at a time, and don't have to work over them. The pine tree to the left of the temple is Payne's gray, Winsor blue, and raw sienna, painted on a slightly wet surface with a no. 20 square brush. When it dries, I rewet it and add the foliage texture with dark strokes of Payne's gray and alizarin crimson, using the edge of the brush like a chisel.

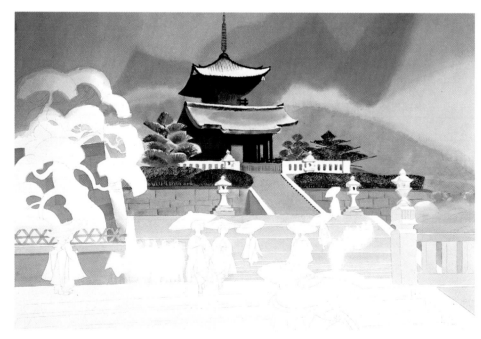

I cut out masks of the shapes of the clusters of leaves and the bushes, and with a piece of ordinary sponge (the kind sold in grocery stores), I pick up the mixture of Payne's gray, Winsor blue, and raw umber on my palette and apply it to the painting using the paper mask and a patting technique. The pine tree on the right of the temple is done the same way.

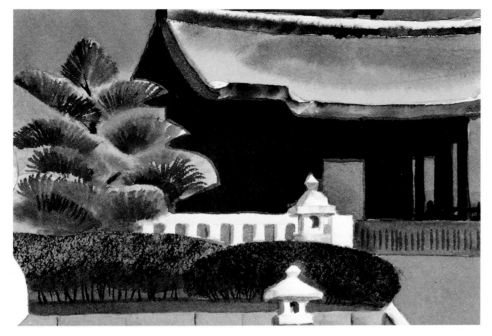

The trunks I add to the bushes give them credence and design. The shadows on the stone lanterns I regard as a symphony of color. They're yellowish (raw sienna), bluish (Payne's gray), or purplish (Winsor violet), but as long as they're light, I can make them any color I want. My brush size varies from nos. 2 to 6 round-pointed sables.

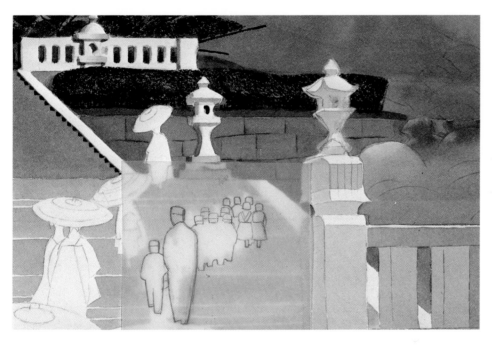

As the painting develops, the lantern on top of the post starts to annoy me. It just doesn't seem right. After much consideration, I decide to remove it. No doubt you have heard people say that watercolor is difficult to correct and that once you put paint down you can't remove it. Well, I'm here to tell you that is a gross, uninformed exaggeration! I remove it with patience and care by wetting the area, counting to ten, and then blotting it with a facial tissue, removing as much paint as possible. If necessary, I repeat the procedure. The important thing is not to scrub—this destroys the surface of the paper and removes the sizing. (The result would be an area as absorbent as a blotter!) In this case, the object is light and the background dark, so it is easily removed. (Note also the tracing-paper drawing of the schoolchildren in position for tracing.)

This is the restored area where the lantern was. The grass above the stone wall was also restored. Most of the correcting was done with a no. 2 pointed sable brush. You have to look very carefully to detect the corrections. At the lower left are the stairs and heads of the schoolchildren.

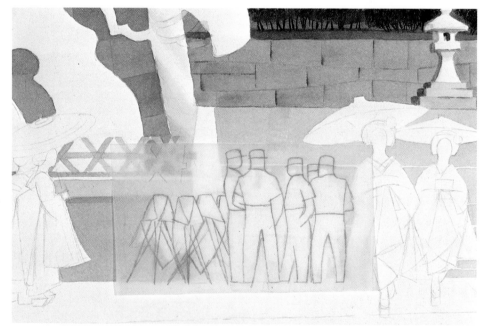

Here I restore the background; virtually all former traces of it have disappeared. When I fill in the area, I carefully match the value of the surrounding area (this is even more important than the color). I paint the schoolchildren going up the stairs and the lady with the parasol (*kasa*) on the tope of the stairs. Her kimono is a mixture of raw sienna and lamp black and her *obi* (sash) is Payne's gray and Winsor blue. The kimono on the lower left is burnt umber and alizarin crimson and her bow is the same, with a lot of water added to it.

The drawing of the young photographers is in place, ready to be traced; the ones I had first drawn were too small. I also define the stones on the wall, strengthening the lines and giving them a more tactile character. I add hard and soft edges with the edge of a no. 20 sable brush, using it like a chisel on dry paper. The color is a dark mixture of Payne's gray and alizarin crimson. I also paint the initial wash on the left-hand wall behind the tree with burnt umber, Winsor blue, and a little alizarin crimson, this time with a no. 18 sable brush.

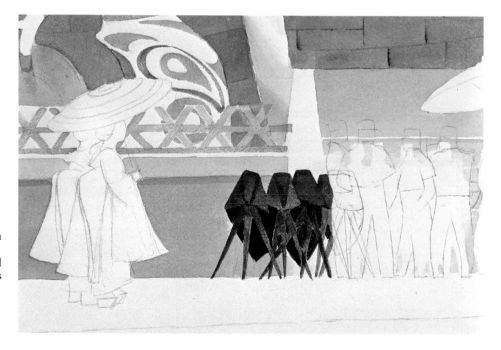

I have traced the figures of the photographers and cameras onto the paper, and compared to the light pencil lines I had initially drawn, you can see how much larger they are now. I paint the red cloth coverings of the cameras cadmium red deep with a touch of Payne's gray, adding a lot more Payne's gray to the shadow areas, working with nos. 6 and 7 pointed sable brushes. I make triangular patterns out of the areas. You can also see the initial serpentine patterns on the tree trunk; it will probably receive a number of additional over-washes.

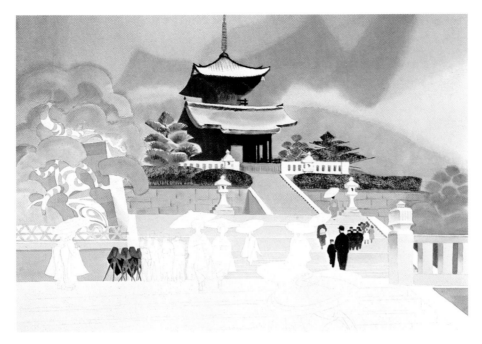

I paint the initial underpainting of the tree foliage on slightly wet paper to keep the edges soft. I work in circular strokes using a no. 18 square sable brush and a mixture of Winsor blue, Payne's gray, and raw umber. I follow the same procedure for the rest of the trees and bushes.

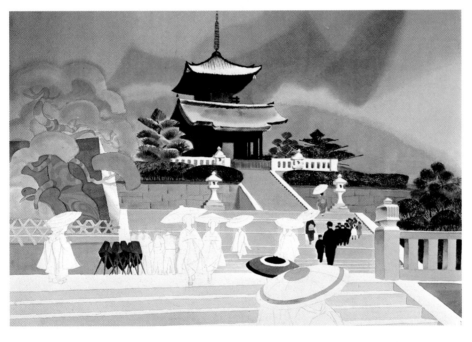

From left to right, I strengthen the wall behind the tree with a mixture of raw umber, Payne's gray, and alizarin crimson. The crimson keeps the mixture from turning green. Adding a touch of Payne's gray thinned with water to the mixture, I wash it over the trunk of the big tree on the left with a no. 18 sable on the dry paper. I paint the parasol (kasa) a mixture of burnt umber and Winsor violet with a touch of alizarin crimson. The dark area in its center is Payne's gray, alizarin crimson, and burnt umber, and so is the edge of the parasol, with more water added to it. The foreground parasol's center is a mixture of Payne's gray and raw sienna, and the larger band near the edge is burnt sienna and Payne's gray. The trees and bushes on the left are done with a sponge applied over a mask. Note the initial value of the steps in the foreground.

At the upper right and center you can see the lunette (window) patterns made by pressing a sponge over a mask. At the lower section, the brushstrokes radiate like linear fans. I call them "dingbats" (the strokes Mary Carroll Nelson referred to in the Foreword), and I make them with a no. 20 sable brush.

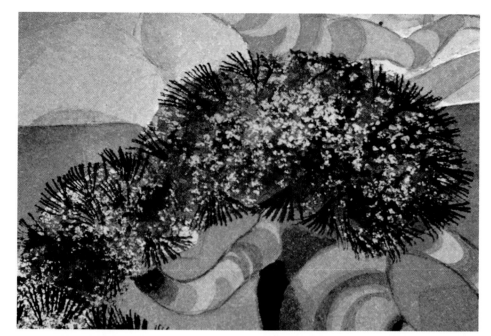

I leave the foliage mixture—Payne's gray, Winsor blue, and raw sienna—loosely mixed intentionally for a broken-color effect, or that of color by juxtaposition. My radiating "dingbat" strokes are also clearly visible here. The boa constrictor pattern on the tree reminds me of Korin's type of pattern, which is sort of serpentine. (Korin was born in Kyoto in 1658 and is probably best known for his painted screens of irises.)

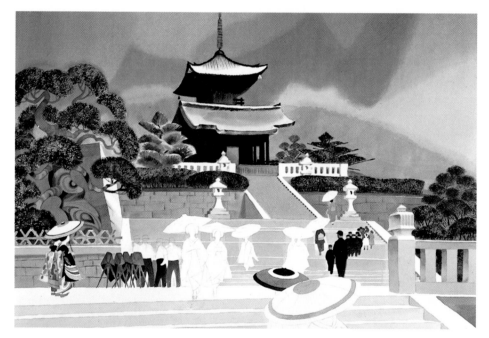

After studying a number of fabric designs for Japanese kimonos, I make up my own. The two young ladies on the left are student geishas, and are called *maiko*. Their dress is much more ornate than that of the geishas, which is more elegant and selective. To give a feeling of a gold pattern to the *maiko* dress on the left, I tint the trailing bow with raw sienna with a touch of lamp black added, and mix darker golds with raw umber and lamp black. In other passages I use burnt umber. The red is cadmium red deep with a little lamp black. The black part is made of Payne's gray, Winsor blue, and alizarin crimson. I paint the kimonos on dry paper with nos. 2 and 4 round-pointed sables, though you can use white sable brushes too. They perform well and are inexpensive.

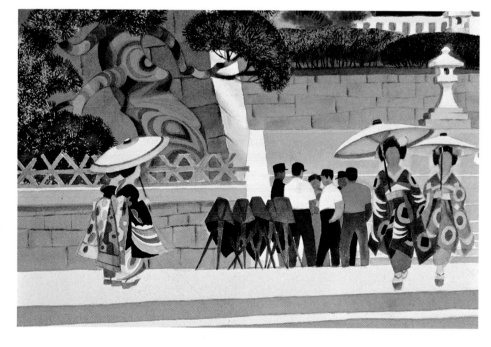

Since the color scheme is basically gray, I try to add as much color as possible to areas such as the undersides of the parasols. I keep the flesh color in the figures a warm gray by adding a touch of cadmium orange to the gray (alizarin crimson and Winsor green). The parasol on the right is raw sienna and the one next to it alizarin crimson with a touch of Payne's gray. Note the addition of smaller branches to the clusters of leaves. The temptation to put features on the faces is great, but it would destroy the simplicity of the work as a whole. The important thing is to make the figures look alive—to add enough detail to make them recognizable while abstract, without turning them into diagrams.

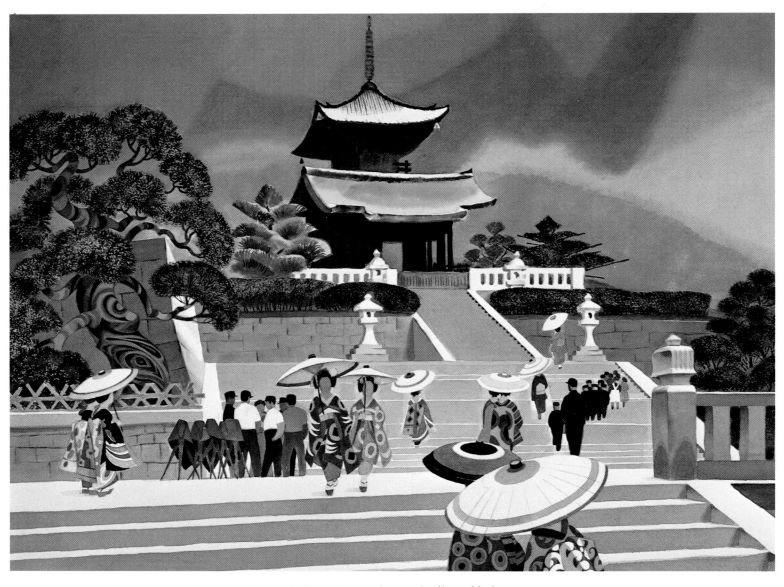

The costumes of the two central young ladies are Indian yellow with a touch of lamp black for the gold color, and raw sienna and lamp black for the darker passages. (Don't combine Payne's gray and Indian yellow unless you want green.) The figure in the foreground fascinates me. I want the costume to have a silver design. For a neutral silver gray that is both delightful and useful, I mix Winsor green and alizarin crimson so neither color predominates.

SALUTE TO THE MET

In 1979 the National Society of Arts and Letters asked the Art Students League of New York to select six instructors to participate in a special exhibition to be held at the Metropolitan Museum of Art that summer as a "salute to the Met." I was one of those chosen.

The main entrance to the museum is on Fifth Avenue at 82nd Street, and the frontal staircase is two blocks long. When people of all ages sit there, it looks like the grandstand of a baseball field with the crowd waiting to hear the "Star-Spangled Banner." I got the idea of painting this scene as my contribution to the exhibition.

Fortunately, since I also teach only a few blocks away at the National Academy School of Fine Arts on 89th Street, in the following weeks I had ample opportunity to make numerous sketches and take many photographs before and after school. Later, going through a number of composition sketches, I finally decided on one. I did a drawing first, then laid out my bond-paper drawing on tracing paper. Some of the figures had to be worked out individually and then added to the large tracing.

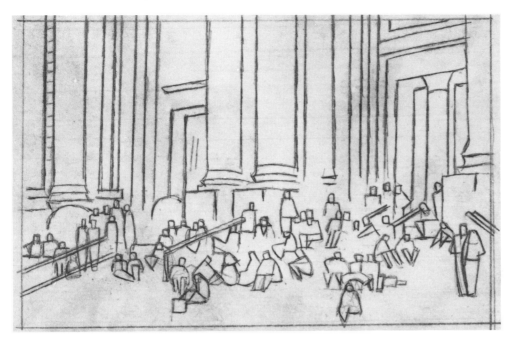

Once I decide on the basic idea of the painting, I make a number of studies. This one describes the underlying abstract design of the painting and the interplay of several opposing forces: the strong verticals of the museum's architecture which forms a backdrop to the oblique railings and the seemingly casual geometric arrangement of the crowd on the steps of the main entrance.

In working out the arrangement of the crowd on the steps, I again turn to a paper collage. Moving squares of different solid colors cut from my collection of magazine advertisements, I arrange them on a horizontal grid (representing the steps) until I arrive at a pleasing group of shapes and colors.

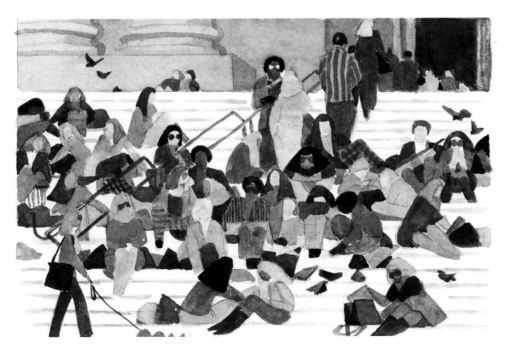

Now I must translate the abstract into the concrete. The trick is to materialize my abstract vision into distinctly individual people and to do so in a way that appears natural, fresh, nonrepetitious, and casual. In deciding how to group them and what specific characters to include (some of them are even students of mine), I work from many quick, candid sketches of groups of people and individual squatters.

75

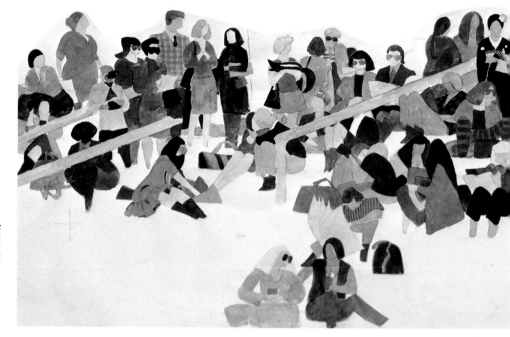

I do a large tracing paper drawing, the exact size of the watercolor sheet. When I am satisfied with it, I retrace it onto a large piece of bond paper and paint it. This is the result. The main colors are in the clothing and flesh of the figures, which float on a silver background (the building). I think of the picture in abstract terms, as a color mosaic with a silver backdrop.

I also do the drawing of the architecture on a separate piece of tracing paper. Then I trace it onto the watercolor paper, which has already been stretched and stapled onto a plywood board ½" (13 mm) larger all around than the 27½" × 39½" (57 × 77 cm) paper. I plan to paint the architectural section first, leaving ample room to fit in the crowd. I have to find stopping points in advance, though, where I can let the paper dry. This is pretty much what Renaissance artists had to do on their frescoes when they established the area of the day's work (called the *giornate*). The boundaries were usually at the edge of a piece of architecture or drapery or in any area that could tolerate a hard line. I darken the values of the entire building, making it a richer tone of gray. I use a no. 18 flat bright sable brush and a mixture of Payne's gray, alizarin crimson, and raw sienna. The difference in color from left to right is quite subtle: it is warmer on the left, where I put a little more alizarin crimson in the mixture.

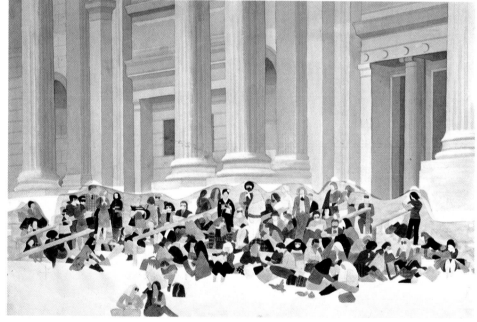

I cut out the painting of the students, which I had done on bond paper, and position it on the watercolor paper for a critical look. I am not too sure I like the third figure standing up on the right, but correcting it can wait. After I trace the figures onto the watercolor paper, I can start painting them.

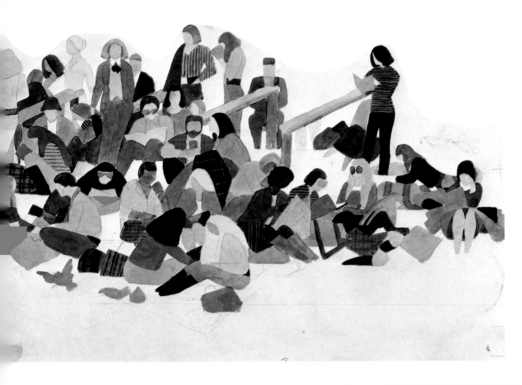

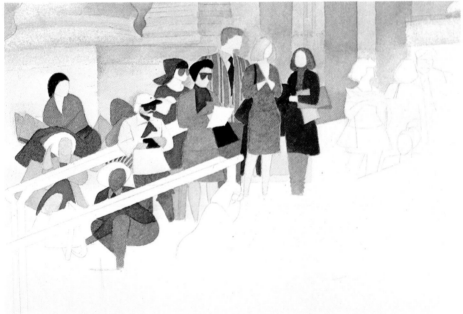

I trace only part of each figure. If I were to trace all of them, the pencil marks would be smudged from the friction of the paper I place under my hand to protect the paper from the oil of my hand. Most of the blacks are made up of a basic Payne's gray, alizarin crimson, and burnt umber. I shall refer to this combination from now on as the "mixture." For instance, the reddish suit worn by the fourth figure from the right on the top left row, the woman holding the paper, was painted with the mixture with more alizarin crimson added. Quite often when I am not too sure what color to use, especially when there is a large number of figures involved, I use a light gray that I can turn into a color by adding pure color to it. At times I will let it remain as it is. This is one of the advantages of working with a palette of gray colors.

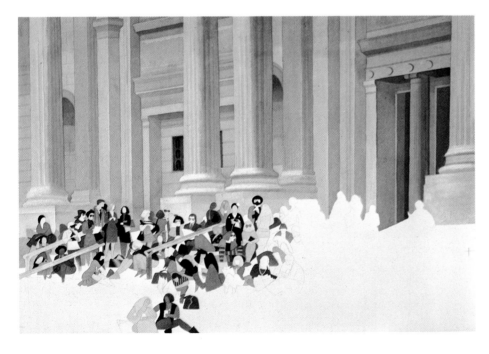

If you take a good look at the painting so far, you will see that the mixture I describe (Payne's gray, alizarin crimson, and burnt umber) is really quite gray. But it is easily modified. If you want to paint something blue, for example, just add a little Winsor blue to it and *voilà*! It's especially effective if you put a complementary color next to it, such as yellow or raw sienna. The hair of the young redhead just below the lady with the kimono is burnt sienna with a touch of the mixture.

As for the flesh, here again I have a rule-of-thumb mixture for it: Winsor violet and cadmium orange, my "flesh mixture." (See also *Tribute to Kukulcan*.) The black man next to the Japanese lady was painted with the flesh mixture used full strength. If I add water to the mixture I get a Latin, and more water, I get a Scandinavian—and *skoal*!

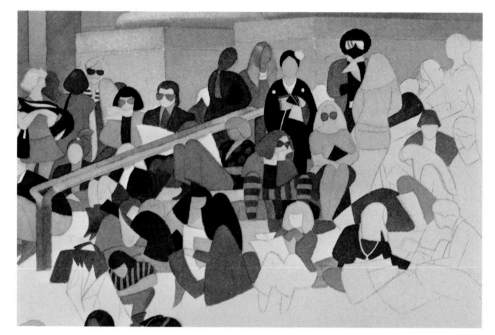

The gold of the kimono is raw sienna and red alizarin crimson. The hair of the young woman to the right of the kimono-clad lady is raw sienna diluted with a touch of the mixture to gray it a little. Her sweater is a greatly diluted alizarin crimson. Black always looks good against this color, as does silver. The blond hair of the woman talking to the black gentleman is raw sienna with a touch of Payne's gray (both colors greatly diluted). Her light turquoise sweater is Winsor blue with a touch of Indian yellow, again greatly diluted.

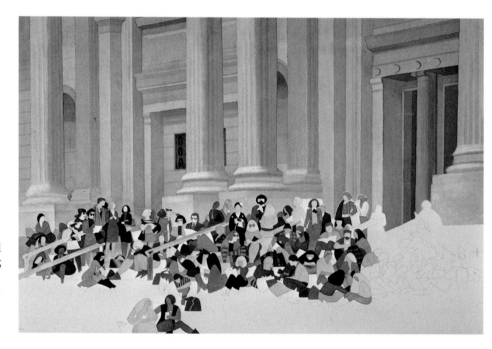

Four figures to the right of the black man is a young woman dressed in a tan suit with a lighter vest. Her suit is raw sienna with Winsor violet, and her vest is a light value of the same color. I'm going to take out the figure to her left because it doesn't look right. Notice the unpainted area behind them. I will have to paint that in soon. I am purposely leaving a lot of white paper showing throughout the crowd until I get more of the figures in.

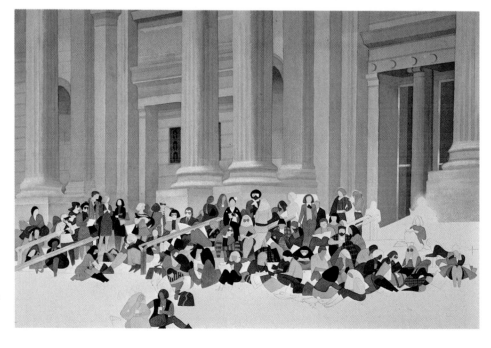

The best way to handle a crowd in a painting is to treat it like a mosaic and just keep adding colors that go together. I lightened the color of the metal door frames. They will eventually be painted bronze (burnt sienna). The two figures on the left that are moving out the picture need to be connected with the rest of the crowd. I may have to add another figure to do it, but I'll leave that for now.

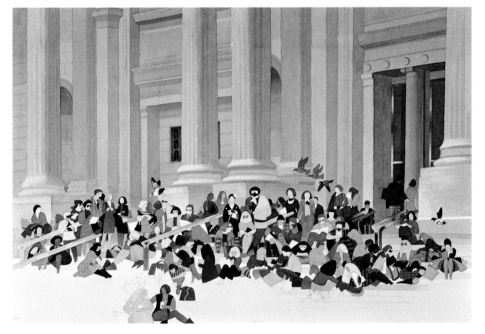

The steps look almost finished, but I have to paint the bronze railings. I'm also having a bit of trouble deciding where to place the birds. To solve the problem, I paint them on a separate piece of paper, cut them out, and place them where they look best, tipping them onto the painting with a little transparent tape. (The tape caught the light of the photolamps as I took this picture. You can see it gleaming above the two girls to the right of the one with the open book.)

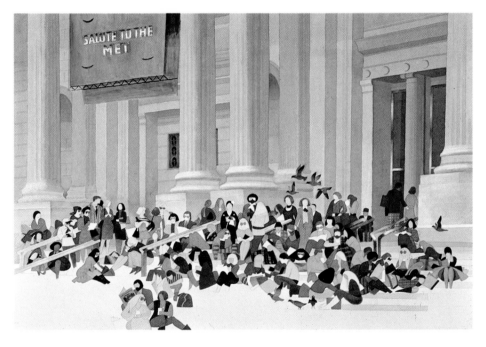

Something bothers me about the building, and I finally figure out what it is. It needs a banner. So I paint one on a piece of paper and "try it on" (stapling it very close to the edge). It looks fine. Now I must remove that section of the building so I can paint the banner there.

I use my "scrub brush"—a no. 3 bristle brush that has been trimmed almost to the ferrule—to take out the area the banner will occupy. First I wet the area, then scrub gently, trying not to break through the surface of the paper, and blot the loosened paint with a facial tissue. Actually, I don't have much to take off because the gray-green banner will cover most of it. I only have to remove the areas where the lettering and golden border will appear.

By now I have applied most of the gray turquoise color there, a mixture of Winsor blue, Indian yellow, and a touch of Payne's gray. You can still see the "ghosts" of the architecture, but I will disguise this easily by carefully painting the lettering over it and also by using the banner color. I always mix extra color for emergencies like this.

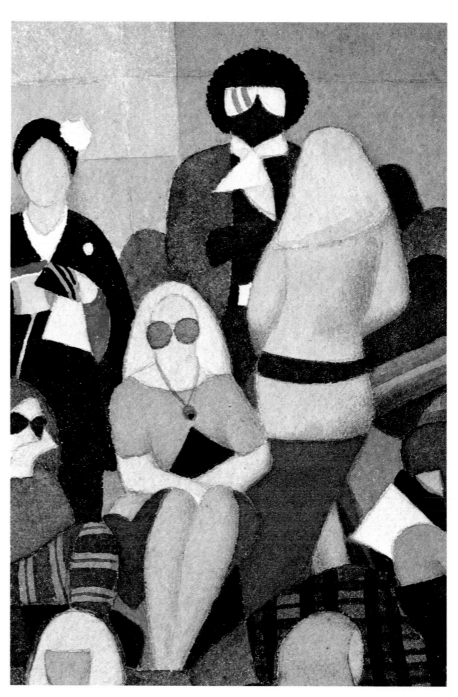

This detail of the finished painting shows my restrained modeling of the figures. This is the "dessert" of the painting, when I put in the finishing touches. I can correct values by darkening or lightening them, adding more color in some instances, and I can add tactility by sharpening or softening edges, generally giving the work finesse. At the start of this painting, I thought I was launching into a nightmare, doing 60 or 70 figures, but it turned out to be a challenging problem in design.

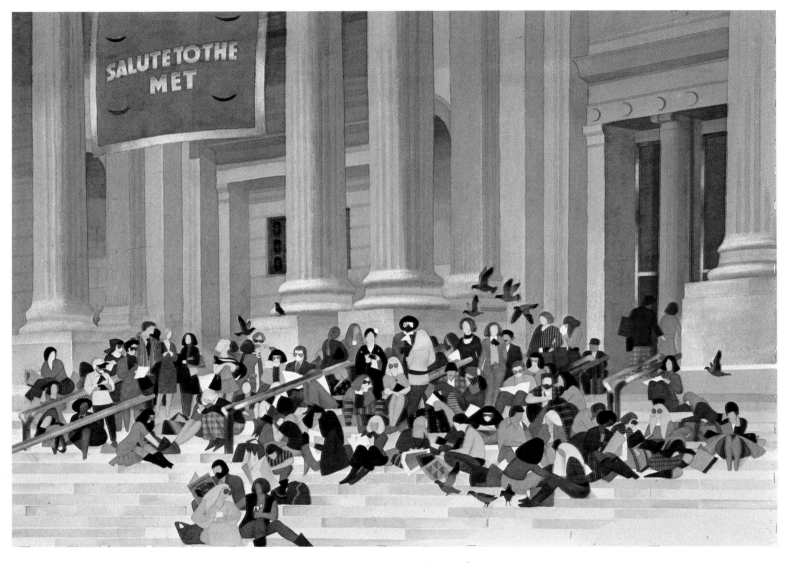

The problems at this point have all been solved. The birds are all in place, the two figures on the left edge are now linked to the group by the addition of another figure. Thoughout this project, I have become familiar with each person. Some are from my imagination (like the young man looking through the want ads in the newspaper), while others are friends and students, and some, members of my family. The lettering is a piece of cake—I was lettering when I was 17! The fun part is getting the bronze textures on the door frame, the railings of the steps, and the edge of the banner.

KOREAN STREETCAR

Many years ago, on a visit to Seoul as a guest artist for the United States Air Force, I had made a painting of a Korean streetcar. For some time now, I have wanted to make another version of it. So one day I took out my slides on Korea and studied them very carefully. It was like taking another trip! As I reviewed them, I tried hard to conjure up the feeling I originally had when I made the first painting, but it didn't work and I almost abandoned the idea. As I kept looking at the slides with pleasure, however, suddenly my enthusiasm was rekindled and I decided to make a full-scale sketch.

I have often thought that a Korean streetcar with the waiting passengers in front of it would make a fine mural. Since I was particularly impressed by the exquisite taste of the Korean women's dress, I tried to get it into the painting.

One problem was to keep most of the values of the dresses very light, like a symphony in white, with tints and pale tones of yellow, blue, red, and green accented by dark tones of the same colors. I also tried to get a linear rhythm in the reflection in the puddle, with accents of lights and darks acting as a counterpoint to the simplicity of the dresses. The umbrellas make their own counterpoint against the squarelike windows by adding their own ovals and circular rhythms, making a much richer design.

SILVER MEDAL OF HONOR, AWS, 1980

One of my early studies is a small tracing paper sketch only a few inches large in which I work out the rhythms and angles of the composition.

When I am satisfied with the composition, I prepare a simplified line drawing $3\frac{1}{4}'' \times 7''$ (8×18 cm) on tracing paper for enlargement to tracing paper the size of the final watercolor.

(*Below*)
The figures of the Korean women are simply and abstractly drawn on tracing paper to their final size and are now ready to be positioned and traced onto the watercolor paper.

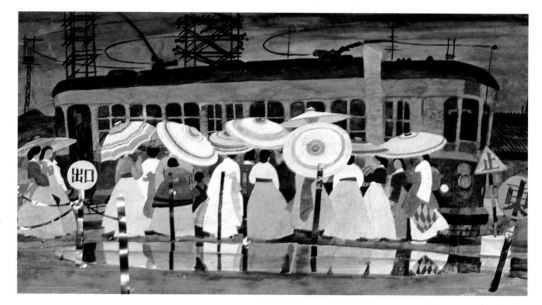

This is the final sketch of the finished painting. The color scheme is simple: a red sky and the light umbrellas and dresses (I am fascinated by the costumes of the Korean women), seen against a gray-green streetcar with a black top. As the sketch progresses, I begin to "feel" the figures and become familiar with them. My enthusiasm is high; the painting has begun.

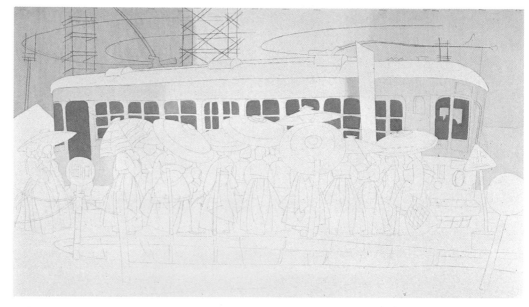

I work on a 29″ × 39″ (74 × 99 cm) sheet of stretched, cold-pressed watercolor paper. This is a good example of the way I usually lay out my skies: cool on the left (diluted Winsor blue), warmer on the right (alizarin crimson greatly diluted), and neutral in the center (in this case, the paper). The streetcar is also laid out the same way, except in reverse: warm on the left side and cool on the right. I paint an initial wash of gray in the windows, composed of Payne's gray with a touch of alizarin crimson and burnt umber. The brushes I use are nos. 20 and 18 square sable brights.

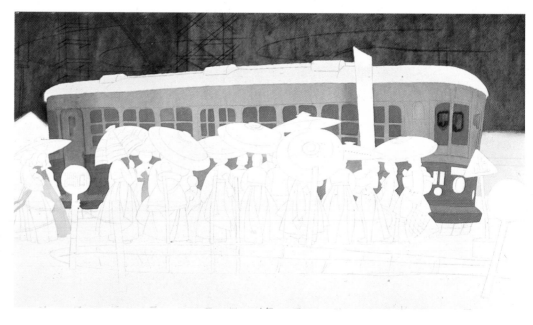

I mix the general color of the sky with alizarin crimson, burnt umber, Payne's gray, and Winsor violet, making quite a bit of it in my plastic ice-cube container. I apply the sky color holding the paper sideways and at a 30-degree angle. The mixture for the streetcar is Payne's gray and raw umber, with Winsor blue added for the dark areas. Again I use nos. 20 and 18 square sable bright brushes.

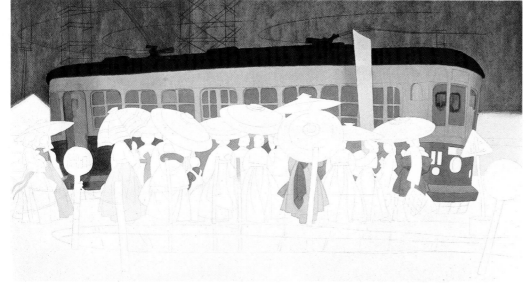

I mix an initial color of dark for the roof of the streetcar—I don't want to get it too dark at this point. The color is Payne's gray with raw umber. The orange gray on the figures is burnt sienna with Winsor red. The color of the figure in the center is Payne's gray with Indian yellow for the sash and greatly diluted for the skirt. The skirt on the figure on the extreme left is Payne's gray and alizarin crimson with a lot of water. The blues are Payne's gray and Winsor blue, highly diluted. The colors are applied with nos. 3 and 5 round-pointed sable brushes.

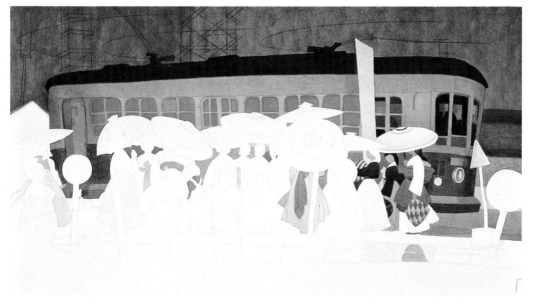

I darken the lower part of the streetcar with Payne's gray and raw umber. For the figure just to the left of the one with the child, I use Winsor blue and raw umber for her blouse and the same color highly diluted for the skirt. The jacket of the figure to her left is Winsor blue with alizarin crimson used full strength. I suggest part of the background on the right, past the signs. The color is mostly Payne's gray with raw sienna, slightly diluted. The round-pointed brushes I use are nos. 2, 3, and 4.

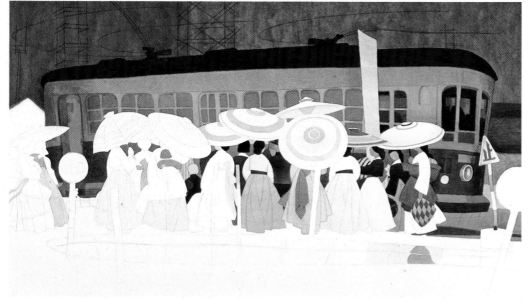

We left the third lady from the right without a skirt: it is raw sienna with a touch of Indian yellow and a whisper of Winsor blue, greatly diluted. The skirt next to that is Payne's gray with a touch of alizarin crimson, again highly diluted. Her sash is Winsor blue with Payne's gray. The reddish gray skirt in the middle is raw sienna and Winsor violet. This picture is interesting in that the colors have to be made very subtle, though they must appear to have great strength. It reminds me of the romantic composer Franz Liszt's "Jeux d'Eau à la Ville d'Este," a piano piece that has great delicacy in the higher values and profound depth in the lower ones.

I will probably leave the clothing of the figure with the very pale gray pink sash as white paper, so I will use her dress as a point of orientation for the other colors. The color value of the bands on the umbrellas is exploratory at this point, so the gray I painted there can be left as is or turned into another color very easily. Any strong color can immediately take over. I don't follow the colors in the sketch too closely because the colors are going to be more precise now and will gain in subtlety as they interact with each other. The figure to the left of the white figure is a woman with a baby. The color of her blanket is Winsor blue, alizarin crimson, and raw umber used fairly thickly, then diluted for her blouse and almost completely diluted for the skirt. The baby's shirt is cadmium orange with a touch of Winsor violet. The reflections are the same colors as the objects reflected, except they're a little darker.

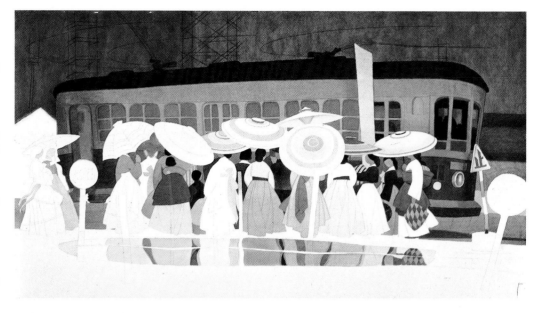

In this step I get busy and paint the foreground with a mixture of Winsor violet, raw sienna, and a touch of Payne's gray. I mix a lot of it up first in my ice-cube container and apply the paint holding the painting sideways and at a 30-degree angle. I add some burnt umber to the mixture and paint the background reflecting into the puddle. The blouse of the figure on the extreme left is Winsor blue, Payne's gray, and alizarin crimson, with a sash of Winsor blue with Payne's gray. Her skirt is the same color as the sash, with a lot of water. The darks behind the figures are mostly a mixture of Payne's gray and burnt umber that can be changed to warm or cold by adding Winsor blue to cool it or alizarin crimson to warm the mixture. Blue and green are cool colors, red and orange are warm ones.

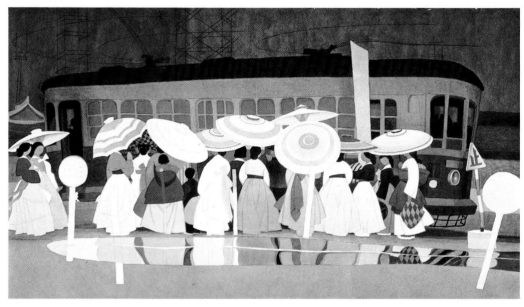

In this step I develop the reflections and further define some of the bands on the umbrellas. The fourth figure from the left is carrying a bundle. I give it a quadricular pattern to change the texture of the area—in other words, to oppose the checkered pattern of the windows of the streetcar. Also, the reflection of the umbrellas on the window-panes helps avoid monotony. I also start to paint the traffic posts, though they'll still need a lot more work. I will have to find some Korean words to put in the signs. The character on the signpost by the front of the streetcar on the right is Japanese; it means "stop."

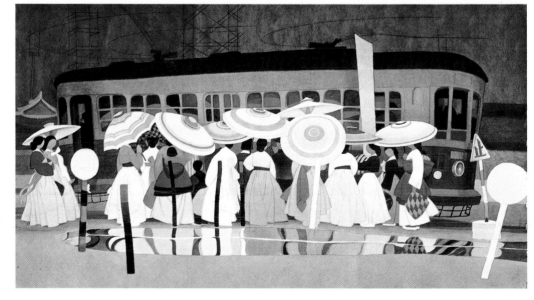

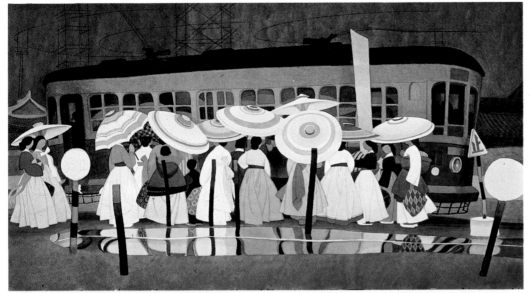

By now I have painted over many of these areas, deepening them by adding more of the same color. I have also placed darks where I feel they would make an area richer. I have had to darken the near side of the puddle because areas closer to the viewer generally appear darker. Most of the hair is a dark mixture of Payne's gray, alizarin crimson, and burnt umber. Again, I can shift this mixture to the warm or cool side by adding more crimson or more blue. The idea is to make the hair harmonious with its surroundings. The Korean words are courtesy of a friend at Columbia University, so I can use them safely.

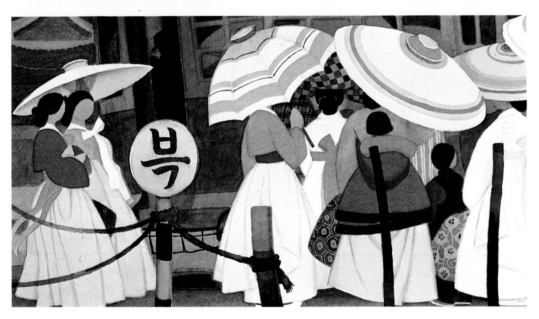

This detail shows the treatment of the edges. Edges can be razor-sharp, dull, or feather-soft. They can suggest crushed rock, sand, or powder. An edge is a means of expression, and like anything that's worthwhile in life, it has to be tactile.

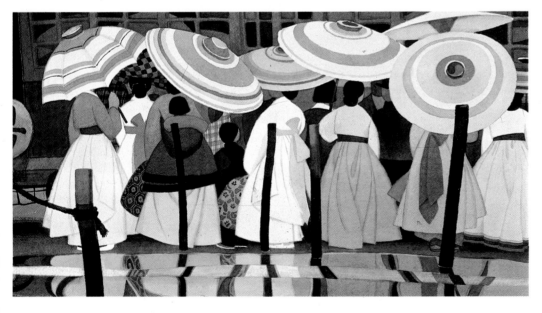

In this detail you can see the way I rendered the subtle tones of the dresses and contrasted their solid masses with the small patches of the geometric-patterned Korean fabrics I found so fascinating.

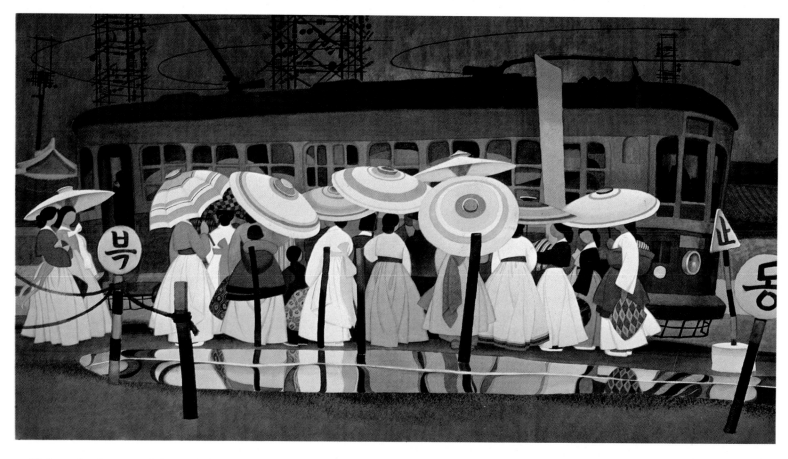

I lighten the sky around the roof of the streetcar. Then I paint the electric-cable-bearing towers with the edge of a no. 20 flat bright brush and the oval wires with a no. 5 round-pointed brush. I work on the lines and edges of the figures, darkening some and strengthening others, softening a few in order to keep them from looking like cutouts. The sign on the left says "north" in Korean, and the sign on the extreme right says "east." The shading on the foreground next to the puddle is done with a sponge.

PONT ALEXANDRE III

I have always thought of Paris as a woman, bedecked with jewels. One of them is the Pont Alexandre III, which spans the river Seine like a necklace of lamps, with their cut-glass global chimneys aglitter, with two giant candelabras at each end. At night when they are lit, they turn the bridge into a dazzling flame.

Crossing Pont Alexandre to the Left Bank one rainy afternoon, I came face to face with the great building of Des Invalides with the big dome of Napoleon's tomb silhouetted against the sky. This building made an excellent backdrop for the glitter that rain puts on everything. Rain acts like a varnish to bring out the rich colors of objects. This is what intrigued me about the scene. In the painting I try to bring out the sparkle of the puddles by using clashes of light against dark supported by touches of grays.

This painting was originally done as a demonstration. The composition was simple: the distant building (Hotel des Invalides, founded by King Louis XIV as a home for disabled soldiers), the column with the gilded sculpture of Pegasus, and the bridge were easily made into a gray pattern. The lamp posts (*electroliers*) on the left, the ornate ones on the right railing of the bridge, and the people were considered as accents. In short, I saw it as a gray pattern, with dark and colored accents, against a light sky.

SILVER MEDAL, AUDUBON ARTISTS, 1979

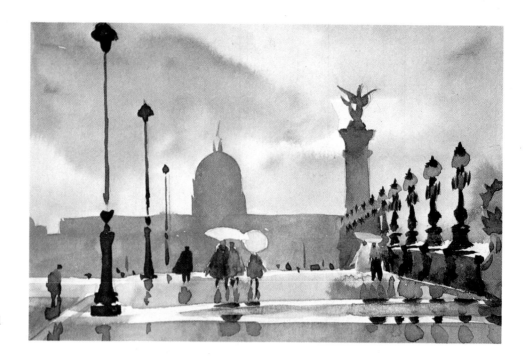

I work out my ideas in a number of sketches and studies until I arrive at this color sketch.

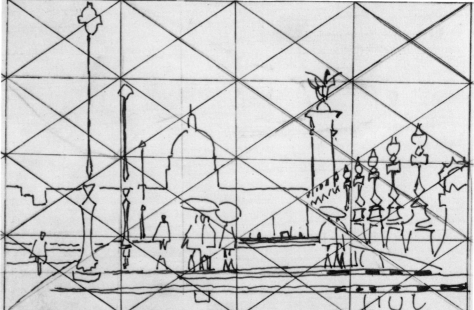

In advance of the demonstration, I briefly indicate the composition in this quick ink sketch on tracing paper and pencil a grid over it for enlargement to the watercolor paper. The sketch is 3¾″ × 5½″ (10 × 14 cm) large, and the watercolor paper I will be using is a 200-lb sheet of imperial-size Arches paper, 22″ × 30″ (56 × 76 cm). I then staple the paper to a three-ply board, ¼″ (6 mm) thick, and wet it with a 1″ (2.5 cm) nylon housepainter's brush. The paper buckles, but I pay no attention to it. When it is free of puddles, I paint the sky with the same brush. The rest of the painting is done with two no. 20 bright sable brushes. (Demonstrations are long on showmanship and short on art!)

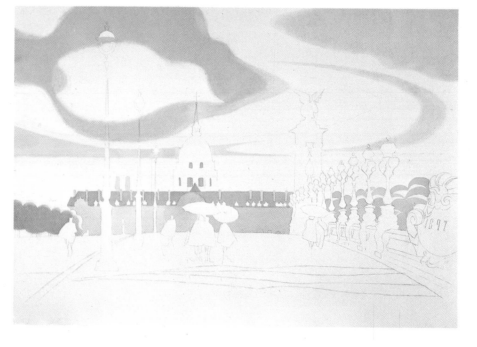

Since the preliminary drawing will get a number of overwashes that will practically wipe off the pencil marks, I carefully lay in some colors to identify certain areas. I use Payne's gray and alizarin crimson greatly diluted with water for the cloud on the upper left, and almost the same color except with less Payne's gray and more water for the triangular area on the upper right. For the color of the building, I use diluted alizarin crimson, and for the roof, Payne's gray with a touch of diluted alizarin crimson. The green on the far left is Payne's gray and raw umber. The crescent in the sky is Payne's gray with just a touch of alizarin. The foliage between the *electroliers* (street lamps) on the right is the same mixture applied with a no. 5 round-pointed sable. Notice the clear Winsor blue on the left.

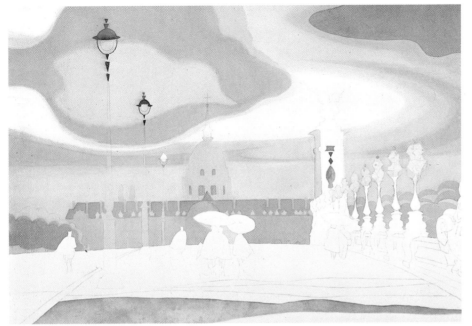

Avoiding the center area, which looks like a free-form bird, I give the clouds on the upper left and right a wash of alizarin crimson, Payne's gray, and cadmium orange. I also wash the same mixture over most of the sky and buildings. Then I block out the electroliers on the right with masking tape. There is no need to block out the umbrellas against the building because the washes can be applied to the building in sections.

This detail shows how I mask the lamps. I will use the white of the paper to create the effect of glittering glass. The darks will be added to them much later.

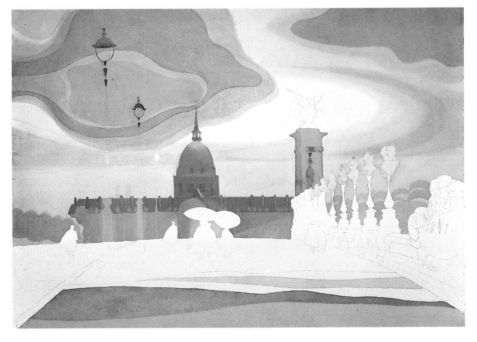

My overwashes on the clouds and the building are much too dark. I will have to erase the areas. I will try the soft kneaded erasers first, and if they won't do it, I'll use ink erasers, which are more abrasive.

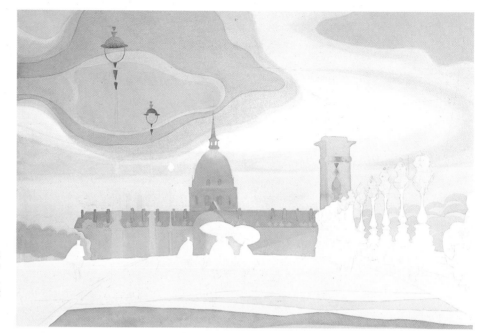

I am able to lighten the clouds and building with ink erasers. Lightening values with erasers can be a very good technique. For one thing, it's a great way to make textures and also a way to make highlights. Many times I have been able to solve a problem that seemed hopeless by the use of sponges and erasers.

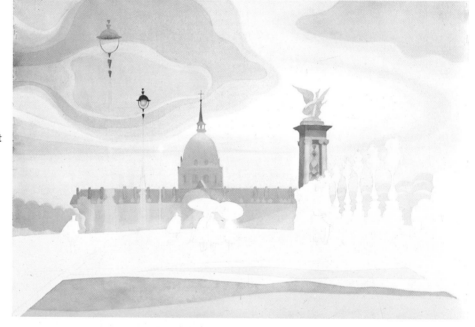

I have restored some of the accents on the electroliers. The sky is a much better value now that I have lightened it. Also I have strengthened the spire on the dome of the Hotel des Invalides. Beneath the dome lies the body of Napoleon, and just a block away is the military school from which Napoleon was graduated. (His final report card carried this notation: "Will go far, if circumstances permit.") I add the initial color to the gilded sculpture on top of the column and darken the underside of the cornice and the side of the column. I use a no. 6 round-pointed sable for most of the small areas. The dark color accents are a mixture of Payne's gray, alizarin crimson, and Winsor blue.

One of the greatest helps in the composition of color is to get color swatches, and as I have said, some of the best places to get them from are the color advertising pages of magazines. In this step I try some color combinations on the two figures at the point of the scissors.

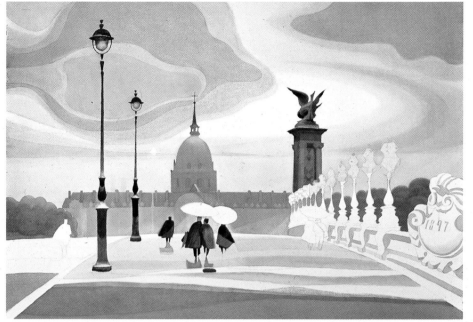

I paint the electroliers with Payne's gray, alizarin crimson, Winsor blue, and a touch of burnt sienna. Alizarin crimson and burnt sienna keep the Payne's gray from looking too blue. The gendarme on the left is painted in the same mixture, with a little burnt umber added. In the couple in the center, the man's coat is a mixture of alizarin crimson, burnt umber, and Payne's gray. The coat of the woman at his right is a light raw umber. I underpaint the foliage behind the electroliers on the right with burnt umber and a touch of Payne's gray. When it dries, I will sponge a greenish mixture lightly over the area (see next step) and let some of the warm color come through. The sculpture at the top of the column is just about finished.

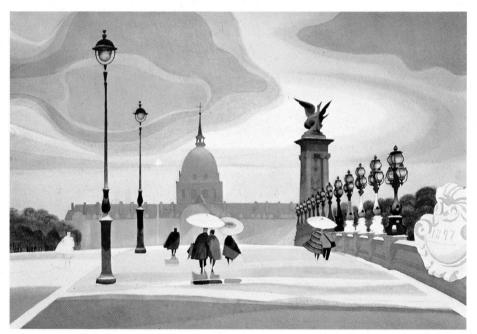

I remove the masking tape from the electroliers and paint the metal lacework around the crystal globes using a combination of Payne's gray, alizarin crimson, and burnt umber. I apply the gray-green mixture (burnt umber and Winsor blue) to the foliage behind the electroliers, using a mask to protect the escutcheon from the sponge. The distant trees on the left are also "painted" with a sponge. After a number of tries, I decide to paint a striped pattern on the figure on the right.

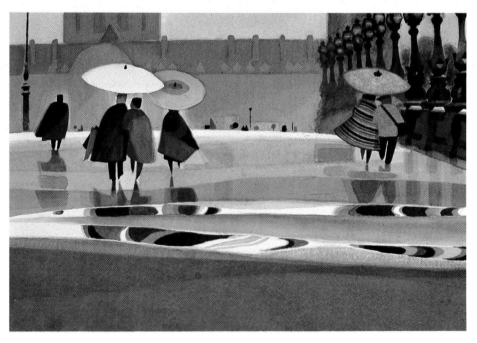

Here you can see my control of the design of the different elements that go to make the entire composition. Each element has to be considered as having its own composition, much as an instrument playing in a symphony orchestra is also capable of being played alone. The two foreground bands of reflection are very interesting to do. Naturally, the white paper forms a very important part of the entire effect, since the extremes of black and white must clash like cymbals to get the effect of metallic or liquid glitter.

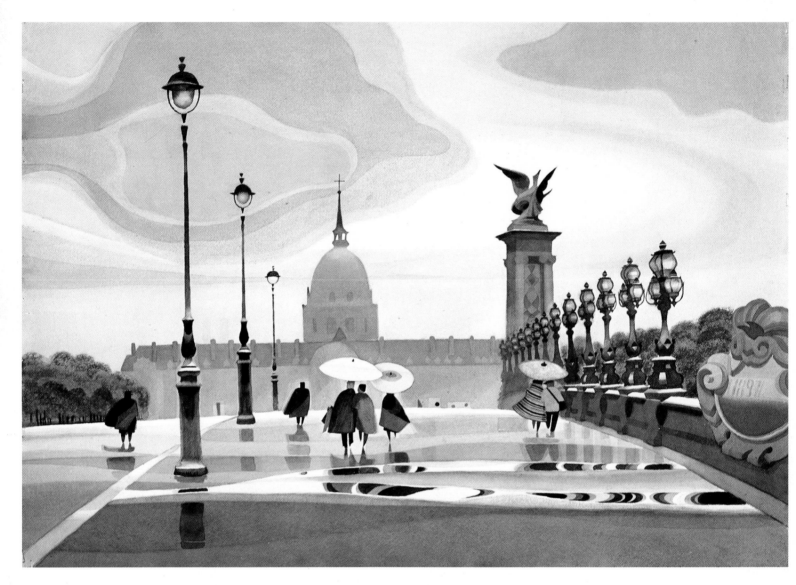

I put accents on the chimneys of the building. The gendarme on the left is a mixture of Payne's gray, alizarin crimson, and burnt umber. The foreground below the lower reflection band is a mixture of raw and burnt umber with Payne's gray and a touch of alizarin crimson. The accents at the end of the bridge are bits of Winsor red with a little Payne's gray added, and the darks are Payne's gray, alizarin crimson, and Winsor blue. When a painting reaches this stage, I start to "police" it—making a soft edge here, adding a little more color there, and so forth. In other words, I start polishing the painting and putting my taste to work.

ONE-MAN SHOW

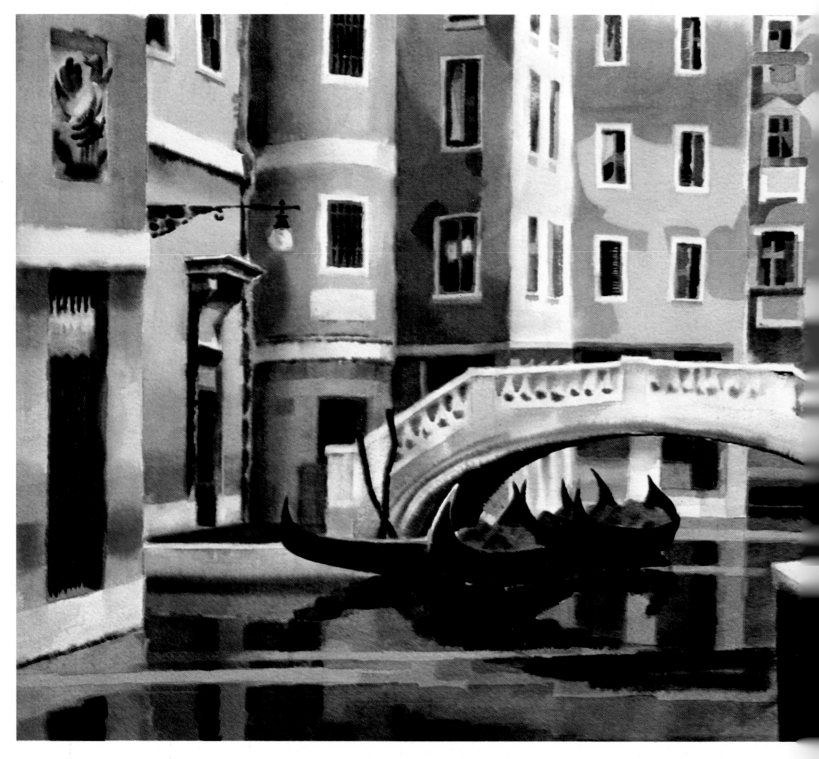

LA FENICE (The Phoenix)

Watercolor, 1967, 22" × 30" (56 × 76 cm). Second version, private collection. (First version won the Samuel Finely Breese Morse Gold Medal.)

This is the rear of La Fenice in Venice, a fantastic theatre that was also an opera house in the 17th and 18th centuries. A great competition existed between Paris, Vienna, and Venice in those days, each city trying to outdo the others in festivals, operas, and masked balls. But La Fenice outshone them all. The richness of its interior and the taper-lit chandeliers were fabulous. Some of the great Carlo Boldoni's comedies and plays were presented here. It was built in 1792, and it burned in 1836; but like its name (The Phoenix), it rose from the ashes and was rebuilt immediately. It's a ten-minute walk to La Fenice from the Piazza di San Marco, and it lies in a network of delightful vistas that make an artist start talking to himself!

I chose a silver-and-blue color scheme with accents of black. I tried to get as many free-form abstractions as I could. The walls of fallen plaster and the reflections all afforded an opportunity for abstract design and form.

96

MARIO
COOPER
N.A.

Rio, Venice

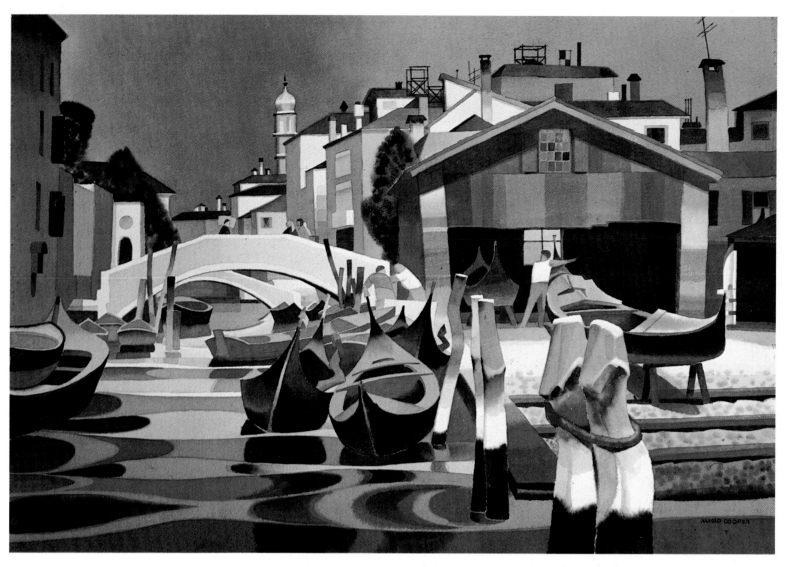

SAN TROVASO
Watercolor, 1974, 22" × 30" (56 × 76 cm). Gold Medal of Honor, Audubon Artists. Exhibited in the Palacio de Bellas Artes, Mexico City, 1979. Collection Museo de la Acuarela, Mexico City.

There are three or four boatyards in Venice that make gondolas, and the craftsmen there do not use plans but pass on the knowledge from father to son. One of the most colorful of these shops is on the Rio San Trovaso, near the Church of San Trovaso. The church is interesting, as it was on the borderline of two feuding families, the Castellani and the Nicolotti. It has a door on each of its sides, one facing the Nicolotti and the other the Castellani. If there were ever a wedding between the factions, the bride and groom would have left by the front door and the families could stomp out in opposite directions!

Right
GONDOLAS AT REST
Watercolor, 1978, 22" × 30" (56 × 76 cm). The Knickerbocker Artists Award, 1979. Ralph Fabri Medal, Audubon Artists, 1978. Collection Dale Meyers.

A picture of Venice without gondolas is unthinkable, but they are always painted in the same position. So this time I decided to paint a pair of gondolas resting free of tourists from a pigeon's-eye view (actually, a view from a bridge). I composed the two gondolas against a background of the free forms offered by the reflections. The reflection in the water near the gondola on the right suggests the figure of a woman (perhaps the ghost of a rendezvousing Duchess?).

The color of the gondolas is a mixture of Payne's gray, alizarin crimson, and Winsor blue—this mixture always gives a dark that is blacker than black paint. The cushions are ultramarine and Winsor blues grayed with Payne's gray. The buildings are mostly earth colors grayed with Payne's gray. However, you have to be careful when mixing Payne's gray with colors like raw sienna and raw umber or you will get a kind of green (in which case, you just add alizarin crimson to offset it). The water is mainly a mixture of earth colors.

Rio, Venice

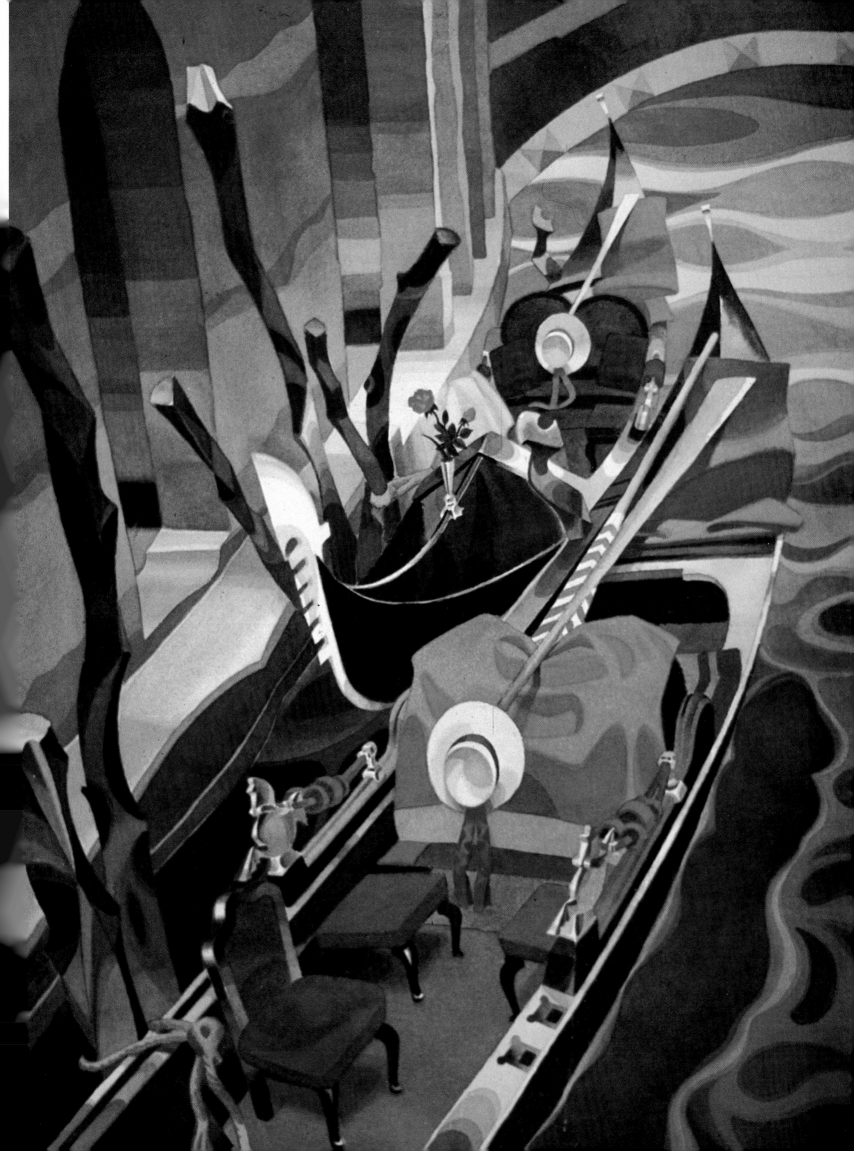

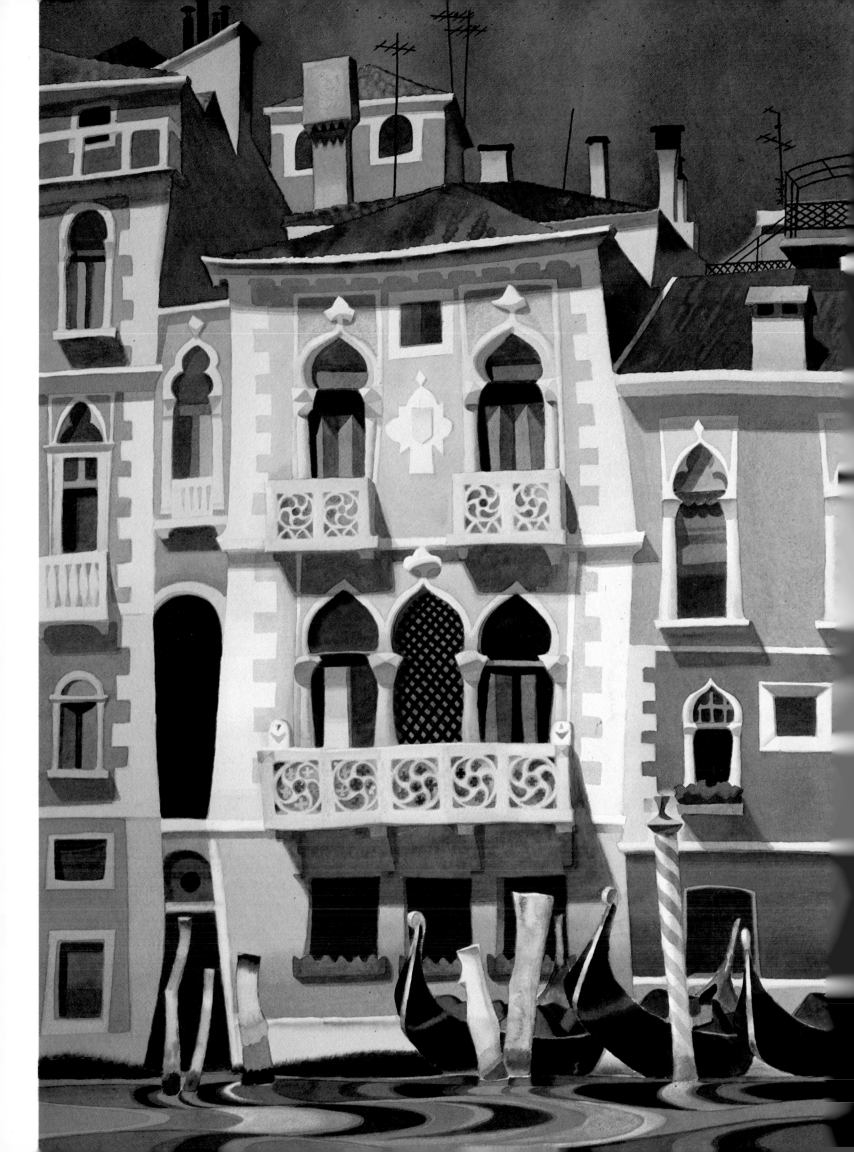

DESDEMONA'S BALCONY
Watercolor, 1979, 22" × 30" (56 × 76 cm). Collection the artist.

No one seems to know why the palazzo of the Contarini-Fasan is called Desdemona's house, but I like to think it really could have been her house if there ever really was a Desdemona. I have committed much of Shakespeare to memory throughout my life, and I tried to get a bit of the drama of *Othello* into the painting. As I worked, I thought of Othello's words:

> Put out the light, and then put out the light:
> If I quench thee, thou flaming minister,
> I can thy former light restore,
> Should I repent me; but once put out thy light,
> Thou cunning'st pattern of excelling nature,
> I know not where is that Promethean heat
> That can thy light relume. (Act V, Scene 2)

An idea should be staged dramatically, pretty much as a stage director would do it. So I planned a moonlight scene in cool silvery blue grays, with no activity in the canal and no other lights in the adjoining palazzos, just trying to get a feeling of silence, of sleep. There was only the moonlight and the feeble yellow light in one window gathering strength by its contrast against the silver grays, one exclamation of color, the last muffled sound of virtuous, dying Desdemona.

The color of the moonlight is Winsor blue with raw umber to gray it. Once I got the main color (the moonlight), it was easy to add to it for variations. I added a touch of alizarin crimson and burnt sienna to the main color and painted the top third of the building on the right. To the middle third I added more Payne's gray, and still more for the bottom third. The roofs, for the most part, were variations of Winsor blue and alizarin crimson. (This happens to be one of my favorite color mixtures.) The sky is a combination of Payne's gray and Winsor blue for the main color, with French ultramarine blue added to it for the left side and Winsor green for the right side. The water is mostly variations of Payne's gray with mixtures of earth colors: raw and burnt umber, raw sienna and Payne's gray. It makes a soft green, the kind you would find in a Venetian canal.

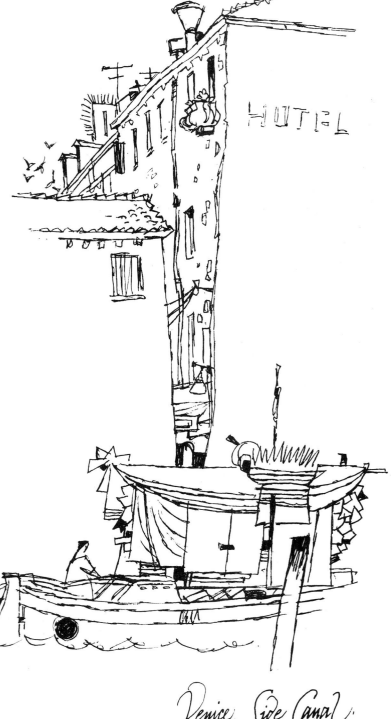

Venice, Side Canal.

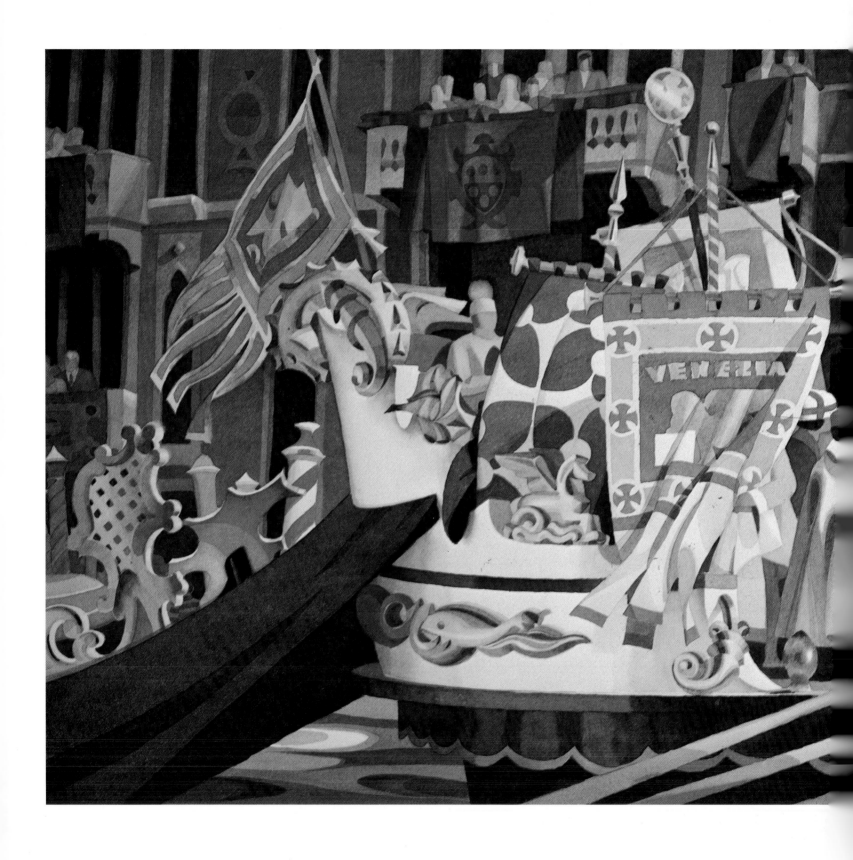

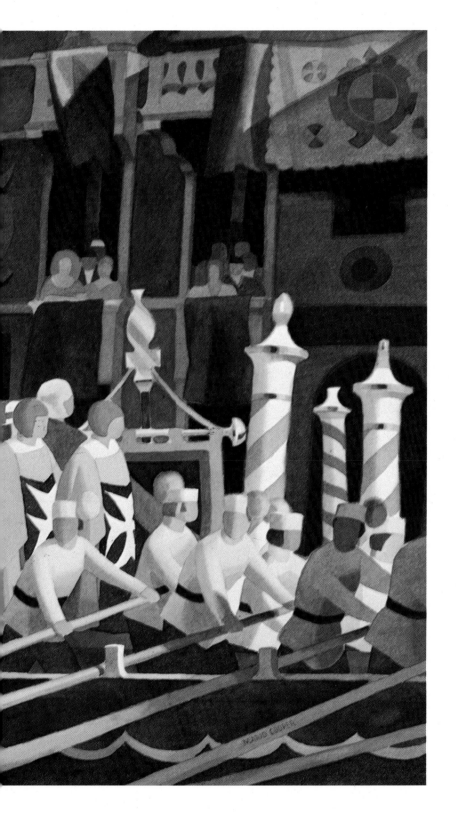

VENETIAN REGATTA
Watercolor, 1978, 27" × 29" (69 × 99 cm).
Allied Artists Award. Collection the artist.

In Venetian history, the marriage between the Doge and the Adriatic Sea was the greatest event in Venice. In the ceremony, the Doge would board the *Bucintoro*, a tremendous and fabulous state barge that had all the splendor of the Doge's palace, and would be rowed out to the sea by 48 oarsmen. There he would cast a jeweled wedding ring into the Adriatic.

The last wedding of the Doge and the Adriatic took place in 1796, two months before a mob boarded the *Bucintoro*, stripped all the gold from it, and tore the gilded sculptures from the Doge's throne. After that the barge became a sailor's prison. Today all that is left of the *Bucintoro* is a piece of an oar in the naval museum near the arsenal. But the festival still takes place on the first Sunday in September, with the present *Bucintoro* pretty much the center of the colorful festival, though it could well be an oversized rowboat compared to the original one. All kinds of barges join in and their decorations are fantastic: golden lions, dragons, sirens, Neptunes—you name it, they have it—oversized and in silver and gold!

I tried to get a bit of this festivity into the painting, and by using a closeup of the state barge, I tried to get the effect of a crowd. Also, I felt the gold trimmings on the barge added to the festive qualities, with the standards, banners, mooring posts (which look like barber poles), and the crowded balconies that display the tapestries. The colors of the background are mostly my usual earth colors (burnt and raw sienna and burnt and raw umber), all grayed with Winsor blue or Payne's gray or both. For the effect of gold, I used raw sienna and raw umber. The mantle being dragged by the *Bucintoro* is Winsor blue and alizarin crimson, and so is the drapery on the rest of the craft.

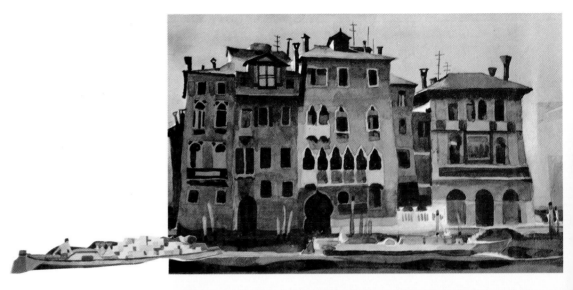

MORNING ON THE GRAND CANAL

Watercolor, 1977, 27" × 39" (69 × 99 cm). The Elizabeth Callan Award, AWS. Collection Dale Meyers.

The Salviati palazzos are the galleries and display rooms for the glassblowers of Venice, whose work is mostly made for the tourist trade. I made a number of small studies of the buildings (see above) until one of them worked. The play of light, especially on the rooftops, intrigued me and I tried to capture its spirit.

The large number of windows and balconies of the palazzos and their variety can easily get out of hand, so I had to group as many into patterns as I could. One way of doing this was through tonal control, and for that I used a value scale. (A value scale is a series of nine values of light and dark, starting with white as number one and ending with black as number nine. There are seven grades of gray between them. I use it pretty much as a pitch pipe is used in tuning musical instruments.) The way I did this was to assign a value number to each set of balconies, and make sure it kept within that assigned value. The colors could change, but the value had to remain constant.

Water, of course, is always a challenge to me, but I think I have conquered it. As in the preceding work, I made the water of free-form female forms that wave across two mixtures, one of Winsor blue and raw umber, and one of burnt sienna and Payne's gray.

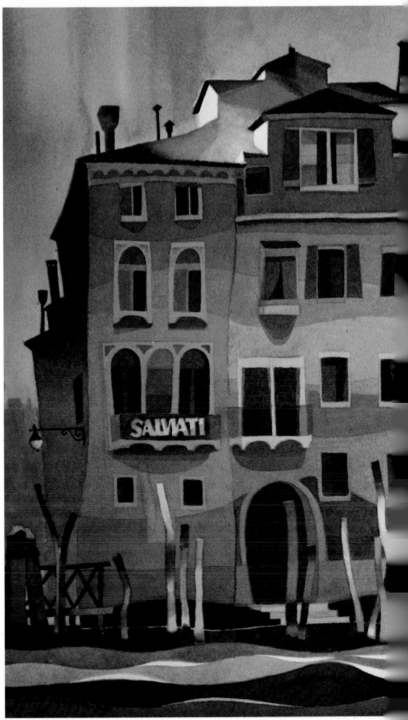

Following Page
CA' d'ORO
Watercolor, 1979, 27" × 39" (69 × 99 cm).
American Artist *collection.*

The Ca' d'Oro is the third architectural gem in Venice, topped only by the Basilica of St. Mark and the Ducal Palace. The details of its long history are extremely vague. Today it is a museum, donated to the state by the good grace of Baron Giorgio Franchetti, who presented it along with his own art collection. One of the former owners was Maria Taglioni, who was reported to have been one of the most glamorous ballet dancers in Europe. When she retired, one of her admirers, Prince Alexander Troubetzkoy, persuaded her to settle near him and gave her the Ca' d'Oro. When the romance ended, she was forced to sell the *palazzo* and move to London, where it is said she gave dancing lessons to survive.

To heighten the romantic feeling of the Gothic building and the city, I chose a moonlit setting. The warm glow of lights from inside the building playing against the cool blues and purples of the façades captures the drama of early evening. (I adjusted the lights until I got just the right range of values.) The sky was first painted Winsor green, then overpainted alizarin crimson, and finally toned with several washes of Winsor blue, with a little Payne's gray.

The painting was selected for the *American Artist* magazine collection and was the subject of the cover and a six-page article by the editor, M. Stephen Doherty, in the September 1979 issue.

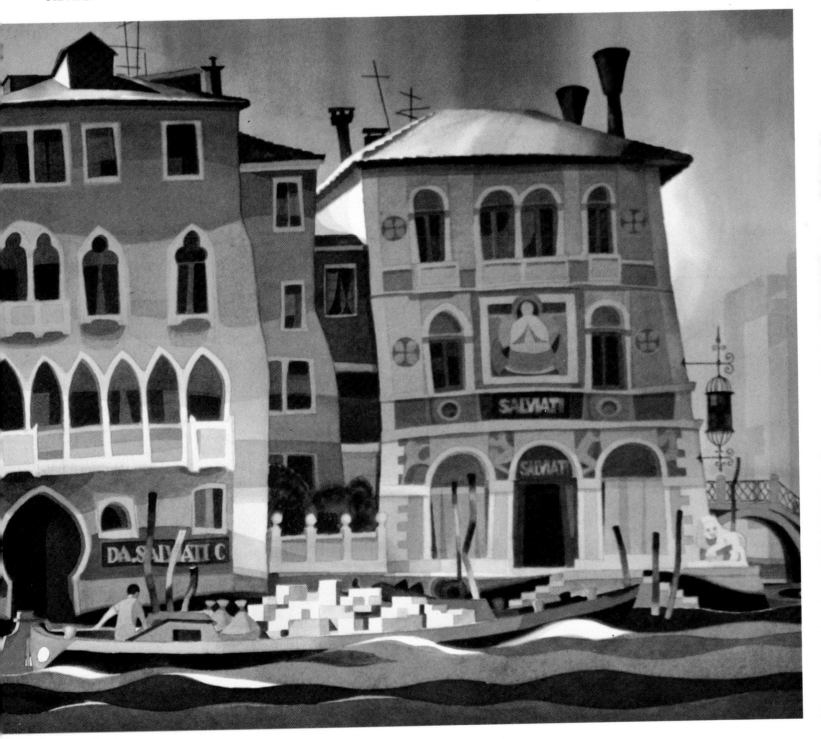

105

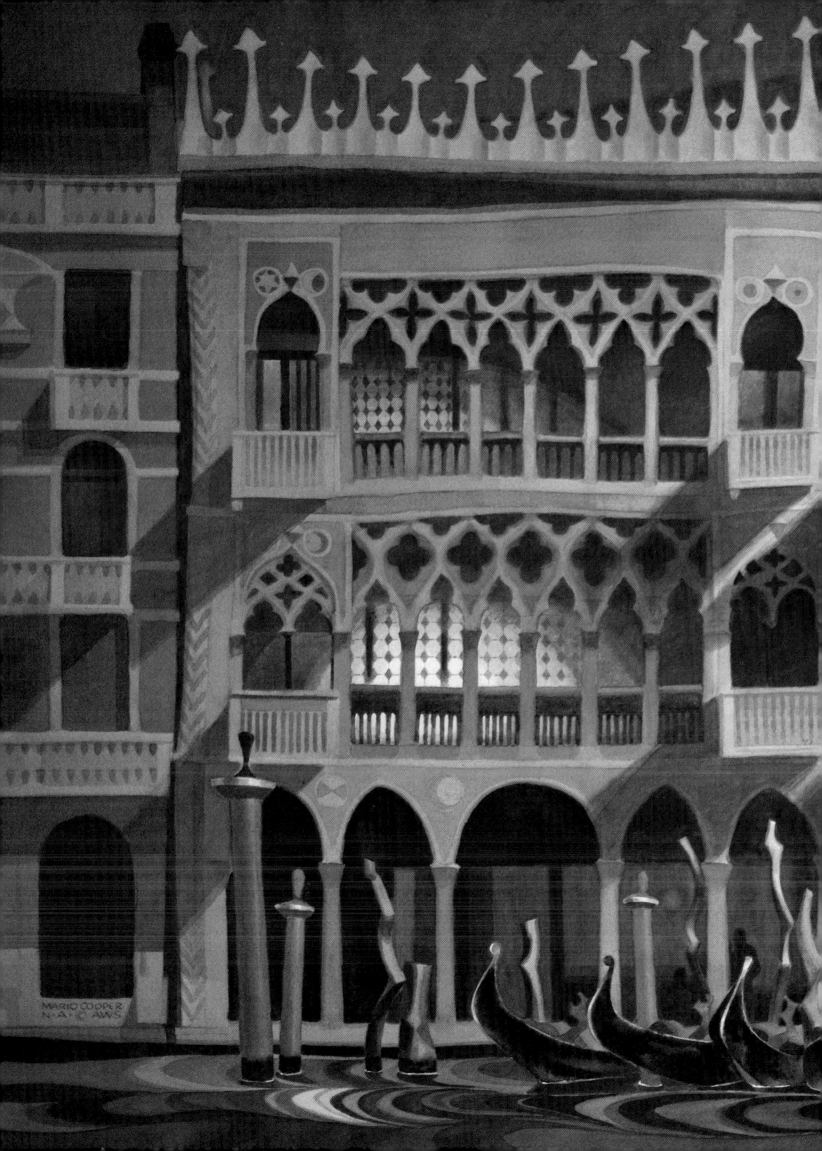

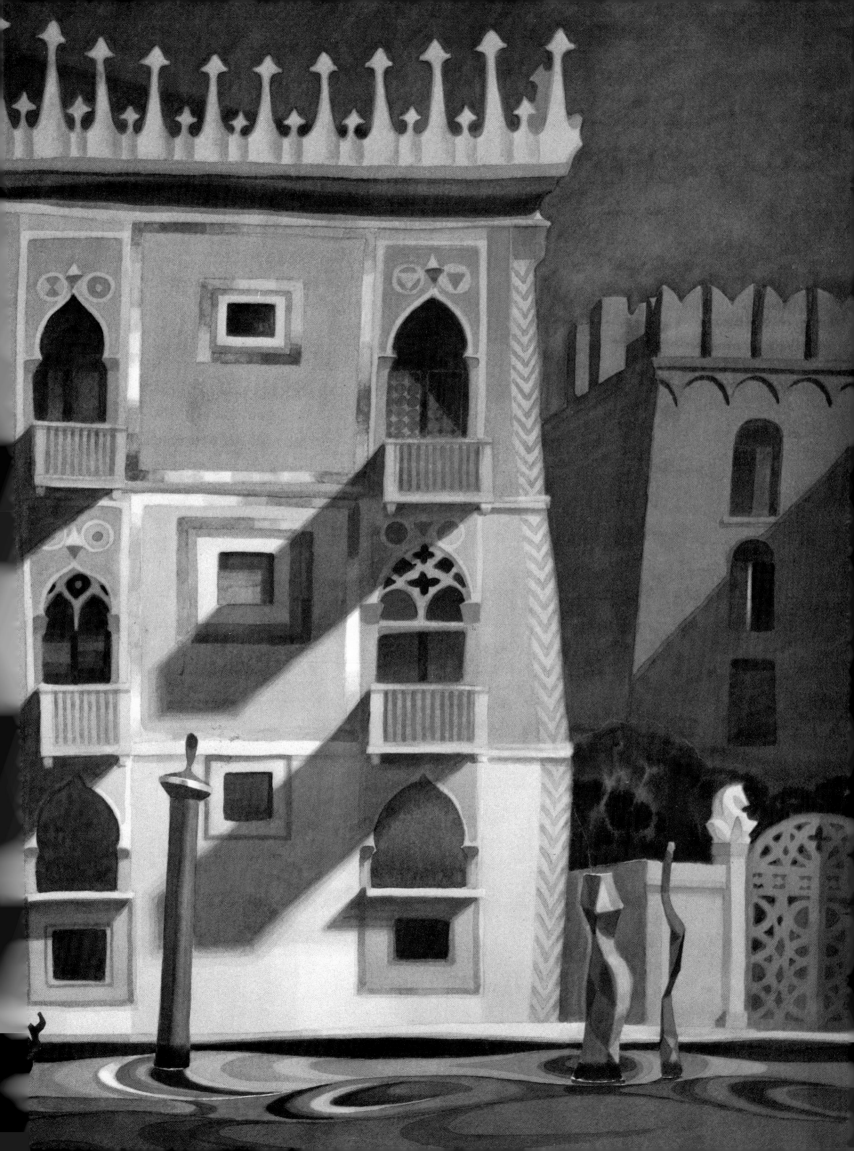

SAN MARCO
Watercolor, 1964, 22" × 36" (56 × 91 cm). AWS Grumbacher Award.
Collection Dale Meyers.

This painting was exhibited in Kyoto and Tokyo, and like many of my paintings was shown in an American Watercolor Society exhibition, where it received an award. I used quite a bit of ink in my paintings during this period. The ink underpaintings could even have remained as they were without the addition of watercolor, though the watercolor did make them richer.

One of the problems I faced in this painting was in arranging the numerous mooring posts facing the Molo. (The Molo is the dock and waterfront by the Doge's Palace.) I had to place them without their getting monotonous. I solved the problem by something I learned in the fourth grade in grammar school—roman numerals! If you take a good look at the posts, you will make out the numbers XII, VI, IX, and so forth.

The Molo has two columns. The one on the left depicts St. Theodore piercing a dragon, and the other portrays a lion that looks more like a chimera. Originally there were three columns, but one of them slid off the barges and was buried deep in the quicksand. Traitors to the Republic were decapitated between these columns with great pomp and ceremony. Among the most notable was Carmagnola, who led a Venetian army to defeat in 1431.

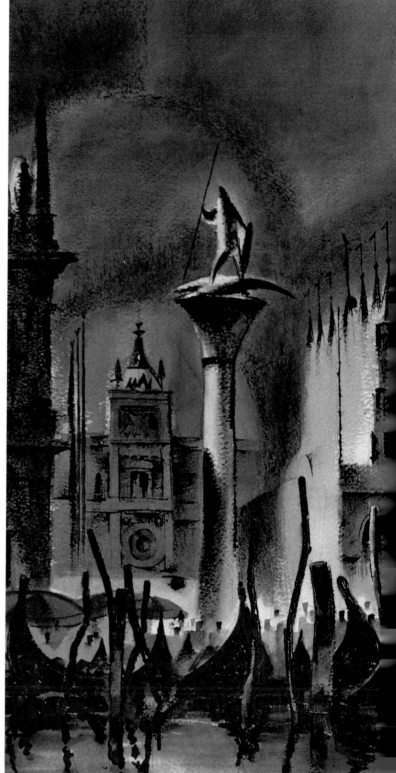

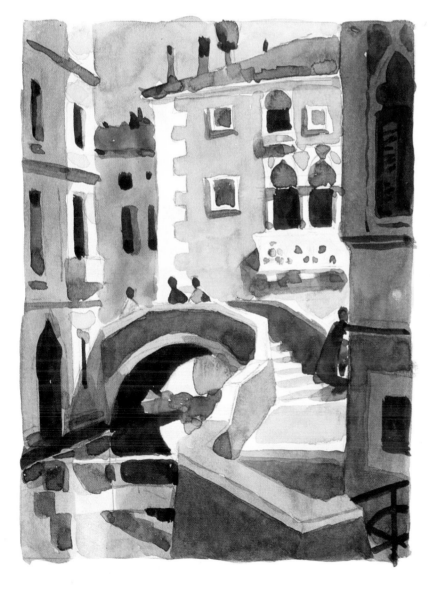

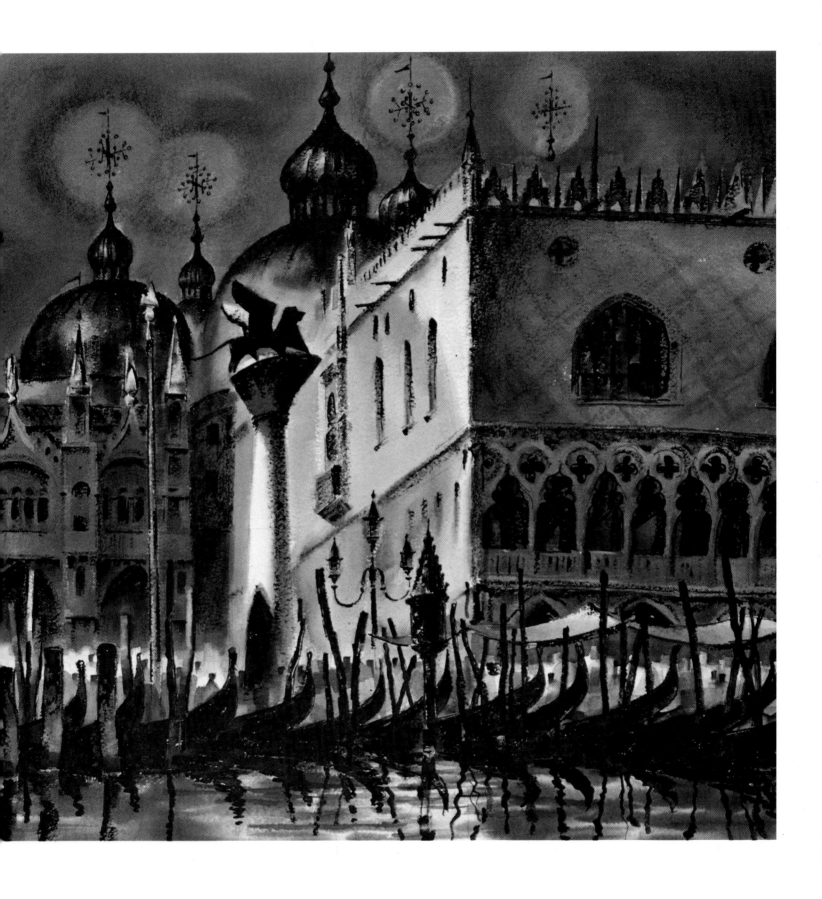

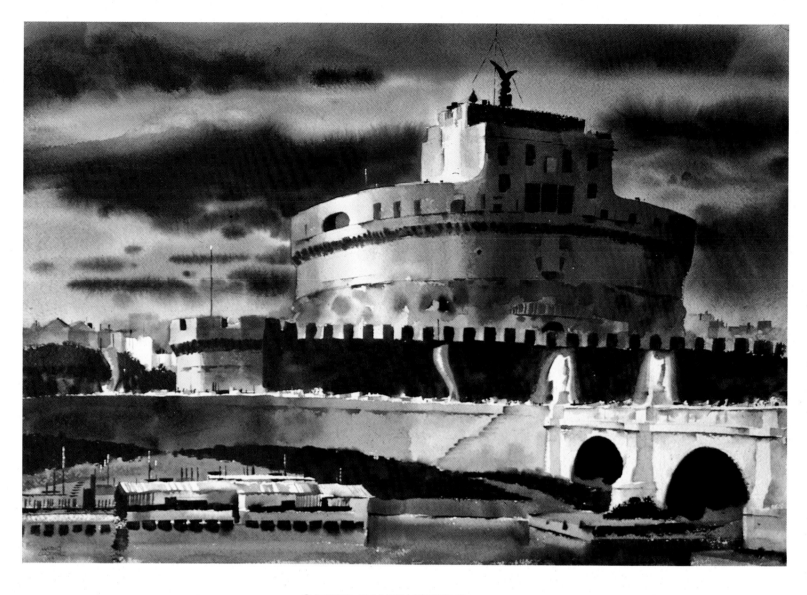

CASTEL SANT'ANGELO
Watercolor, 1961, 22" × 30" (56 × 76 cm). Audubon Artist Award.
Collection Mr. and Mrs. Solomon Litt.

This powerful cylindrical fortress was originally a mausoleum. Legend has it that
an angel appeared on its top, ending the plague of Rome in 590. From then on,
the castle took the name of Sant'Angelo. Its history is filled with torture, crime,
and bloodshed. The beautiful and ruthless duchess of Forli, Catherine
Sforza—who as captain of her troops brilliantly opposed Cesare Borgia—was
imprisoned by him and underwent tortures here. In 1527 Clement VII was
besieged in this fortress during the terrible sack of Rome and witnessed the
horrible rape, sacrilege, and vandalism created by the troops led by the Prince of
Orange. To add to this, the ferocious hordes of the Constable of Bourbon entered
the city. The Tiber literally ran red with blood. From the castle, Benvenuto Cellini
defended the city and killed the Prince of Orange. Cellini was later a prisoner
here at least twice. This castle was the backdrop for Puccini's *Tosca*.

 I chose a wine-red sky at sunset, with a golden light of raw sienna striking the
castle. I used Winsor blue and alizarin crimson for the sky, and added burnt
umber to the mixture for the clouds. I left the bridge of the castle white and
gradually darkened the value of the gray along the wall to the left. To the bottom
of the sky on the left, I added a white building to balance the white of the bridge.

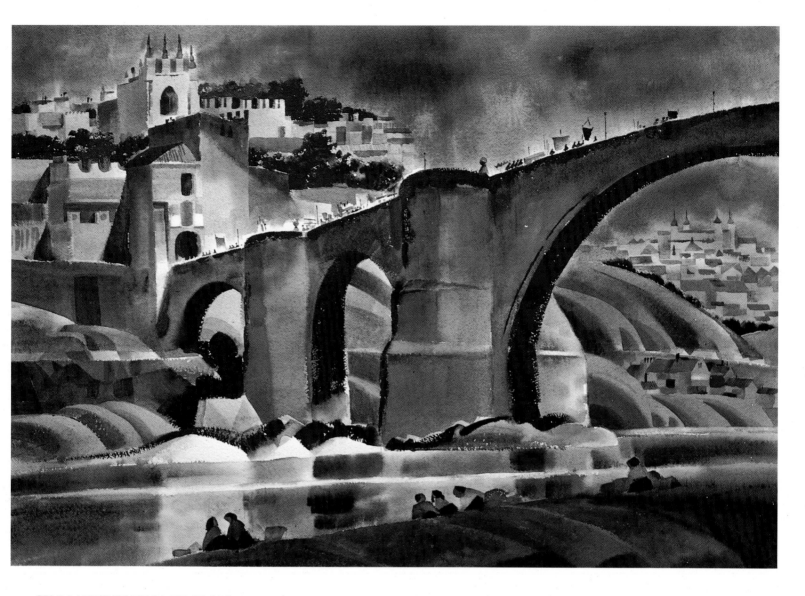

ST. MARTIN'S BRIDGE (Toledo, Spain)
Watercolor, 1975, 22″ × 30″ (56 × 76 cm). Salmagundi Club Award.
Collection Mr. and Mrs. E.E. Marble.

From this view of the bridge we can see the town gate, built in 1512. On top of the hill is the Church of St. John of the Catholic Kings (Fernando and Isabella), remembered for liberating Granada from the Moors in 1492 and aiding Columbus in his voyage.

Legend has it that the architect in charge of the building of the bridge was convinced he had made an error in his calculations and was so frightened at the thought of removing the wooden frames and having the whole bridge crash that he became seriously ill. In those days, a mistake like that would cost you your head. His wife had a plan to save his life. What if the frames caught fire before the bridge was finished? Her husband couldn't be blamed for that. So, with the help of a dark Toledan night, her plan worked. After her husband recovered, he rebuilt the bridge—and this time he did it right!

As in many of my paintings, this sky is a gray purple red. (I feel that the sky should reflect not only the glory, but some of the tragedy of the Spanish past. The rest of the painting is a golden mixture of raw sienna and raw umber. Parts of the river bank are mixtures of burnt umber and burnt sienna. The dark foliage in the distance is Winsor green, Payne's gray, and raw umber. The dark under the big span is Payne's gray, alizarin crimson, and Winsor blue. I suggested a procession on top of the bridge.

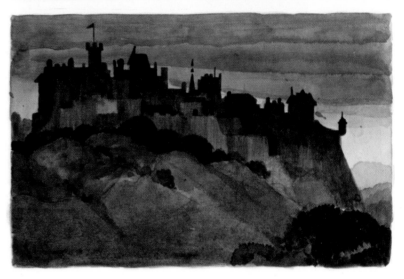

SEGOVIAN WALL
Acrylic, 1963, 22" × 36" (56 × 91 cm). Collection the artist.

Visiting Segovia in Spain is like going to a museum to see a dream city. The castle, Alcazar, is of the fairy-tale variety with towers that have a French candle-snuffer roof. The city is shaped like a flatiron, with Alcazar Castle at its tip and the Roman aqueduct as its base. The color of the city is a golden raw sienna. Visiting the city I felt like a little boy in a three-ring circus; I wanted to paint every doorway and wall I saw.

This particular wall fascinated me. I used acrylics because of the range of textures possible in that medium. Throughout the painting, dynamic lines were employed. The shadows between the exposed stones presented an interesting opportunity for abstract shapes. One thing I found was that the black didn't have any depth. I had to add Winsor blue and alizarin crimson to get a rich black. I painted most of the picture with palette knives. The wall is a mixture of raw sienna and raw umber with a little blue. The stones are Payne's gray with a touch of burnt sienna.

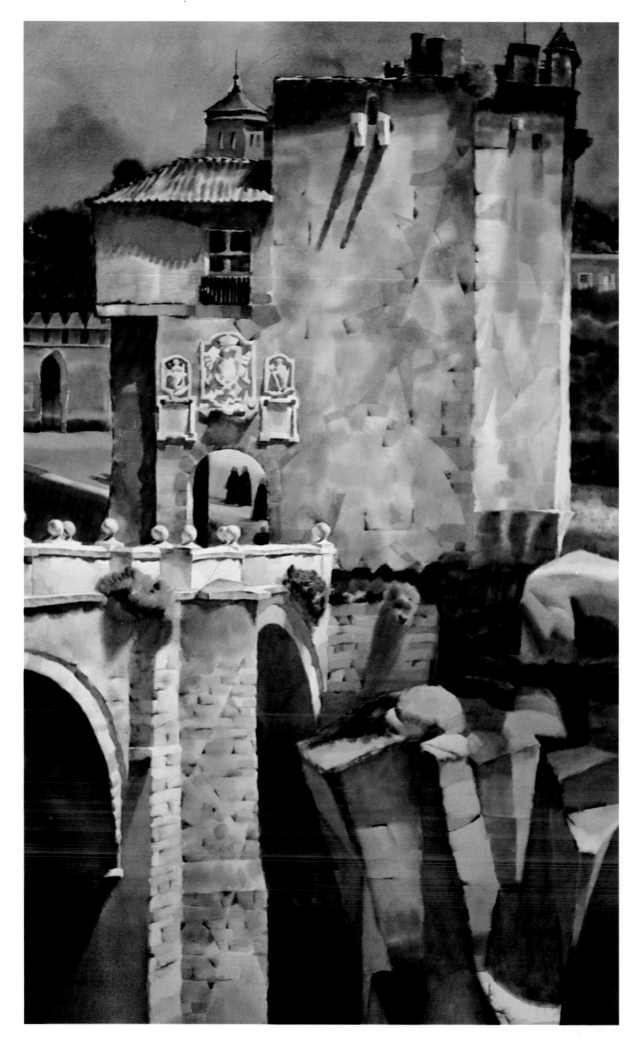

ST. MARTIN'S GATE, TOLEDO

Watercolor, 1968, 27″ × 39″ (69 × 99 cm). AWS Watercolor USA Award. Collection Utah State University.

Toledo's history is steeped in the mist of legends—some terrible, some heroic, and some romantic. One legend has the descendants of Noah founding the city. Another claims that the last Visigoth king, Don Rodrigo, seduced the daughter of Count Don Julian, Florida La Cava, and that they had a fantastic love affair. For revenge, her enraged father asked Tarik, the Arab chief in charge of the Moorish troops, to help him, and he did. Tarik invaded Spain in 711 A.D. The Moors liked Spain and stayed until the Catholic rulers, King Fernando and Queen Isabella banished them in 1492.

The terrain of Toledo is a natural fortress, with the Tajo River making a perfect moat on three sides. The city and river look like the bottom of an Arabian horse's hoof. The huge curve of the river starts in the east with the gate and the Alcantara Bridge, makes a curve south, then turns toward the west where the St. Martin's Bridge and gate (with the arms of Toledo) form the western entrance to the city to complete the horseshoe.

For the texture of the walls of the gate, I made a series of abstract mosaic free forms and patterns. I did the same for the bridge. A closer look will reveal many triangular shapes. I also handled the negative shapes in the coat of arms as free forms. The general color of the painting is a sandy gold made of raw umber and raw sienna grayed with Winsor blue and alizarin crimson.

Alcala Street, Madrid

Cuchilleros Street, Madrid

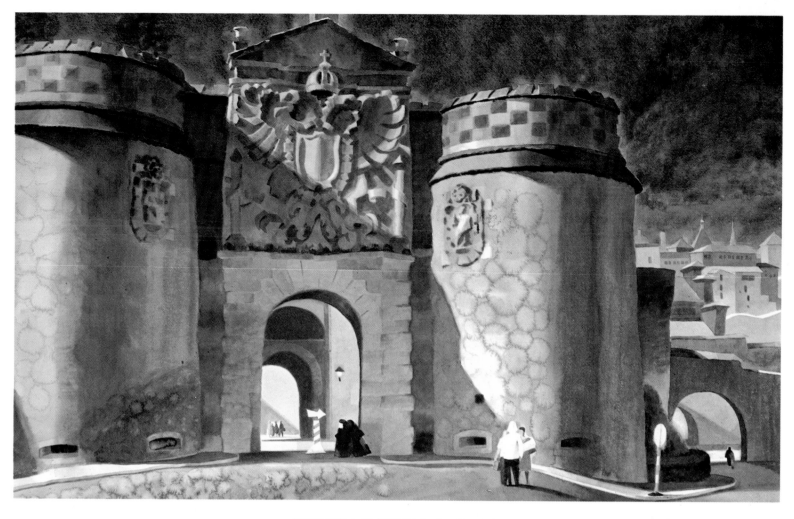

BISAGRA GATE (Toledo, Spain)
Watercolor, 1968, 22" × 30" (56 × 76 cm). Collection Dr. Homer Clark.

The Alcantara Gate on the east side of the city starts the horseshoe of the river that ends on the west side with St. Martin's Gate, leaving the two ends of the horseshoe exposed to open terrain. This was protected by a series of walls (*murallas*). The Gate of Bisagra was built in 1550 and lies between the east and west gates. The gate is very impressive and richly decorated, especially by the imperial coat of arms of Charles V, placed there by Philip II. The towers were very interesting to do. For the walls, I used a technique I call "Flowers," which was done in the following manner: I applied a light wash of charcoal gray over the whole of the desired area, and just before it dried, dropped some clear water on the area. The charcoal gray wash pulled away from the area and made a flower effect. (A word of caution: don't overdo it.)

Right
BIG BEN, LONDON
Watercolor, 1966, 15" × 22" (38 × 56 cm). Collection the artist.

Like everyone who has gone to London, I fell in love with Big Ben, and I have painted it several times. This is not unusual. Monet made a number of paintings of the great door of the Rouen Cathedral, each one a variation on a theme. I have often thought of an artist being like a musician. If you compose a piece of music that you like, must you only play it once? Does an author have a book published so that he can read it once? Then why can't an artist paint the same subject a number of times, especially if he likes it? I say he can!

This painting of Big Ben was done as a demonstration on 140-lb paper, and was painted wet-in-wet, working against the clock. Experience is very valuable in such an operation because you have to know just when to add rich darks to keep them from spreading out of control. I used four no. 20 brushes because I didn't have time to rinse one clean when I needed it.

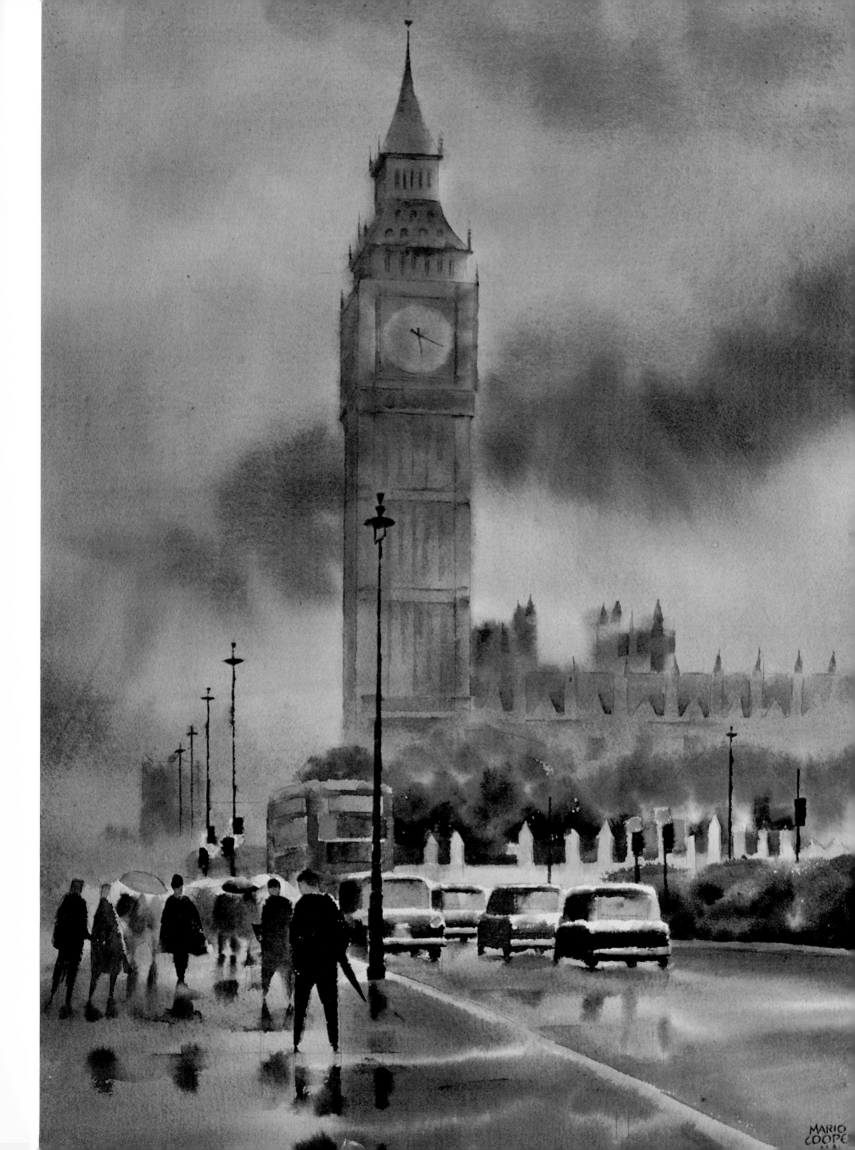

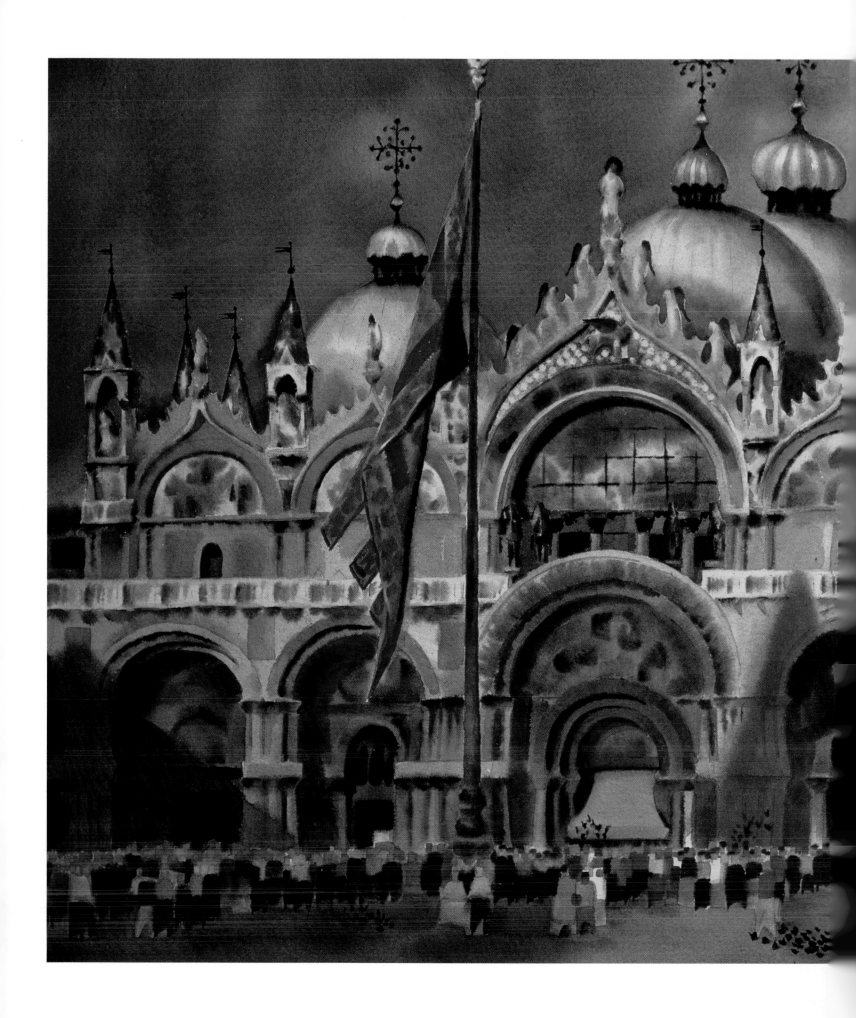

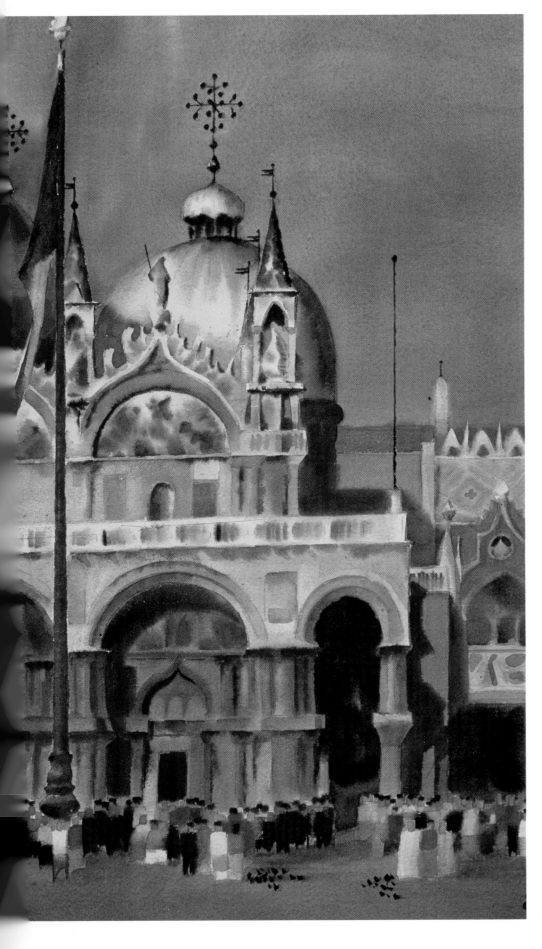

BASILICA
Watercolor, 1969, 27″ × 40″ (69 × 102 cm). AWS Syndicate Magazines Medal of Merit. Collection Dale Meyers.

To capture this superior treasure of art and history is, of course, impossible. If there were a form of expression that could include poetry, history, sculpture, jewelry, and music, all in one unit, perhaps that could do it. However, I settled for this. I chose a golden color scheme to give the feeling of sunset light bathing the basilica. In the crowd just to the left of center, by the main entrance with the birds overhead, is your author (with the camera case) and his wife, Dale Meyers.

Over the doorways are mosaic murals. I painted them in a wet technique, trying for large patterns of color. The crowd, too, was a problem, so I united as many of the darks as possible, making an up-and-down pattern across the painting—this keeps the crowd organized. The architecture, too, had to be severely simplified to be kept under control.

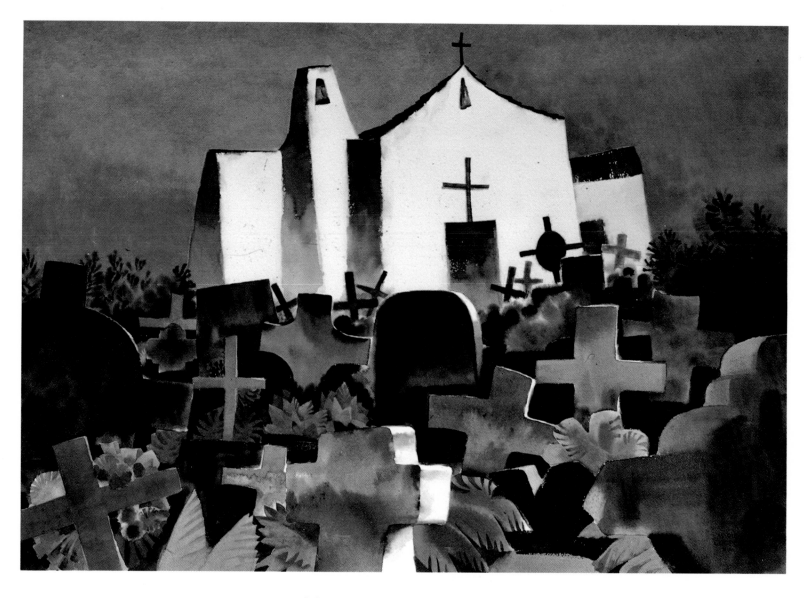

GOLDEN, NEW MEXICO
Watercolor, 1972, 22" × 30" (56 × 76 cm). Collection the artist.

Near Albuquerque, New Mexico, is one of many picturesque towns, called Golden. In its environs is a churchyard with a chapel that has become Motif no. 1 to many a visiting artist. I was invited to send a Western subject to an important Western exhibition—and here I had been knee-deep in Venice, Rome, and Japan. So I looked over some of my sketches and slides of Golden. I had enough for a picture, but the problem was how to paint it so it didn't look like everyone else's. I made a number of sketches and finally came up with this study of a white church against a gray-yellow sky, with a band of crosses and squares and with a Mario Cooper-type of foliage running across the bottom.

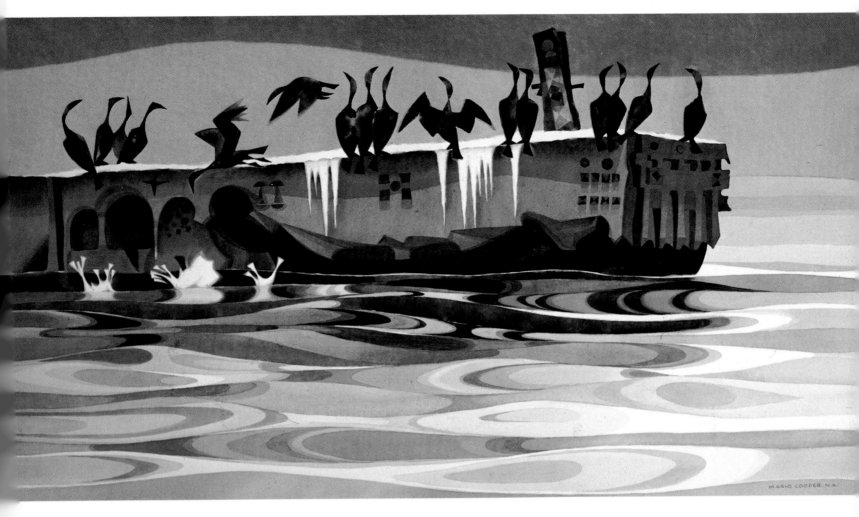

CORMORANT DOMAIN
Watercolor, 1974, 24" × 39" (61 × 99 cm). AWS Medal of Honor.
Collection Dale Meyers.

The Portland Light in Maine is famous and marks the southern entrance of Casco Bay. The bay was very busy during World War II and many of its remains on the bay and the islands (blockhouses, piers, gun emplacements, and the like) still can be seen.

One of those piers was appropriated by a flock of cormorants. I took the painting of them as a project. The water rhythms were especially interesting to paint. The sky is divided into two areas of gray. The darker one on top is an orange gray on the right side and a blue gray on the left. The lower pattern is a gray crimson on the left and becomes violet to the right.

I enjoyed painting the cormorants and I gave each one a different personality. I would explain them to you, but I think you might have more fun if you deduced their personalities for yourself. Their color is mostly a mixture of Payne's gray, Winsor blue, alizarin crimson, and a little burnt umber. I would vary the amount of one of the colors for each cormorant, adding a little more blue for one, a little more crimson for another, and generally, to my taste, including a little burst of bright color around their necks for interest.

PEAKS ISLAND DOCK (Peaks Island, Maine)
Watercolor, 1976, 21" × 30" (54 × 76 cm). Audubon Artists Silver Medal of Honor. Collection Dale Meyers.

For about ten years, Dale and I have conducted a workshop on Peaks Island in Casco Bay, Maine. Peaks has lost all of its former glamour and glory. It used to be a swinging resort with gambling casinos only 20 minutes from Portland. But it still retains much of its charm as a hideaway. We were lured there by a siren named Betty Callan, who was the first woman vice-president of the American Watercolor Society. She was also known as "Mrs. Peaks Island."

The island has its haunted houses and a number of spots where pirates roosted. Longfellow's poem, "The Wreck of the Hesperus" was based on a ship that foundered on Peaks' rocks. A few of the remaining docks have formed motifs for our students' paintings.

I chose this old discarded ferry dock that had served well in its day and was left to fade away. The problem here was to design a subject that is usually painted by most artists in a blast and flourish of brushstrokes. Halfway through it I almost gave up, but Dale said it looked good, so I continued. The color scheme is a silver gray with an occasional accent of color; in this case, the sou'wester of Indian yellow.

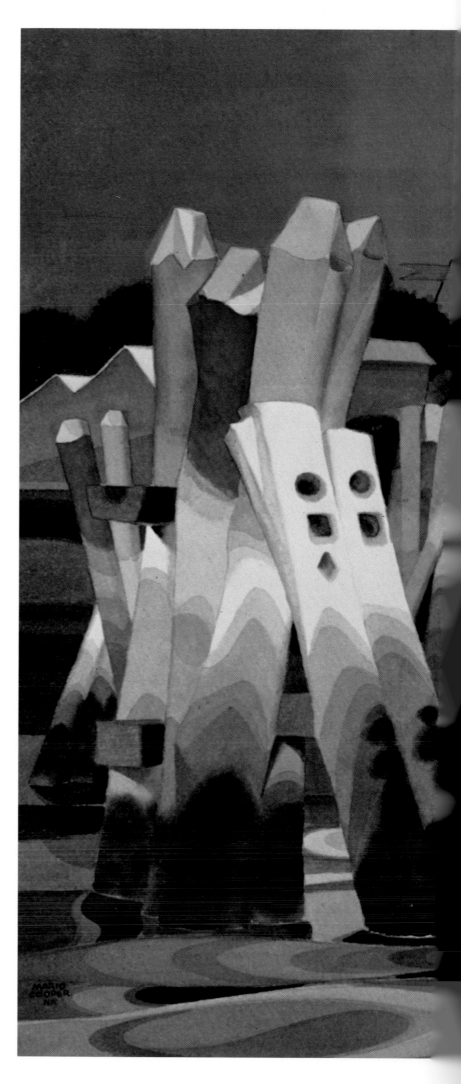

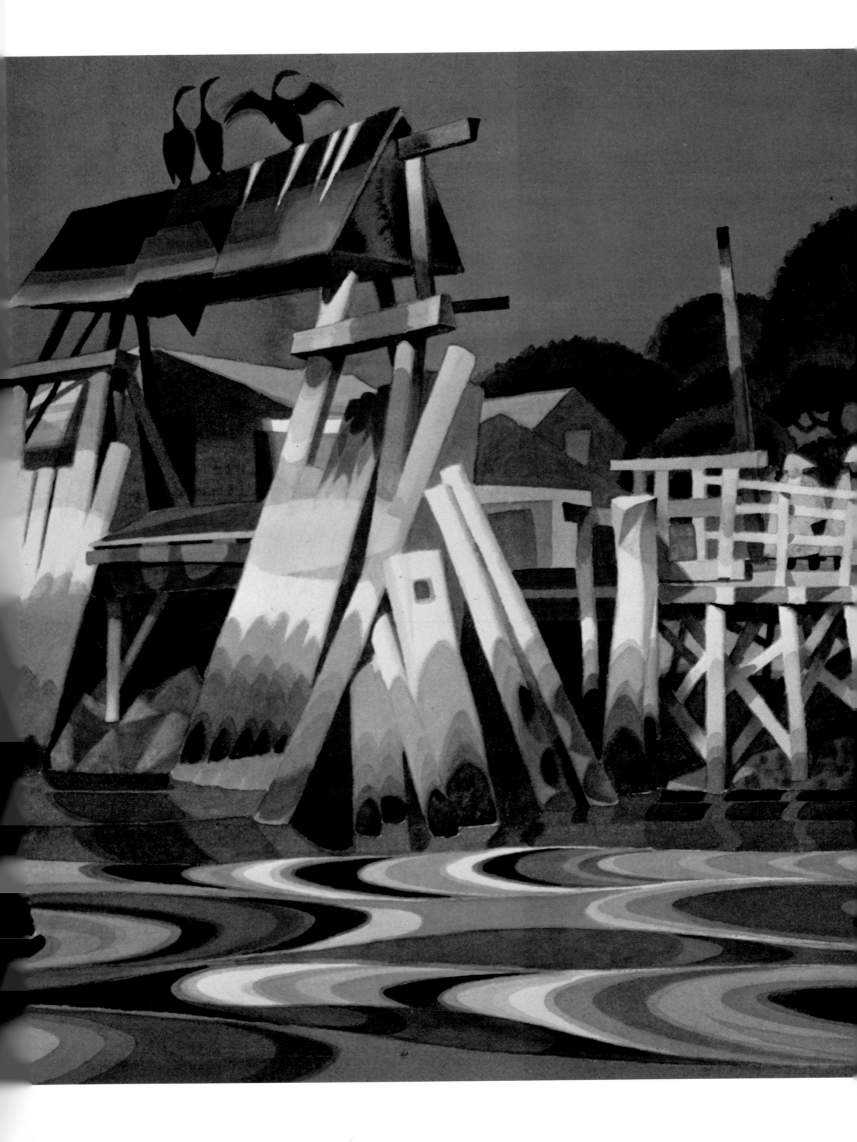

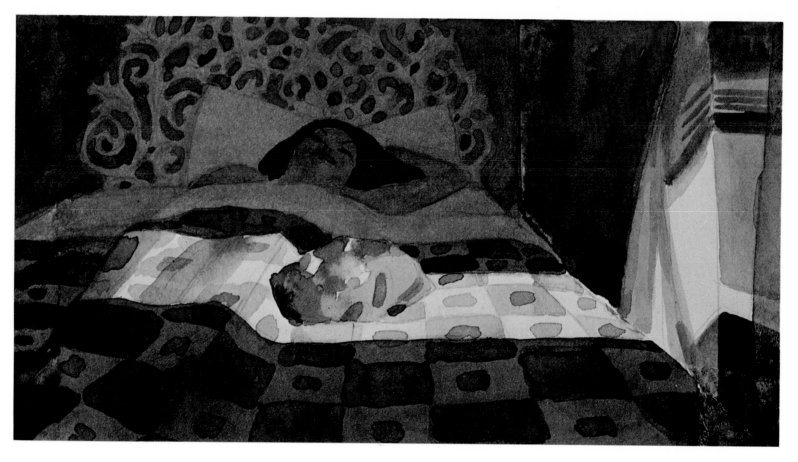

DALE AND JASPER

Watercolor sketch on ordinary writing paper, 1976, 3¼" × 6¼" (9 × 16 cm). Collection the artist.

We were staying on Peaks Island in our friend Betty Callan's cottage. One of her daughters had brought with her a little Siamese kitten that could conquer snakes ten times his weight—he believed he was a Bengal tiger! His name was Jasper, and Dale fell in love with him. He would spend most of the night in Dale's bed, and just to keep me from being jealous, he would spend a few minutes in my bed too.

We have since lost track of Jasper. It seems he was boarded out, didn't care for his host, and like a true Siamese, ran away. But Dale has pictures of him that she carries with her, and from time to time I catch her sighing.

I tried to capture that feeling in the sketch: with the moonlight streaking through the window, enveloping Jasper, his shadow against Dale, and she asleep in a luminous background. It's an intriguing theme.

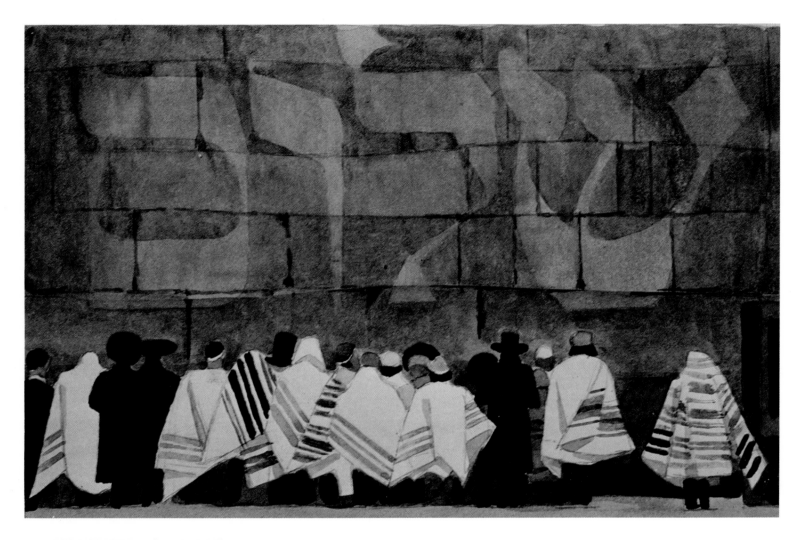

THE WESTERN (WAILING) WALL
Watercolor study on ordinary writing paper, 1968, 4" × 6" (10 × 15 cm).
Collection the artist.

There are so many stories told about the miracles, hopes, and wishes that have been consummated by prayers at the Western Wall in Jerusalem. One of the most frequently told stories is about a father and son who were separated by one of those disasters that Mother Nature throws at us that end in extraordinary personal misfortune. After many years of searching for his son, the father was leaving a prayer between the stones of the Western Wall when a piece of paper dropped out bearing his name. It was from his son, and after all those heartbreaking years, they were united.

When I wrote the Hebrew word for "peace" (*shalom*) across the stones, I tried to make it look like a watermark left by time and weather. I first outlined the characters and painted the negative space around them, making sure to leave soft edges at some point or another, preferably where one stone block met another and went into slight shadow. The mixture I used for the wall itself was raw sienna mixed with Winsor violet and Payne's gray. This mixture comes closer to the color of the wall, which is limestone. However, I added some raw umber and a little more Payne's gray to give it a touch of pathos. I then applied the same grayed mixture to everything else except the pilgrims wearing the white prayer shawl. This second color gave me an opportunity to introduce an angular contrast with the rectangular character of the wall and the striped patterns of the shawls helped accentuate these angles. The letters were mixed with a combination of raw umber and Winsor violet.

PAGEANT OF JERUSALEM

Watercolor, 1978, 27" × 39" (69 × 99 cm). AWS Walser S. Greathouse Medal. Collection Dale Meyers.

The trip to the Old City of Jerusalem was like taking a flying carpet and landing in Old Baghdad of the *Arabian Nights*. I tried to get some of the feeling of the bazaars through the mixture of English, Hebrew, and Arabian signs, which fascinated me. (I think that next to chess I like languages most.)

I also wanted to get a sense of the vastness of time into this picture, and the wall around the gate supplied this power. However, one of the problems was in painting the stones in the wall: I wanted to show them, yet still keep them as part of the design as a whole. To solve this problem, I arranged the stones in rhythmic horizontal bands. At first I thought of them only as bands, but later, when the values were established, I made them into stones, arranging some of them to suggest crosses. Besides the wall, the other element that gave the picture weight was the arches in the entrance that went back into darkness, then emerged into light through a series of circular gradations.

The priest on the right catches your eye because the greatest contrast of light and dark is there. From there, you're drawn to the upper part of the picture, giving it a sense of height. The shadow on the lower right goes up the steps and gets narrower and suggests a cross as it ends, which also helps to point to the key priest.

The costumes of the priests and the ritual accoutrements were so ornate that had I painted them as they really were, they would have detracted from the design as a whole. So I simplified and improved them, and invented every chance I had, which I greatly enjoyed doing.

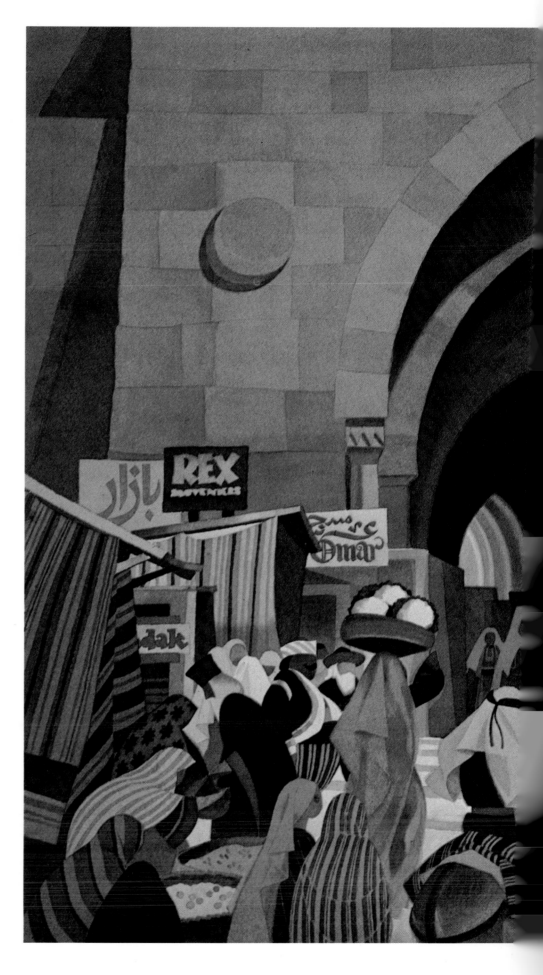

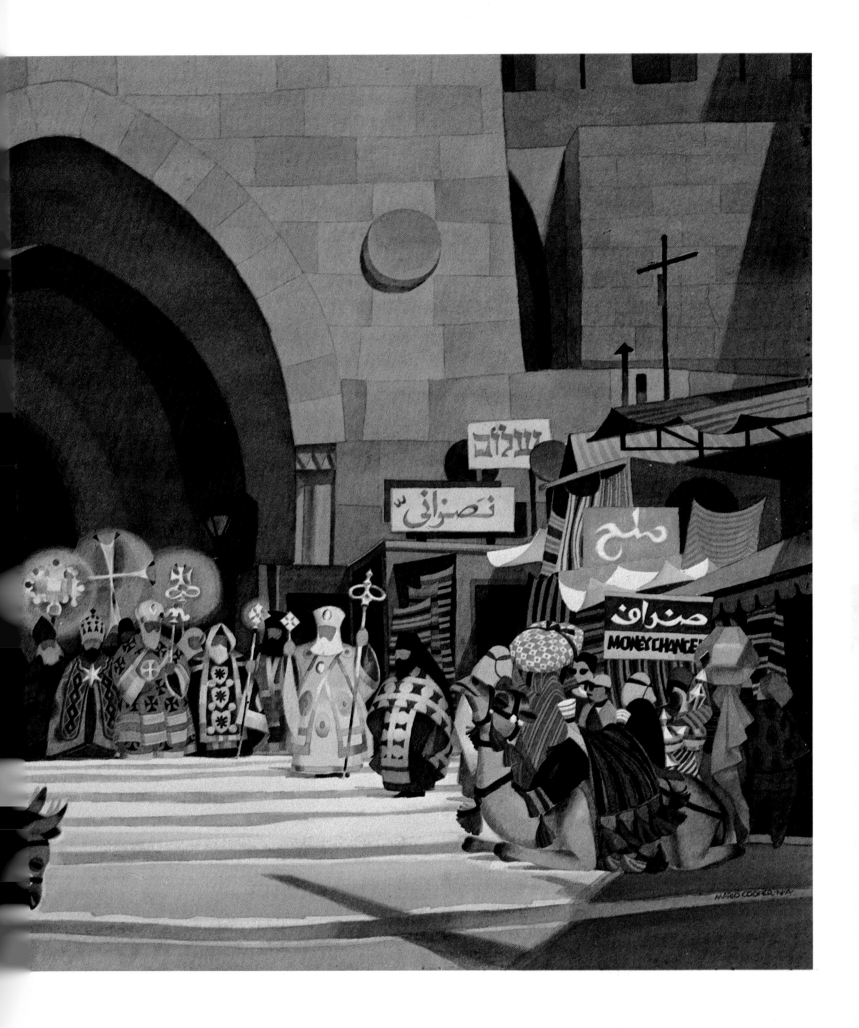

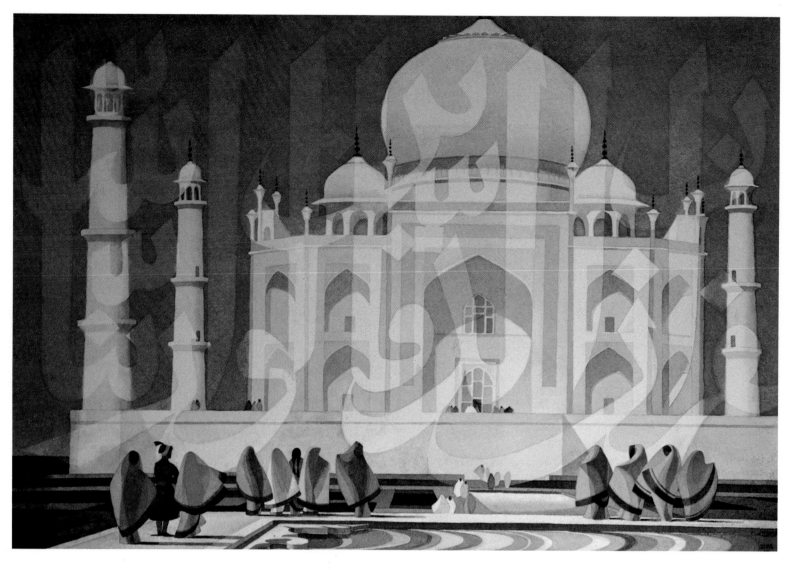

MARBLE SONG TO MUMTAZ
Watercolor, 1976, 27" × 39" (69 × 99 cm). The Mary Pleissner Memorial Award, AWS. Collection Dale Meyers.

Is there anyone who doesn't know that Mumtaz was the wife of the Indian emperor Shah Jahan, and that the wonderful monument called the Taj Mahal was built by him to be her mausoleum, as a tangible symbol of his undying love? When you think of the millions of photographs and paintings that have been made of the Taj Mahal, it could discourage any attempt of trying to make a painting of it for fear that it would look like a postcard. However, I wanted to paint it, even if it was a challenge. But I needed a new slant.

I finally got the idea of using the calligraphy written on the sarcophagus of Mumtaz as a veil across the front of the Taj. I asked an artist friend who taught at Columbia University to have one of the professors of Arabic translate the inscription. I discovered that loosely translated it meant, "Those who believe in Allah will find Allah."

The group in the foreground gave me some problems and I had to remove and repaint them a number of times. I eventually solved the problem: I wasn't keeping them simple enough. On the sky I used my usual three kinds of color, warm on one side, neutral in the middle, and cool on the other. Red and orange are the warm colors, blue and green are the cool ones, and the rest are neutral in temperature, depending on the others for their coolness or their warmness.

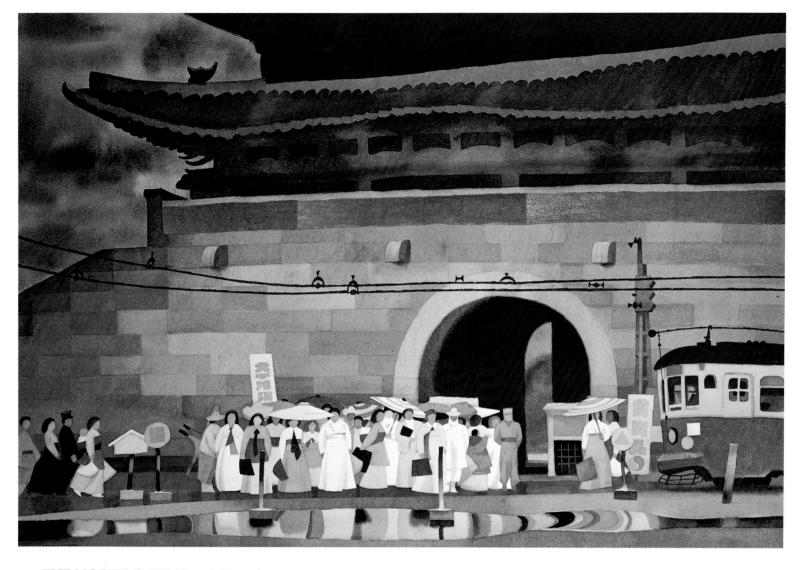

THE NORTH GATE (Seoul, Korea)
Watercolor, 1975, 27" × 39" (69 × 99 cm). Exhibited at the National Academy.
Collection the artist.

Years ago I did some homework on Korea and found out that its civilization dates
back to 2333 B.C. I also discovered that Korea had the first ironclad battleship, the
Tortoise Boat, invented by Yi Soon Sin in the 16th century. The battleship enabled
the Koreans to defeat the great Japanese general, Hideyoshi, in Chinhai Bay.
When I finally had the opportunity to visit Korea as a guest of the USAF for the
Far East Art Program, I was delighted. The women amazed me with their
immaculate dresses, many of snow white or the most delicate color
combinations.

I tried to portray the tremendous size of the North Gate by showing only a
section of it. As in many of my other paintings, my color scheme was a silver gray
that ranged from light to dark, with a horizontal band of light figures and a
streetcar, and another band of their reflections running across the painting from
one side to the other.

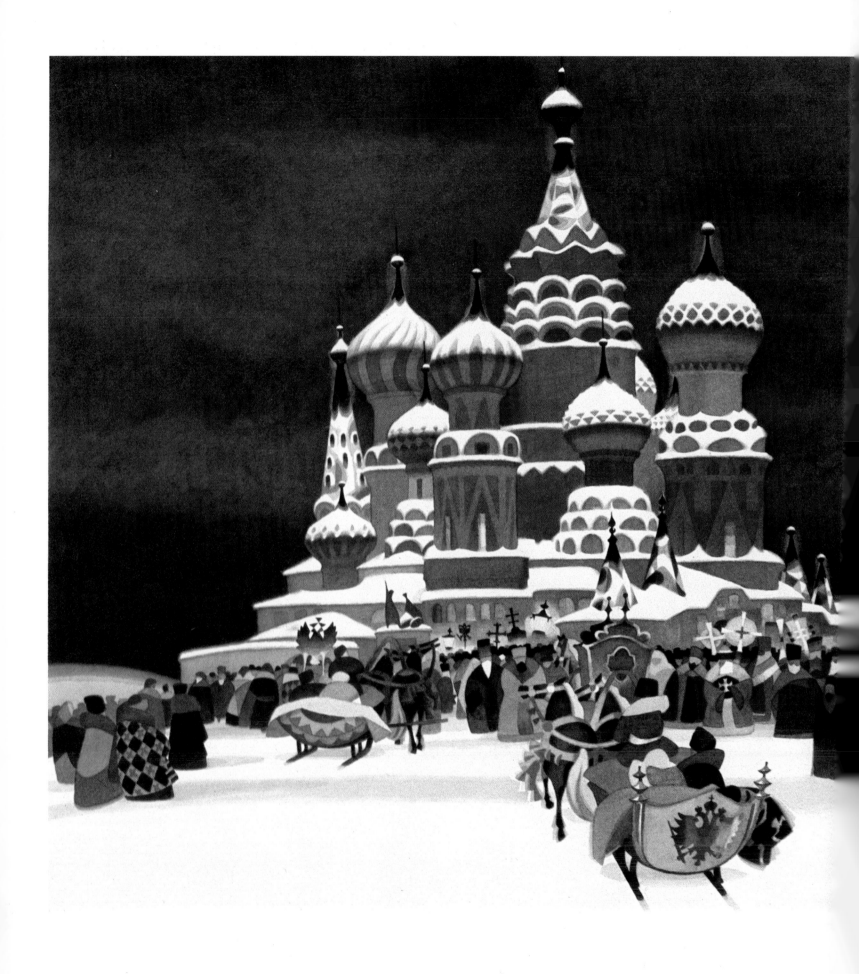

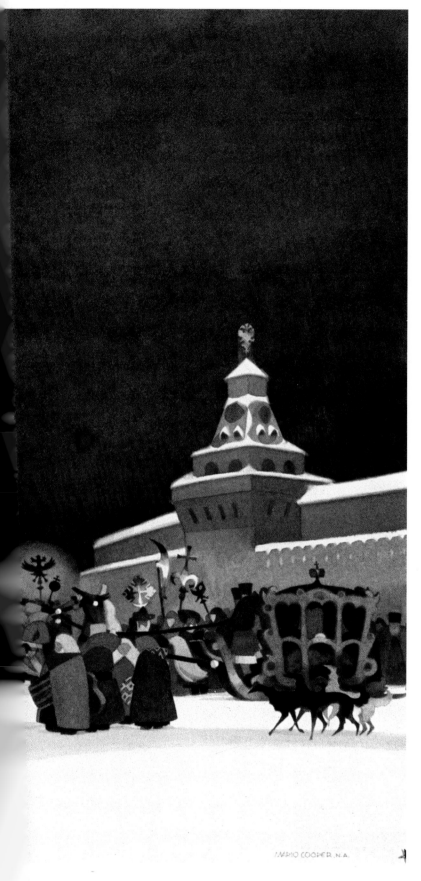

MOSCOW OF YESTERYEAR

Watercolor, 1975, 22" × 30" (56 × 76 cm). First version, Collection Dale Meyers. (The second version won the Watercolor USA Award and is in the Collection of the Charles and Emma Frye Art Museum, Seattle, Washington.)

When Dale and I visited Moscow, the most outstanding building in the city was Saint Basil's Cathedral, built in the reign of Ivan the Terrible. This architectural jewel stood out like a large iridescent pearl against a misty background. It is difficult to be in Russia and not feel the heavy brooding of its colorful past, rich in tragedy, heroics, intrigue, and crime in a land of Tsars, gypsies, and Cossacks, a land of music, dance, and poetry, of Pushkin and Rimsky-Korsakov—I could go on and on.

To paint the cathedral, I conceived of it as a backdrop for something like a stage with a play or the opera *Boris Gudonov* in progress. And, of course, the season was winter. The most difficult part of the picture was the sky. I had to use masking tape to block out the onion-shaped domes. I applied an initial wash of Winsor green on the left and alizarin crimson on the right. Then I washed a mixture of Winsor blue and Payne's gray, grabbing a bit of French ultramarine blue now and then, over the whole sky. The domes are mostly gray washes of raw sienna and/or raw umber with Payne's gray and alizarin crimson.

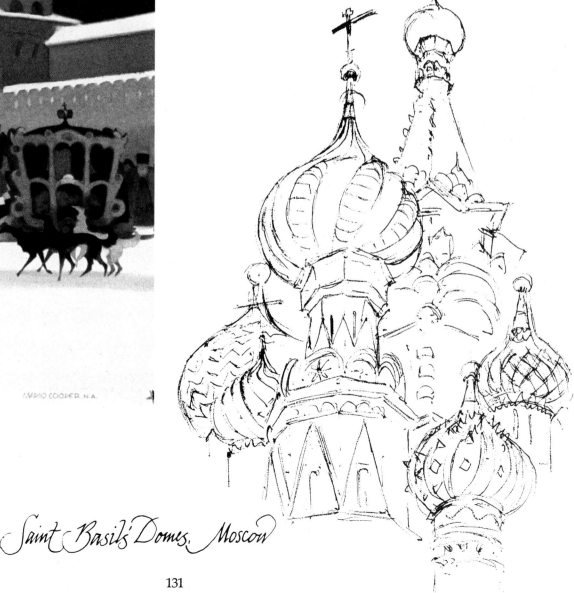

Saint Basil's Domes, Moscow

ASAKUSA, TOKYO
Casein, 1955, 22" × 30" (56 × 76 cm). Brooklyn Society of Arts Award. Slater Memorial Museum Collection, Norwich, Conn.

I was struck by the color of the banners outside a small shrine in the Asakusa district of Tokyo, a pleasure area crowded with entertainment houses and movies. The most outstanding courtesans of the day once paraded in festivals here, dressed in splendor and surrounded by an entourage of assistants.

At the time I made this painting in the early fifties, casein was highly publicized, so much so that a Casein Society had been formed. (I was one of its founders.) Casein, like gouache (also known as poster or designer's colors), is opaque. But gouache will dissolve when rewet, and casein won't. Once it's dry, it's there to stay. Another virtue of casein is its density; you can make a hairline rule with light paint and still have it remain sharp. (See Ralph Mayer, *The Artist's Handbook of Materials and Techniques* [New York: The Viking Press, 1941], p. 311.) In transparent watercolor, you are always working against the ever-present light of the paper; in casein, you supply it yourself with white paint.

The greens in this painting are Winsor green with mixtures of raw umber and burnt umber. Always keep them toward the gray when featuring their complement (here, the red banners). The light coats the women wear are mostly variations of raw sienna, raw umber, and burnt umber. This contrasts with the red banners, which *are* the picture—and when you use red in casein, it's red!

MAIKO OF PONTOCHO
Watercolor sketch on ordinary writing paper, 1960, 2" × 3" (5 × 8 cm). Collection the artist.

It is a delight to see the *maiko* (student geisha) in Pontocho, one of the two geisha districts in Kyoto. With their colorful costumes, they look like butterflies fluttering in the silver mist of the Kyoto foothills. This little sketch captured that dreamlike mist, and the foggy and rainy backdrop makes an ideal foil for the colorful kimono, painted here with Winsor blue, French ultramarine, and alizarin crimson. Behind the two *maiko* is a large post marking the entrance to the Third Street Bridge, which crosses the Kamo Gawa ("Wild Duck") River. A good mixture for fog and mist is Winsor violet, cadmium orange, and a little Payne's gray.

*Japanese Mother.
MATS Plane. Summer. 1957*

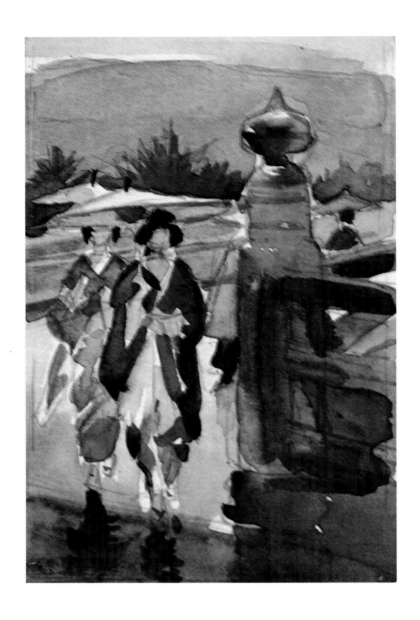

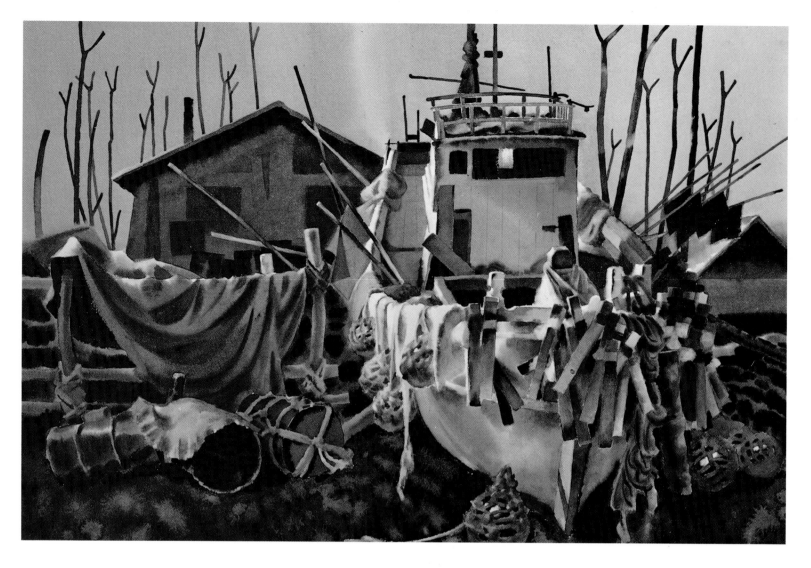

HOKKAIDO FISHING BOAT

Watercolor, 1971, 22" × 30" (56 × 76 cm). Allied Artists of America Award. Collection Dale Meyers.

Hokkaido is the northern island of Japan. On its southern tip is a spa and near it are hot springs close to a valley, "The Valley of Hell," that must have been a crater of a volcano. With my love for Dante's *Inferno*, I just had to see this valley. It was fascinating to walk on sulphur and dodge smoking fumaroles, but the real payoff of the trip was the nearby fishing village with its black volcanic sand. At sunset, the women as well as the men helped launch the fishing boats. The long poles with a fork end support the rods that hold the drying nets.

The sky is usually one of the major parts of a landscape. At times, when I want it to appear as one color, I make it into a *chord* of color. For example, when I want a blue sky, the first thing I do is to divide the sky into three sections: left, front, and right. Then I cool the blue on the left by adding a little green, leave the front (center) the blue I choose, and warm the right side by adding a little alizarin crimson. It's like playing a tune with one finger and then adding other fingers to make a chord. In this sky I tried to get a pre-sunset feeling, so I divided the sky into seven sections of light gray. From left to right: yellow green, orange, blue, white (the paper), red violet, gray, and yellow. They are all grays, of course; a gray chord with seven fingers.

Whistler also used many colors in his two paintings of women in white, which he called *Symphony in White Nos. 1 and 2*. A self-styled critic once wrote of them in the London *Saturday Review*, "You call this a symphony in white? Why I can see pinks blues, yellows, etc. . . ." to which Whistler retorted: "Do you think the composer of *Melody in "F"* just used the note F, F, F, you fool!" (From *The Art of Whistler*, by Elizabeth Robins Pennell with Joseph Pennell. New York: Modern Library, 1928).

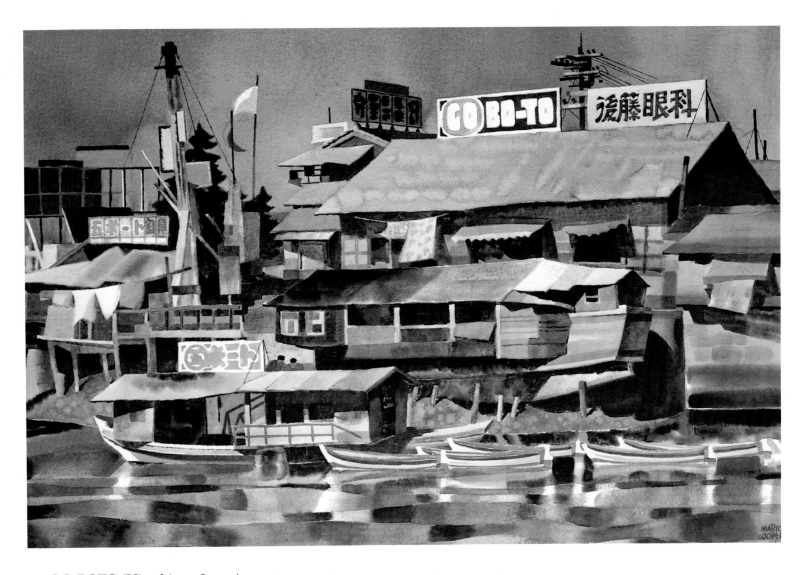

GO-BOTO (Hiroshima, Japan)
Watercolor, 1970, 22" × 30" (56 × 76 cm). Collection Dr. Homer Clark.

Just a few yards from the Peace Memorial in Hiroshima was this boat-renting houseboat on the river. The scene of the little pleasure boats against the Peace Memorial seemed to incongruous that I didn't want to introduce the memorial. So I made this painting of the colorful, peaceful-looking boats. As I stood on the opposite side of the river making sketches, I soon found myself surrounded by a group of Japanese children, all painting in watercolor.

The sky is a gray blue on the right. It gets a little darker toward the middle (the middle is yellow gray), and ends in a gray red on the left. I organized geometric patterns for the reflections. This was the first time I departed from the literal and casual handling of reflections. I was developing a style of my own.

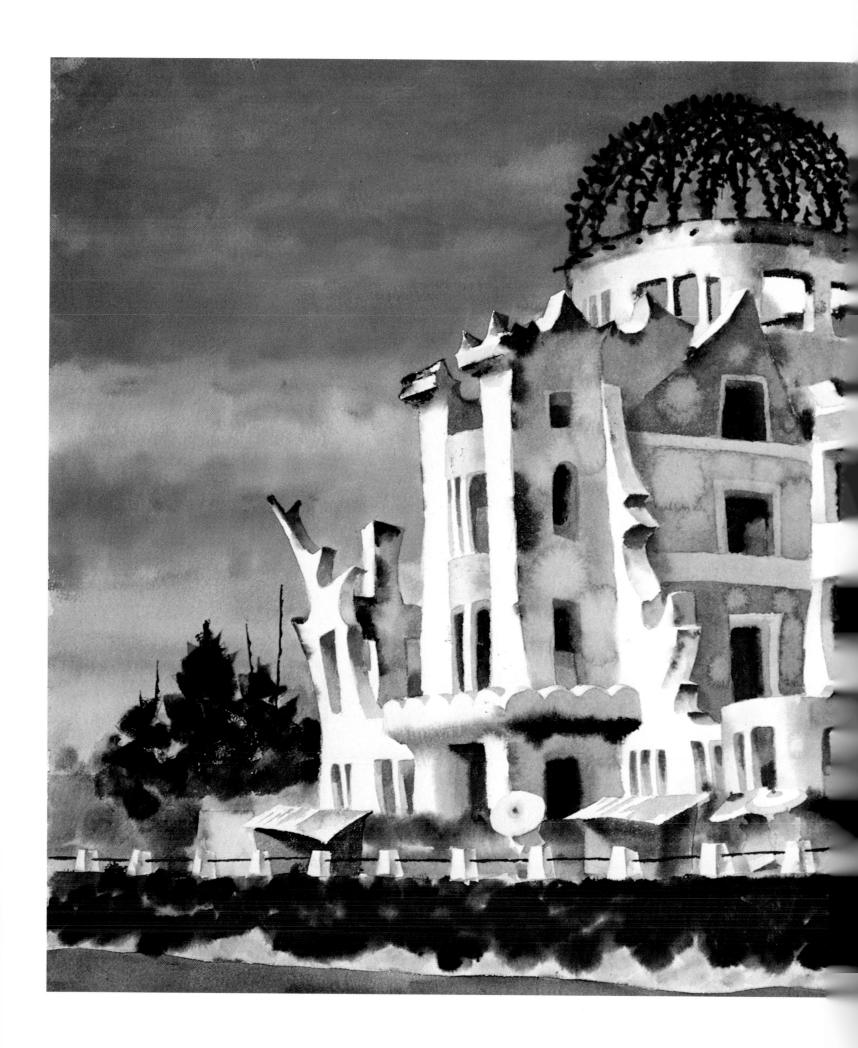

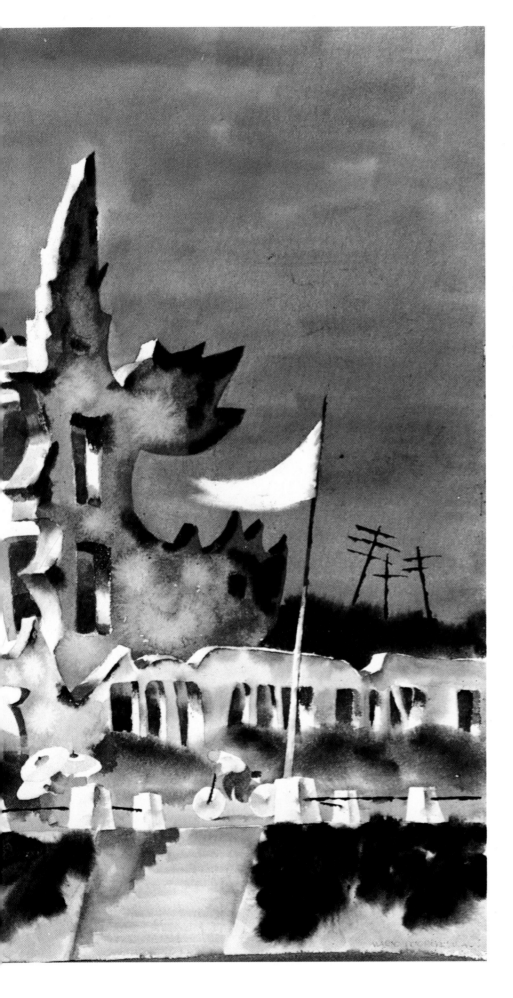

PEACE MEMORIAL, HIROSHIMA
Watercolor, 1970, 22" × 30" (56 × 76 cm).
Collection Dale Meyers.

In 1956, on one of my trips for the USAF Art Program, I visited Hiroshima. I stayed in a Japanese inn, and after bathing and putting on my *yukata*, I had some tea, then walked out and sat on the veranda. There I contemplated the garden, admiring the artistic selection of stones—the triangular, the round, and the square—all like instruments in a symphony orchestra. I listened to the dripping of the water from a bamboo faucet and the fluttering sound of birds, and I recalled what I had been earlier: the Peace Memorial, the tortured remains of an exhibition hall and library that had stood half a mile from where the A-bomb had been dropped.

I visualized a painting: a white structure against a red sky with the skeletal remains of the black dome, a dark band running across the bottom for the river with the serrated pattern of the growth on the river bank, and a group of figures with their parasols to relieve the starkness.

This is the third painting I have made on this theme and I think it's the best. The first won the top award in the National Academy Open Exhibition for Watercolors and the second is in the collection of the United States Air Force.

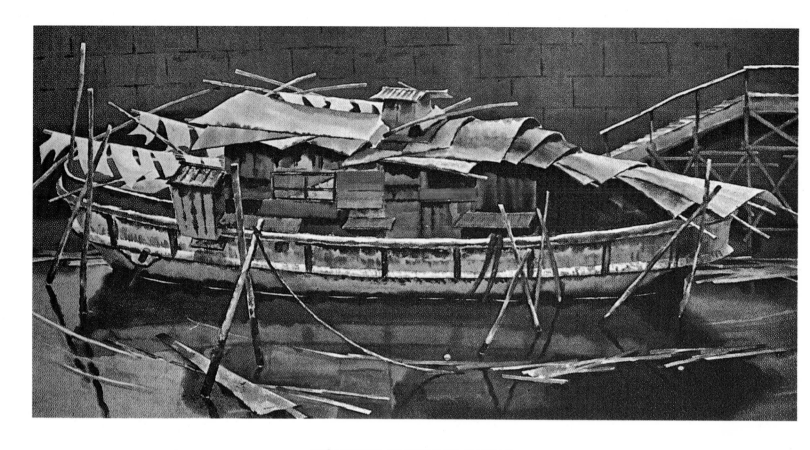

HOUSEBOAT, TOKYO CANAL
Watercolor, 1959, 22" × 40" (56 × 120 cm). AWS Award, 1959. Collection Metropolitan Museum of Art, New York.

When I was in Tokyo for the USAF in 1954, there were a number of canals and bridges lacing the city. One of the bridges, Nihonbashi, is famous for being the first (or the last, depending on the direction of travel) stop on the legendary Tokaido Road that went all the way to Kyoto, made famous by Hiroshige's 53 block prints. It was from this bridge that I made sketches for this painting.

There were a number of houseboats like this one in the canals. I remember while painting playing the fourth movement of the *Symphonie Fantastique* by Berlioz, the march to the scaffold, and trying to get the macabre beat into my painting. I kept this in mind even when I was cutting out the masking tape that I used to block out the mooring posts, floating objects, and rods projecting from the houseboat.

I used 140-lb paper, which was a bit thin and could easily have left hard edges, so that rendering the wall could have been a problem. (It could have given me a ladder effect that I did not want.) So I planned to do it in two or three washes and, in fact, I used three. The paper was stapled onto a ¼" three-ply board and turned sideways; I rendered the wall with a no. 20 sable brush, working from left to right with a mixture of Payne's gray, burnt sienna, and alizarin crimson.

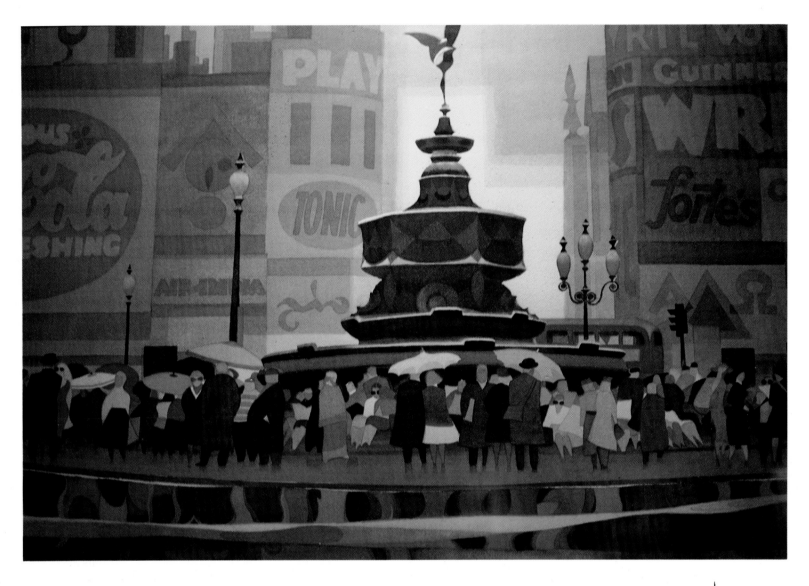

PICCADILLY CIRCUS
Watercolor, 22" × 30" (56 × 75 cm), private collection.

Piccadilly Circus is probably the best-known spot in London. It is pretty much like Times Square of New York City with movie houses and general meeting places. The celebrated statue of Eros was designed by Sir Albert Gilbert as a memory to the Earl of Shaftesbury, and the column with Eros at the top makes a great silhouette against the distant London background as you look down Shaftesbury Avenue. Using signs that have a lot of lettering gave me an opportunity to use the letters as abstract patterns. Once again my color scheme is a gray one. Again I placed some of my friends and family among the crowd. The important thing here was to let the buildings on each side of the picture melt into the middle distance, allowing the band of figures to form the dark checkered pattern across the bottom. The reflections on the street offered additional opportunity for design.

Edingburgh Canongate Tolbooth

141

BIBLIOGRAPHY

Books on Art

Albers, Joseph. *Interaction of Color*. New Haven: Yale University Press, 1975.

Birren, Faber. *Color Psychology and Color Therapy*. New York: McGraw-Hill, 1950 and New Jersey: Citadel Press, 1978 (paperback).

——. *Monument to Color*. England: McFarlane Warde and McFarlane, 1938.

Clark, Kenneth. *The Nude: A Study of Ideal Form*. New York, Doubleday (paperback).

Gardner, Helen. *Art Through the Ages*, 5th ed. or later. New York: Harcourt Brace Jovanovich.

Henri, Robert. *The Art Spirit*. Compiled by Margery A. Ryerson. Philadelphia and New York: J. B. Lippincott Company, 1923 (paperback, 1960).

Hale, Robert Beverly. *Drawing Lessons from the Great Masters*. New York: Watson-Guptill, 1964.

Itten, Johannes. *Design and Form: The Basic Course at the Bauhaus*, 2nd rev. ed. New York: Van Nostrand Reinhold, 1975 (paperback).

Refregier, Anton. *Natural Figure Drawing*, 2nd ed. New York: Tudor Publishing, 1960.

Schider, Fritz. *An Atlas of Anatomy for Artists*, 3rd American New York: Dover, 1957.

Thomson, Arthur. *A Handbook of Anatomy for Art Students*, 5th ed. New York: Dover, 1964 (paperback).

Vanderpoel, John H. *The Human Figure*. New York: Dover, 1958 (paperback).

Books on Artists

Comini, Alessandra. *Gustave Klimt*. New York: Braziller, 1975 (paperback).

——. *Egon Schiele*. New York: Braziller, 1976 (paperback).

Kley, Heinrich. *The Drawings of Heinrich Kley*. New York: Dover (paperback).

Marnat, Marcel. *Klee*. New York: Leon Amiel, 1974.

Soby, James Thrall. *Ben Shahn: His Graphic Art*. New York: Braziller, 1957.

Literature of General Interest

Boccaccio, Giovanni. *The Decameron*. Translated by John Payne. New York: Blue Ribbon Books, 1931.

Bowie, Henry P. *On the Laws of Japanese Painting*, 1911 ed. New York, Dover (paperback).

Cellini, Benvenuto. *The Autobiography of Benvenuto Cellini*. Translated by John Addington Symons, with an introduction by Royal Cortissoz New York: Brentanos, 1906.

The Horizon Book of the Renaissance. New York: American Heritage Publishing Co., 1961.

Ovid (Publius Ovidius Naso). *The Metamorphoses*. Translated by Henry T. Riley. London: H. G. Bohn, 1861.

Seton, Kenneth M. "The Norman Conquest 900 Years Ago," *National Geographic*, vol. 130, no. 2, August 1966. (Article on the Bayeux tapestry in Normandy.)

Young, G. F., *The Medici*, 2 vols, reprint of 1913 ed. Norwood, Pa.: Norwood Editions.

INDEX